ON AN ANTIDOTE

The exhibition *L'œuvre a-t-elle lieu?*, curated by Daniel Buren, was shown at Witte de With, from 9 April until 22 May 1994. Buren invited the artists Giovanni Anselmo, Michael Asher, Stanley Brouwn, Patrick Corillon, Jacqueline Dauriac, Krijn de Koning, Thierry Kuntzel and Chen Zhen to make site-specific works without his revealing where they would be shown (see *Witte de With -- Cahier # 2*, pp. 200-205). The artists were also offered use of the *Cahier*, which resulted in the following contributions.

FEBRUARY **1995**

WITTE DE WITH
CENTER FOR CONTEMPORARY ART, ROTTERDAM
RICHTER VERLAG, DÜSSELDORF

WITHDRAWN

contents

L'OEUVRE

DOES the work take place?

A-T-ELLE LIEU?

GIOVANNI ANSELMO	JACQUELINE DAURIAC
MICHAEL ASHER	KRIJN DE KONING
STANLEY BROUWN	THIERRY KUNTZEL
PATRICK CORILLON	CHEN ZHEN

Michael Asher

Except for the basic information about the display area for each artwork, the exhibition proposal for *L'œuvre a-t-elle lieu?* had no information regarding the site. It seemed that such a proposal would encourage artwork which had an arbitrary relationship with the exhibiting institution. Therefore, in response to the exhibition concept, I took this opportunity to try to develop an artwork which would function specifically in relation to the unknown exhibition space while still being governed by the proposal. The elements I chose to employ were driven by questions I believed inhabited Daniel Buren's exhibition concept: in particular, its desire to revisit the period when the possibility of a neutral setting for the work of art could supposedly exist alongside the reliance upon exhibition themes and a more contemporary concern regarding the scope of site-specific practice relative to more traditional practices.

I found it impossible to finalize this project without requesting that the realization of my installation be contingent upon a placement in juxtaposition to bookshelves within the visitor's visual range or else part of a photographic exhibition. If one or the other of these conditions were unavailable, I would not have been able to participate in the exhibition. My proposal with its requirement was accepted by Buren. Thereafter I learned that the exhibition would take place at Witte de With.

The artwork I presented was a 35mm-slide projection of the subject index for *The Directory of Free Stock Photography*; published by Infosource Business Publications in 1986. This book enables its user to save money on fees charged by commercial-stock photo libraries and to assist in finding rare prints. The subject index is structured thematically, beginning with "Aerials" and ending with "Zoos." Page numbers refer to the listings which provide addresses for photographic requests following each entry.

The image for the projection was photographed directly from the book, allowing two facing pages to be represented and the source to be evident on each slide. The slides were taken with black-and-white print film and processed with a reversal kit which produced a positive transparency rather than the usual negative. It was projected in the Witte de With reception area, which is open to the exhibition space. As well as bookshelves for catalogues, the reception area has a vitrine, work desk and reception desk with a cash register. This is the point at which visitors pay their admission and purchase catalogues. When the viewer approached this area, the projection could be seen upon the left-hand wall in between the end of the wall and the existing catalogue display shelves. The image was 20 ⅛ inches wide and 40 inches from the floor. The 35mm projector was positioned on the reception desk next to the cash register. Its carousel was on an automatic timer which allowed the images to be read in the same sequence as in the book. A wall label identified the source of the image and the photographer to the left of the projected image. Next to the projector a label identified the artist.

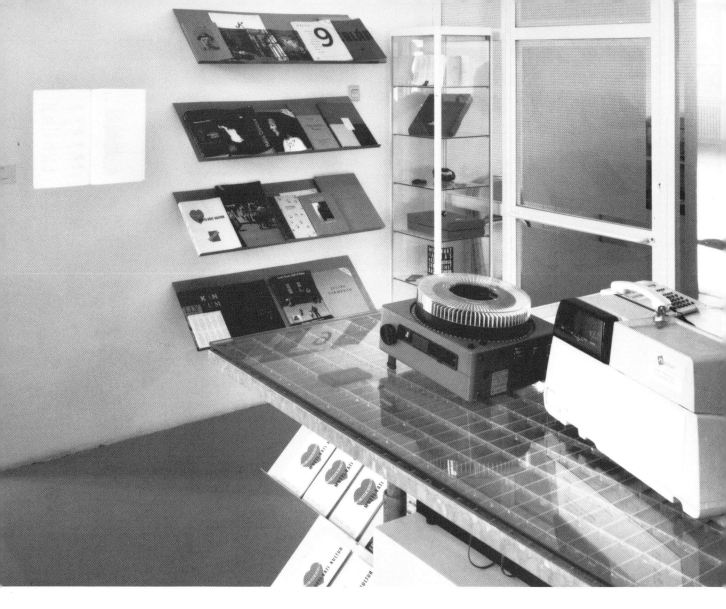

The Directory of Free Stock Photography

ISBN: 0-939209-00-4

LCC#: 80-640589

Art Direction Book Company
10 East 39th Street, 6th Floor
New York, NY 10016

Photographed by Andrew Freeman

282
National Hockey League
1221 Avenue of the Americas Phone: (212) 398-1100
New York, NY 10020 Press Office
Photos: Hockey. **Formats:** 3, 5. **Credit line required. Office hours:** 9 to 5.

283
National League
1 Rockefeller Plaza Phone: (212) 582-4213
New York, NY 10020 Public Relations
Photos: Baseball, National League stars and teams. **Formats:** 3, 5, 9. **Credit line not required. Office hours:** 9 to 5.

284
New York Racing Association
PO Box 90 Phone: (718) 641-4700
Jamaica, New York, 11417 Public Relations
Photos: Horses, racing, others. **Formats:** 3, 5. **Credit line not required. Office hours:** 9 to 5.

285
RCA Corporation
30 Rockefeller Plaza Phone: (212) 621-6004
New York, NY 10020 Freida Schubert
Photos: Industrial, products, people. **Formats:** 3, 5, 9. **Credit line required. Office hours:** 9 to 5.

286
Schwartz Associates
200 Fifth Avenue Phone: (212) 683-7810
New York, NY 10010 Barry Schwartz
Photos: Various. **Formats:** 3, 5, 9, 11. **Credit line not required. Office hours:** 9:30 to 5:30.

287
Sony Corporation Phone: (201) 930-6440
Photos: Industrial, products, manufacturing. **Formats:** 3, 5. **Credit line not required. Office hours:** 9 to 5.

A

F

Farming

Arizona State Parks Board 11
Nebraska State Historical Society 162
New Hampshire Department of Resources and Economic Development
 166

Festivals

Ceylon National Tourist Board 37
French Government Tourist Office 77
Japan National Tourist Board 107
Manchester Historical Society 125
Greater Milwaukee Convention and Visitors Bureau 141
New York Public Library of Performing Arts in Lincoln Center 174
Philippine Ministry of Tourism 195
San Mateo County Convention and Visitors Bureau 217
State of West Virginia Department of Commerce 265

Film

Astoria Motion Picture and Television Foundation 16
Walt Disney Productions 60
Walt Disney Productions 61
Motion Picture Department U.S. Library of Congress 151
U.S. National Archives 255

Fire (department, protection, etc.)

Bureau of Land Management 30
Forest Service, U.S. Department of Agriculture 72
Manchester Historical Society 125

Fish(ing)

Clearwater Chamber of Commerce 44
Georgia Department of Natural Resources 80
Pittman & Associates (Hotsprings, AZ) 89
Jacksonville Beaches Chamber of Commerce 104
Peter Martin Associates (Jamaica) 105
Government of Newfoundland and Labrador 179
Oregon Department of Transportation 188
Oshkosh Convention and Tourism Bureau 189
Shakespeare Company 220
Tennessee Valley Authority 240
U.S. Fish and Wildlife 249
Virginia Division of State Parks 261

Floral

Chicago Park District Public Information Department 42
San Mateo County Convention and Visitors Bureau 217
Tyler Chamber of Commerce 246
Virginia Division of State Parks 261

Forests

Forest Service, Department of Agriculture 72
New Mexico Chamber of Commerce 169
Pennsylvania State University Library 193
Tennessee Valley Authority 240

Folklore

Austrian National Tourist Board 20
Bulgarian Tourist Office 28
Cyprus Tourism Board 52
French Government Tourist Office 77
National Museum of Man 156

G

Golf

El Paso Convention and Visitors Bureau 66
Jacksonville Beaches Chamber of Commerce 104
Killington Ski Resorts 112
Mount Snow Ski Resorts 152
Palm Springs Convention and Visitors Bureau 190
Pocono Mountain Vacation Bureau 197
Prince Edward Island 200

Gondolas (skiing)

Killington Ski Resorts 112
Mount Snow Ski Resorts 152

Government

Charles County Chamber of Commerce 40
New Zealand Government Tourist and Publicity Office 176
Pennsylvania State University Library 193
Pueblo Chamber of Commerce 204

H

Hiking

Pittman and Associates (Hotsprings, AZ) 89
New Hampshire Department of Resources and Economics 166
South Lake Tahoe Visitors Bureau 232

Historic

Anchorage Historical Society 9
Arkansas Department of Parks 12
Austin Chamber of Commerce 17
Baton Route Area Convention and Visitors Bureau 23
Cape May County Chamber of Commerce 36
Chattanooga Area Chamber of Commerce 41
Connecticut Historical Society 48
Historical Society of Delaware 56
Denver Public Library 57
Walt Disney Productions 60
Consulate General of Finland 69
French Embassy 76
General Motors Corporation 78
Georgia Department of Natural Resources 80
Glenbow-Alberta Institute 82
Guatemala Tourist Office 84
Illinois State Historical Society 94
Indiana Historical Society 100
Kansas Department of Economic Development 109
Consulate General of Korea 113
Louisiana Office of Tourism 121
National Tourist Board—Malta 124
Maryland Office of Tourism 130

I

L

M

N

O

Office (Buildings, settings)

P

Parks (general, national, state)

People

Performing Arts

R

Rafting

Railroads

Recreation, general

Resorts

Restaurants

S

T

U

V

Krijn de Koning

A proposal to create a space of one's own in which to present one's work is the principal reason for accepting the invitation. For an artist who involves the given space in the realization of a work, that proposal leaves nothing to be desired.

Many of the things which are going to define this space are specified in the criteria laid down in the invitation.

These conditions act as a point of departure, and thus as the real-life situation and conditions which normally define a work.

There is no patently obvious point of departure on which to base a color. There appears to be no reason for orientating oneself towards color, and hence no excuse for using an extreme color.

The physical dimensions dictated by the proposal clearly entail limitation. In specific terms, the artist's responsibility for designing the space does not exceed the consequent measurements. By that token it is quite natural to take those physical measurements as the size of the work, and to use the entire space, literally making it.

In the first place the resulting space is not a space which gestures towards its surroundings. It generates a situation which seems to favor the work as an object.

Although the work's allotted place is not yet known, that place will be there during the exhibition. So will a public which has been informed of the concept. In that place a different responsibility holds sway; it is appropriate to take a risk in that environment. The visual consequence is not four walls, but fenestration.

An idea is creating a space as a sculpture. And at the same time creating a sculpture as space. A work in which space and sculpture can function as one. An important factor will be what separates sculpture and space: ingressiveness. A simple access opens the way to a perambulation which identifies the position of the sculpture and the space. Openness, uniformity and symmetry identify the environment.

In the end it will be seen that the conditions of the concept have been carried out to the letter: a space actually has been created, and one or more works actually are presented in it.

Experiencing the sculpture in the space belongs to the object's history. Experiencing space as sculpture belongs to the history of in situ. In the concept, the two are united or linked.

Het voorstel om zelf een ruimte te maken waarin het werk zal worden gepresenteerd, is de eerste reden de uitnodiging aan te nemen. Voor een kunstenaar die de gegeven ruimte betrekt bij de realisatie van een werk, bevat dit voorstel naar de letter een ideale situatie.

Veel gegevens die deze ruimte zullen gaan bepalen, staan geformuleerd in de criteria van de uitnodiging. Deze gestelde voorwaarden functioneren als uitgangspunt, dus eigenlijk als de reële situatie en condities die normaal het werk bepalen.

Er is geen overduidelijk uitgangspunt aanwezig om een kleur op te baseren. Er blijkt geen reden voor een oriëntatie op kleur, en dus geen aanleiding een extreme kleur te gebruiken.

Duidelijk is dat de fysieke maat die aan het voorstel is meegegeven een limiet in zich draagt. De beeldende verantwoordelijkheid van de kunstenaar reikt reëel gezien, niet verder dan de daaruit voortkomende afmeting. Het is vanzelfsprekend om die fysieke afmeting weer als de maat van het werk te nemen, en om de complete ruimte te benutten en deze letterlijk te maken.

In de eerste plaats wordt de ruimte die zo ontstaat niet een ruimte die een geste maakt naar de aanwezige omgeving. Het brengt een situatie voort die het werk als object lijkt te willen voorstaan.

Welke plaats het werk krijgt is weliswaar niet bekend, maar die plaats zal er zijn tijdens de tentoonstelling. Evenals een publiek dat geïnformeerd is over het gestelde concept. Op die plaats geldt een andere verantwoordelijkheid, een risico nemen naar die omgeving is op zijn plaats. De beeldende consequentie daarvan is: geen vier opgetrokken muren, maar raamopeningen in de ruimte.

Het idee ontstaat een ruimte te scheppen als beeld. En tegelijkertijd een beeld te scheppen als de ruimte. Een werk waarin ruimte en beeld kunnen functioneren als één. Belangrijke factor wordt wat beeld en ruimte onderscheid: de betreedbaarheid. Door een enkelvoudige toegang wordt er een rondgang mogelijk die de positie van het beeld en de ruimte kenbaar maken. De openheid, gelijkvormigheid en symmetrie zorgen dat de omgeving kenbaar wordt.

Uiteindelijk blijkt dat de gestelde voorwaarden van het concept letterlijk zijn genomen: letterlijk een ruimte geschapen, met daarin letterlijk één of meerdere werken gepresenteerd.

De beleving van het beeld in de ruimte staat in de geschiedenis van het object. De beleving van ruimte als beeld staat in de geschiedenis van in situ. In het concept zijn beide verenigd of verbonden.

Krijn de Koning
Witte de With, April-May 1994

een denkbeeldige ruimte van 7 x 7 x 7 voet,
in een denkbeeldige ruimte van 7 x 7 x 7 el,
in een denkbeeldige ruimte van 7 x 7 x 7 stap,
in een denkbeeldige ruimte van 7 x 7 x 7 m;
in een ruimte van witte de with, witte de
withstraat 50, rotterdam.

stanley brouwn

Patrick Corillon

Does the Work Take Place?

Leonardo da Vinci once asked himself this question: "If a tree falls in the forest and no one is there to hear it fall, does it make a sound?"

Does the work take place if no one is there to see it?

The spectator, in my view, is indispensable to the work's taking place. But the problem is that for many spectators, the work has already taken place before they see it. Before even going to an exhibition they already have a preconceived idea of what they are going to see. And what they see will only become a work if it conforms to what they conceive as a work. In this case, they see nothing more than a work which has already said its piece, a dead work.

To cut through these prejudgments, maybe it is necessary to put the work in a situation where it is not presented as such, where the spectator first discovers it by its purely decorative, historical, or even political qualities, and where the notion of being confronted with a work only comes as an aftertaste.

If the work takes place, it does so less through its physical presence than through the moment spent in its company. The work is above all a contact made in a particular moment, in a particular place, by a particular object; but it will only truly live when it is confronted with other moments of life, when it can give a perspective to these other moments. Maybe the work stands only on its qualities of memory, which can be called upon at any moment and in any place.

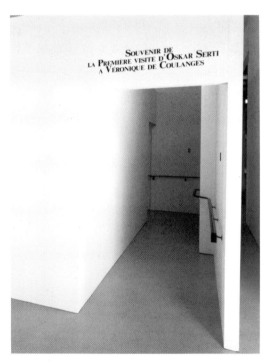

Patrick Corillon
Souvenir de la première visite d'Oskar Serti à Véronique de Coulanges
(Souvenir of Oskar Serti's First Visit to Véronique de Coulanges), 1994

L'œuvre a-t-elle lieu?

Léonardo da Vinci s'était posé cette question : "Si un arbre tombe dans la forêt et que personne ne se trouve dans la forêt pour l'entendre tomber, il y a-t-il un bruit ou non?".

L'œuvre a-t-elle lieu si personne n'est là pour la voir?

Si, à mes yeux, le spectateur est un élément indispensable pour que l'œuvre ait lieu, le problème est que pour beaucoup de spectateurs, l'œuvre a déjà lieu avant qu'ils ne la voient. Avant même d'aller voir une exposition, ils ont déjà une idée préconçue de ce qu'il vont voir. Et ce qu'ils vont voir ne deviendra une oeuvre que si cela correspond à ce qu'ils conçoivent comme œuvre. Mais dans ce cas, ils ne regardent plus qu'une oeuvre qui a déjà tout dit, une œuvre morte.

Peut-être, pour casser ces préjugés, faut-il placer l'œuvre dans une situation où elle ne se présente pas comme telle ; où le spectateur la découvre d'abord pour ses qualités purement décoratives, historiques, ou même politiques ; et où la notion d'avoir été confronté à une œuvre n'intervient que comme un arrière-goût.

Si l'œuvre a lieu, c'est moins grâce à sa présence physique que par le moment que l'on a passé en sa compagnie. L'œuvre est avant tout un contact qui se fait à un moment précis, dans un lieu précis, par un objet précis ; mais qui ne vivra véritablement que quand elle sera confrontée à d'autres moments de la vie, quand elle pourra donner une perspective à ces autres moments. L'œuvre ne vaut peut-être que par ses qualités de souvenir auquel on peut faire appel à tout moment et en tout lieu.

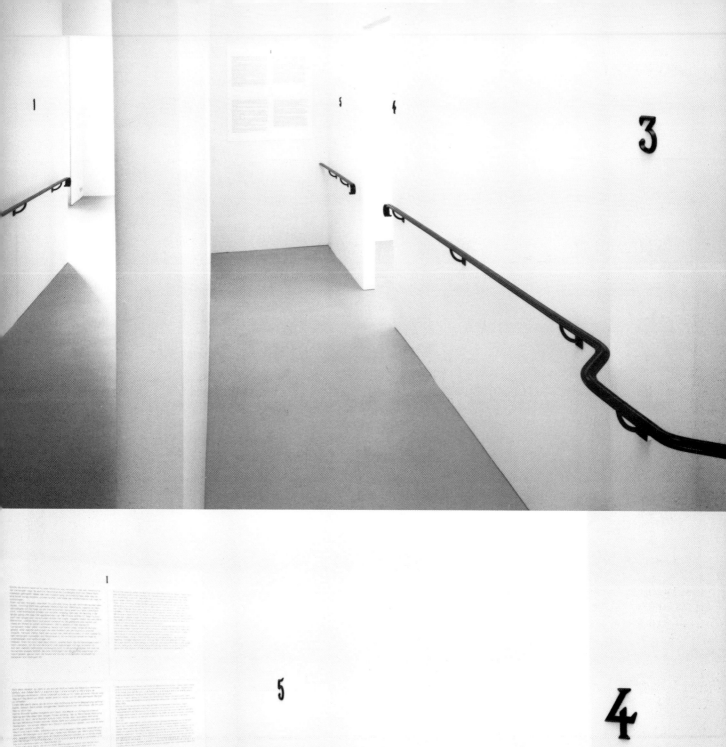

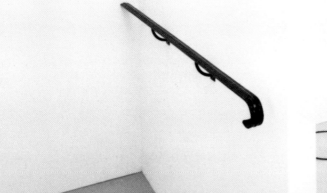

Souvenir of Oskar Serti's first visit to Véronique de Coulanges

I

Since the evening when he saw her incarnate Bérénice on stage, Oskar Serti was stricken with a mad passion for the actress Véronique de Coulanges. For more than a month, day after day, he incessantly addressed her letter upon letter, without, unfortunately, receiving the slightest sign from her.

Then, one morning, when he had just given up all hope of an encounter, Serti received a hurried phone call from Véronique, inviting him to have tea with her. Less than an hour later, his legs quivering with emotion, Serti was holding on feverishly to the hand-railing along the corridor which led to Véronique's apartment (1). As he could no longer shelter himself behind the sweet and fragile image of a distant Bérénice, Serti suddenly felt paralyzed by the idea of finding himself face to face with someone, a being of flesh and blood, of whom he knew absolutely nothing (2).

Little by little however, as his hand slid slowly along the railing whose contours discretely married the wall's numerous angles, Oskar Serti regained a semblance of self-assurance; he even felt born in him the desire to take Véronique in his arms and entangle her with caresses (3).

Unfortunately, once in front of the door to her apartment, Serti saw his fleeting courage abandon him, and he didn't find the strength to ring (4).

As a last resort he took refuge in the great staircase which led to the upper floors, letting his hand slide along the railing whose numerous contours gave him the illusion of being able to calm his impossible desire (5).

II

In the attempt of preserving her private life, the actress Véronique de Coulanges vowed never to answer the enflamed letters of her admirers. Thus, when the young writer Oskar Serti wanted to take her heart by storm, she stood her ground for more than a month.

Then, one morning, rereading the letters which he had not ceased to write to her, she fell under their spell. Moved by an obscure force, she could not live a moment more without knowing this man. She grabbed her telephone, and invited Oskar to come as soon as possible and have tea with her.

Noticing that she was still in her nightgown, Véronique rushed to the bathroom to change into something more suited to the occasion (1). Unfortunately, she tripped on the telephone wire, lost her balance, fell head first onto the floor, and passed out (2).

Nearly an hour later, Véronique finally regained her senses. Deeply troubled, with beads of perspiration all over her body, she immediately remembered that during her loss of consciousness, she had dreamed of Oskar Serti. The latter had not ceased to hug and caress her as no one had done until then (3).

The moment she stood up, she wanted to disentangle herself from the telephone wire; but when she saw to what extent it had wrapped around her legs, arms and neck, she understood the origin of her indecent dream (4).

It was then, with a surprising blend of anxiety and impatience, that she heard a man's step stop at the door to her apartment. But after a moment's hesitation, as if he was looking for someone else, the man continued to make his way along the great staircase which led to the upper floors.

Dejected by the presentiment that Oskar wouldn't come, Véronique took stock of the weight of her solitude and decided to remain an instant longer, prisoner of her wire (5).

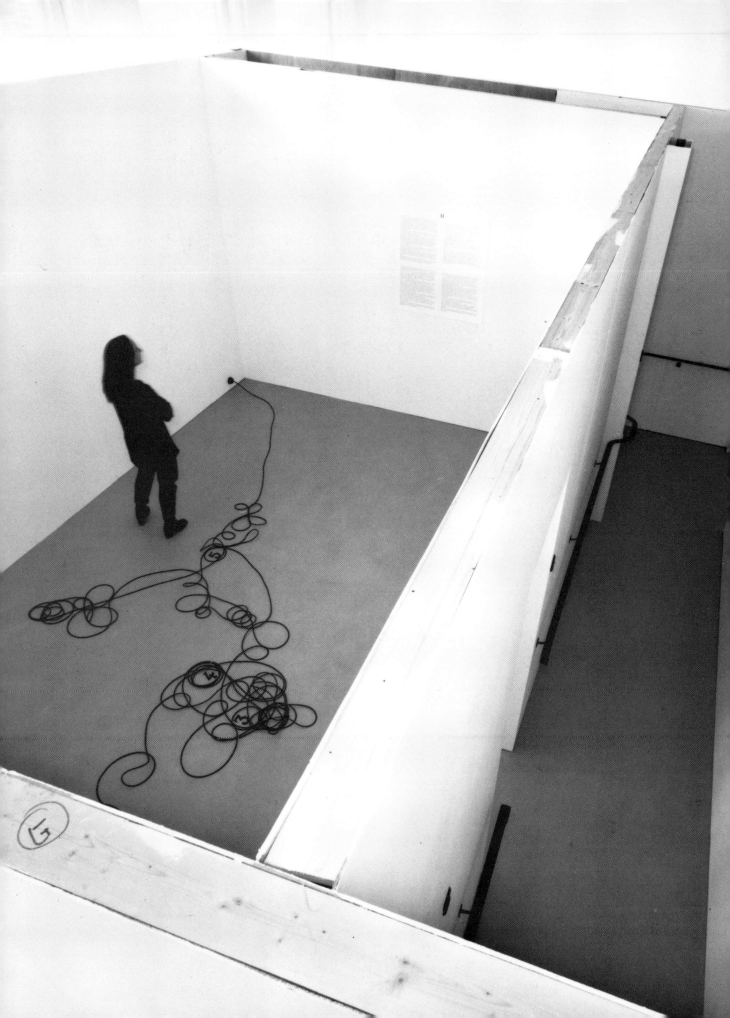

Giovanni Anselmo

The partial information of the invitation notwithstanding, I decided to participate in *L'œuvre a-t-elle lieu?* as much for the desire to respond to the questioning title of the exhibition as for the spirit of adventure.

The initial information of a "greenish-grey" colored floor helped me to understand that the exhibition would however take place on the earth. This information constituted a concrete point to start from and to refer to when conceiving a work plan, while keeping in mind, of course, the possibilities permitted by the budget and the space.

Nonostante le parziali informazioni dell'invito, ho scelto di partecipare a *L'œuvre a-t-elle lieu?*, vuoi per il desiderio di dare risposta al quesito-titolo della mostra, vuoi per spirito di avventura.

Il dato iniziale circa il *pavimento "verde grigio scuro"* mi è stato di aiuto per capire che l'esposizione sarebbe avvenuta comunque sulla terra.

Questo dato ha costituito un punto concreto da cui partire ed a cui fare riferimento per pensare ad un progetto di opera, tenendo conto, ovviamente, delle possibilità consentite dal budget e dallo spazio.

Giovanni Anselmo
Quattro particolari sulla terra lungo il sentiero verde grigio chiaro (Four "particolari" on the earth along the light, greenish-grey path), 1994

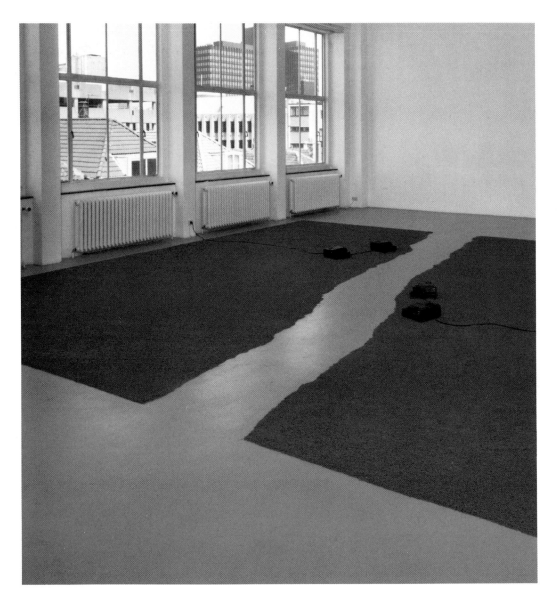

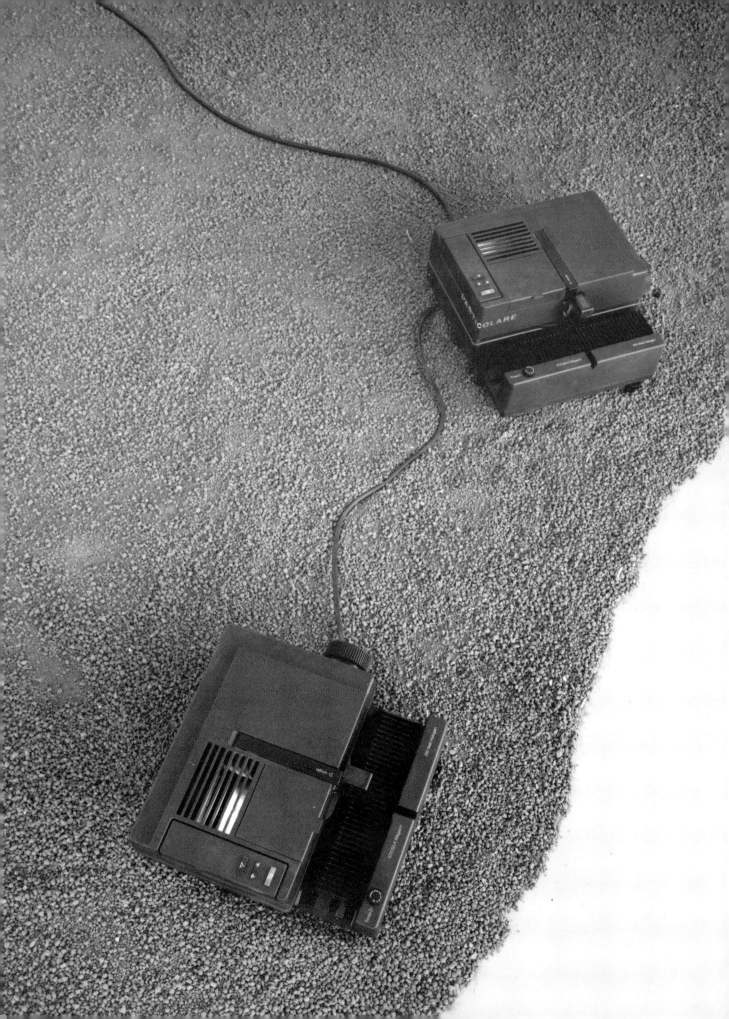

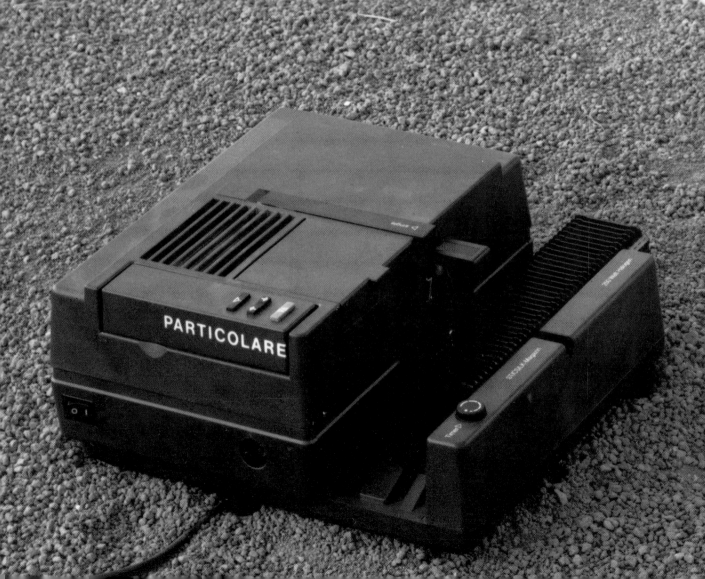

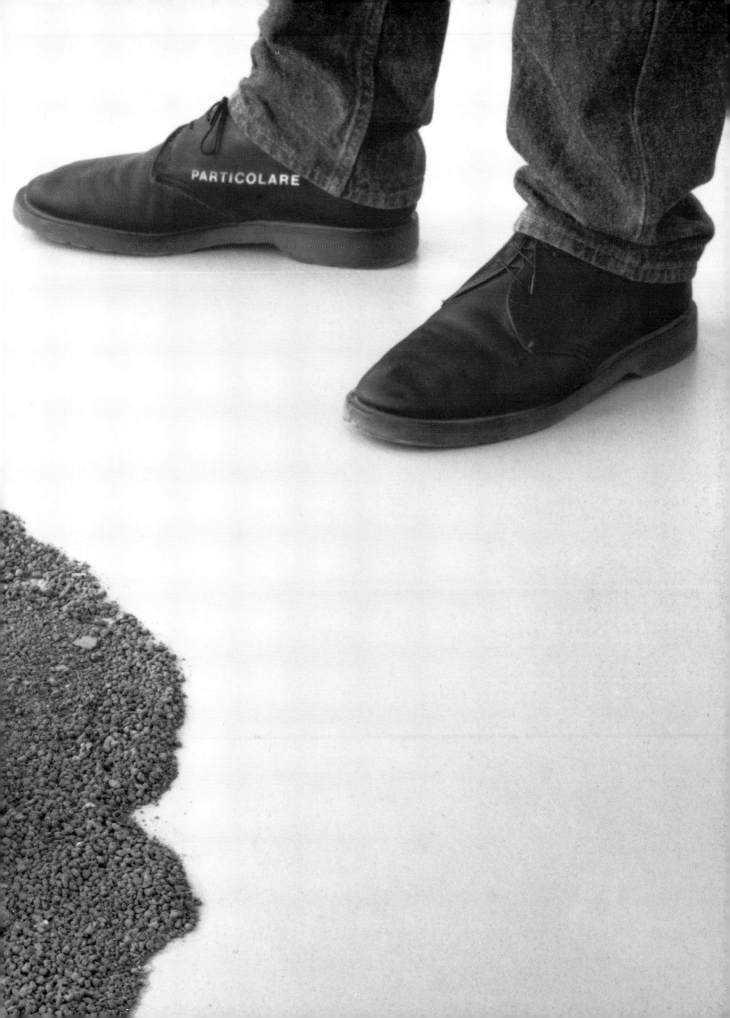

Jacqueline Dauriac I was very happy to receive Daniel Buren's letter-invitation, yet Daniel Buren's refusal to participate in the exhibition immediately posed two problems:

1. What was the political position of the institution "facilitating" the realization of the exhibition? Would it consider the entire exhibition as a work by Daniel Buren, in which case it would be able, though not without cynicism, to disengage itself completely from the seven invited artists, putting Daniel Buren in the very situation of the exhibition curators that he has criticized with such force and pertinence? Or would it also consider all seven singularities invited by Daniel Buren, that is, would it have a real relationship with eight different people? The invitation to the opening would be the first clue of the institution's attitude towards this ethical problem …

2. Through his refusal to participate, Daniel Buren seemed to be asking a question about his own work. His fore-knowledge of the place did not allow him to produce the desired work: the in situ concept was being brought into question.

Two months later, this was confirmed by the appearance of the title: *L'œuvre a-t-elle-lieu?* (Does the Work Take Place?) I find this question extremely interesting. It was already brought up in certain works by Daniel Buren, in particular *Les Guirlandes* at *documenta 7* in Kassel and *C'est ainsi et autrement* in the Kunsthalle Bern, where it was resolved through a kind of excess of the plane surface (resonance).

And yet the demand for shelter remains present, like a resistance, or a challenge to go beyond: to leap into a new plane, a new decision; to become active, to produce a human relationship. And here, for me, the problem is not one of the object-shelter, but one of a movement, of a passage from into ex situ.

It was within this crisscrossed double bind that I accepted Daniel Buren's invitation.

J'ai été très heureuse de la lettre-invitation de Daniel Buren, néanmoins, le refus de Daniel Buren de participer à l'exposition posait immédiatement deux problèmes :

1. Quelle est la position politique de l'institution "aidant" à la réalisation de l'exposition ? Va-t-elle considérer l'ensemble de l'exposition comme un travail de Daniel Buren, et dans ce cas, non sans cynisme elle pourra se désengager vis-à-vis des sept artistes invités, mettant Daniel Buren dans la situation même des commissaires qu'il a critiqués avec tant de force et pertinence ! Ou considérera-t-elle les sept singularités invitées par Daniel Buren, soit huit personnes, avec lesquelles elle aura une véritable relation ? Le carton d'invitation nous montrera le premier signe de l'institution vis-à-vis de ce problème d'éthique …

2. Dans son refus de participer, Daniel Buren semble poser une question sur son propre travail : la pré-connaissance du lieu ne lui permet pas de produire le travail souhaité : c'est l'in situ qui est mis en question. Le titre apparait deux mois plus tard et confirme *L'œuvre a-t-elle lieu ?*.

Je crois extrêmement intéressante cette question déja soulevée dans certains travaux de Daniel Buren, en particulier *Les Guirlandes* à la *documenta 7* à Kassel et *C'est ainsi et autrement* à la Kunsthalle Berne, résolue alors dans une sorte d'excès du plan (résonance).

Et pourtant la demande d'abri reste présente, comme une résistance, ou un défi à un dépassement : sauter dans un nouveau plan, une nouvelle décision : devenir actif, produire un rapport humain, et ici enfin le problème n'est pas pour moi celui de la finalité de l'objet-abri, mais celui d'un mouvement, passer de l'in à l'ex situ.

C'est dans cette double entrave croisée que j'ai accepté l'invitation de Daniel Buren.

Jacqueline Dauriac
Sans abri (Without Shelter),
1994

DENK AAN IEMAND DIE U HIER HEEFT ONTMOET

SOUVENEZ-VOUS D'UNE PERSONNE RENCONTREE ICI

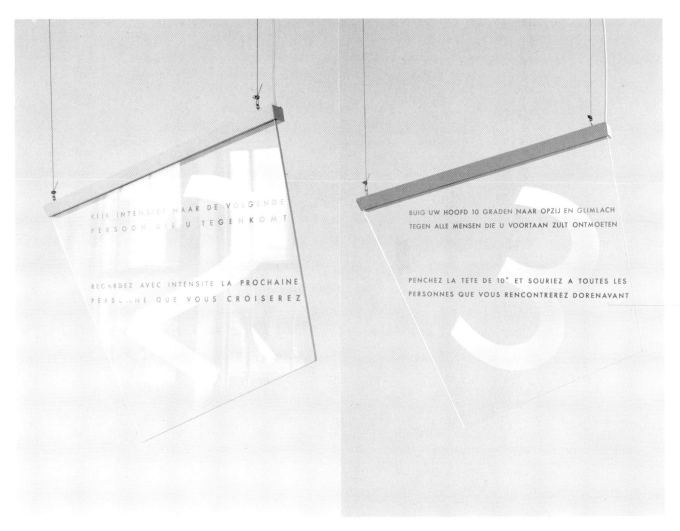

KIJK INTENSIEF NAAR DE VOLGENDE
PERSOON DIE U TEGENKOMT

REGARDEZ AVEC INTENSITE LA PROCHAINE
PERSONNE QUE VOUS CROISEREZ

BUIG UW HOOFD 10 GRADEN NAAR OPZIJ EN GLIMLACH
TEGEN ALLE MENSEN DIE U VOORTAAN ZULT ONTMOETEN

PENCHEZ LA TETE DE 10° ET SOURIEZ A TOUTES LES
PERSONNES QUE VOUS RENCONTREREZ DORENAVANT

2. Look intensively at the next person you meet

3. Tilt your head 10 degrees and smile at all people you will meet from now on

Thierry Kuntzel
Le Tombeau de Henry James.
Le Tombeau de Herman Melville.
(The Tomb of Henry James.
The Tomb of Herman Melville.)
1994
project for
Witte de With - Cahier # 3

WHAT MAISIE KNEW

Thierry Kuntzel
Le Tombeau de Henry James.
Le Tombeau de Herman
Melville.
(The Tomb of Henry James.
The Tomb of Herman Melville.),
1994

Utrecht, 13 September, 1993

Dear Daniel,

I am very happy to accept your invitation for this extraordinary exhibition of "the non-knowledge of the place," which interests me tremendously.
I thank you very much for your confidence and friendship!
Of course it will not be a normal, easy exhibition. But this non-regularity and non-comfort are just what I find fascinating.
I will send you my proposal later (before October 15, as understood).
This really gets us into a "detective story."
My warmest greetings to you!
We'll be in touch soon!
Chen Zhen
P.S. I'm now carrying out an installation at the Centraal Museum, Utrecht.

Project for Daniel Buren's exhibition

1. First proposal sent on 12 October 1993

The givens:
There is as yet no title for the exhibition
Place: "anonymous"
Techniques: various
Dimensions: in a 7 x 7 x 4 meter volume

Imaginary context

…
In fact, the interesting thing at the core of this exhibition is that the curator has set out a "trap" before us. Consequently, the way of reacting to this proposal is not only to reflect on maximizing one's possibilities within the given conditions, but above all to discover the "potential givens" hidden behind the "non-knowledge of the place," in order to put oneself in an imaginary context

and deliberately give up one's own systematic manner of working. For me, the important thing in the final realization of the project, including both the constructed space and the work laid out inside it, is not only revealed in the self-protection of the work of each of the artists through their own respective spaces, but rather the adaptation to both the artists and the space of the location. In other words, the primary element of the project is not "an independent sculpture" in space, but a "spatial sculpture" integrated to the space.
The problem is precisely to know how it is possible to work without being able to determine the conditions necessary to attain this.

Evolving reaction

Faced with such circumstances, I must ask myself how to find a very flexible solution that will allow me to work with the curator "in evolving time."
My first objective is therefore to propose three spaces (each very different from the others) which can eventually be adapted to the different contexts of the places; the curator will choose one of these. Then I will modify the chosen space according to the given conditions, but above all according to the real constraints. Finally, I will react on site during the last four days to definitively decide what will happen in my space. I will give my project a title at that time.

The three proposed spaces:
1. The suspended space.
This proposal is based on the imagination of a space whose height is 5 to 6 meters and whose light emanates from the ceiling. The specificity of this proposal is its lightness, both physical and visual. The material is the texture of the curtains that compose the space (see drawings number 1 A and B).

2. The transverse space.
This space is suggested for a room including wall windows. The principle of this construction is to arrange $^2/_3$ of the space within the building and $^1/_3$ outside the institution. The aspect of the walls of this transverse box will be of the same nature as the

Chen Zhen
Working Drawing 1 (A) and (B),
October 1993

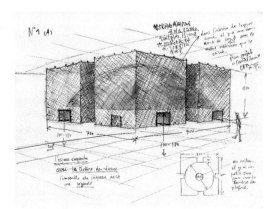
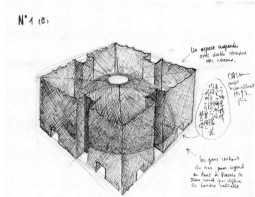

original walls of the space (if this is technically possible and does not exceed the production cost limits); that is to say, we will attempt to create a block as though it already existed in this space. The interest of this space is to lead us from the interior toward the exterior of the building, and to reinforce the link between these two spaces by the intermediary of a second interior proposal. The materials used are brick, metal, and glass (see drawings 2 A and B).

3. The sculptural space.
The space proposed here is an independent element within a place. It can be moved according to the curator's needs and the spatial availability of the location. The idea of constructing this element by creating two parts, one being an empty space (in metal and glass) and the other a full volume (in straw), lays the accent on the ambiguity of the sculpture-space itself. The materials used are metal, glass, and straw (see drawing number 3 A and B).

Of course I will concretize all the technical details as soon as one of these three propositions will have been chosen by the curator, and if need be, I can combine different aspects of these three setups on the levels of structure, of materials, and of disposition in space, with all sorts of technical, material, and budgetary suggestions coming from the curator and the institution.

…

2. Definitive proposal sent on 1 March, 1994: "The Cave of Introspection — the Cow Pat, the Chair, the Mask."

The new givens:
Title of the exhibition: *L'œuvre a-t-elle lieu?* (Does the Work Take Place?)
Place: Witte de With, center for contemporary art, Rotterdam
Technique: straw, metal, plexiglass, cow pat, chairs, gas mask
Dimensions: 7 x 7 x 4 meters

Developed context
In conformity to Daniel Buren's project, my first proposal consisted in two "evolving" elements: first, leaving the curator

the freedom to chose one of the submitted proposals; second, developing the interior elements of my space and defining the title at the moment when the place became known.
In the end Witte de With, which is located in Holland, fit perfectly with one of my proposals — the plexi-metal space and the straw, the project chosen by Daniel Buren. The national context is strongly linked to the spirit of the countryside, to agriculture, to cows, and to the problem of cow pats which I had encountered during my last stay. … This extraordinary coincidence between an imaginary space made for an exhibition proposal whose site was not known in advance and a memory of the past acquired through personal experience is what pushed me to ally the two, in order to create a multiplied dimension which in the final analysis goes beyond the actual matter and space of my project.

Cow pat, chair, mask
3-4 cubic meters of cow pats, 12 salvaged chairs, and 1 gas mask will compose an installation in this cave-space. These three components will engender a series of reflections linked to the nature-man conflict, to the confrontation between city and countryside, and to the material, the cow pat — which used to constitute a kind of primary matter, synonymous with fecundity and prosperity, being used both as fertilizer and as medicine; whereas today it tends to become a dangerous pollutant … In short, a series of reflections linked to present behavior and to the original nature of man himself.

3. Results on the eve of the opening, 8 April, 1994: "The Cave of Introspection."

All that remains of the interior installation is a broken chair. The piece is positioned at an angle against the window reflecting a panorama of the city.

Chen Zhen
30 August 1994

Chen Zhen
Working Drawing 2 (A) and (B),
October 1993

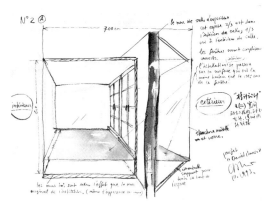 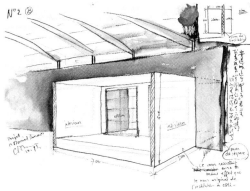

Utrecht, 13 septembre 1993

Cher Daniel,

Je suis très heureux d'accepter ton invitation pour cette extra-ordinaire exposition de "la non-connaissance du lieu" qui m'intéresse énormément.
Je te remercie profondément pour ta confiance et ton amitié !
Bien sûr, ce ne sera pas une exposition normale et facile. Mais c'est justement cette non-régularité et ce non-confort qui me passionnent.
Je vais t'envoyer ma proposition plus tard (avant le 15 octobre bien entendu).
On est vraiment dans une "detective story".
Je t'embrasse très fort !
A très bientôt !
Chen Zhen
P.S. Je suis en train de réaliser une installation au Centraal Museum, Utrecht

Projet d'exposition de Daniel Buren

1. Première proposition envoyée le 12 octobre 1993

Les données :
Il n'existe pas encore de titre d'exposition
Lieu : "anonyme"
Technique : divers
Dimensions : dans un volume de 7 x 7 x 4 mètres

Contexte imaginaire
…
En fait, le noyau intéressant de cette exposition est justement que le commissaire dresse un "piège" devant nous. Par conséquent, la façon de réagir à cette proposition doit être non seulement de réfléchir aux possibilités maximales face aux conditions données, mais surtout de découvrir les "données potentielles" qui se cachent derrière la "non-con-

naissance du lieu", ceci afin de se placer dans un contexte imaginaire et de quitter délibérément le systématisme de manière à travailler de nous-mêmes.
L'important dans la réalisation finale du projet, comprenant l'espace construit et l'oeuvre disposée à l'intérieur, ne se montre pas selon moi dans l'auto-protection de l'œuvre de chacun des artistes à travers leurs propres espaces respectifs, mais plutôt dans l'adaptation à la fois aux artistes et à l'espace du lieu. En d'autres termes, l'élément principal de ce projet n'est pas "une sculpture indépendante" dans l'espace, mais "une sculpture spaciale" intégrée à l'espace.
Le problème est justement de savoir comment il est possible de travailler sans détenir les données nécessaires pour parvenir à tout cela.

Réaction évolutive
Face à de telles circonstances, je me demande comment trouver une solution très souple qui me permettra de travailler avec le commissaire "dans l'évolution du temps".
Mon premier objectif est donc de proposer trois espaces (très différents les uns des autres) qui s'adapteront éventuellement aux contextes différents des lieux, et parmi lesquels le commissaire en choisira un. Ensuite, je modifierai mon espace choisi en fonction de la condition donnée mais surtout de la contrainte réelle. Enfin, je réagirai sur place durant les quatre derniers jours pour décider de façon définitive de ce qu'il se passera dans mon espace. Je donnerai un titre à mon projet à ce moment-là.

Les trois espaces proposés :
1. L'espace suspendu.
Cette proposition est basée sur l'imagination d'un espace qui a pour hauteur 5-6 mètres et dont la lumière émane du plafond. La spécifité de cette proposition est la légèreté à la fois physique et visuelle. Le matériau est la texture des rideaux qui composent l'espace. (voir le dessin no. 1 A et B).

2. L'espace transversal.
Cet espace est suggéré pour une pièce comportant des fenêtres aux murs. Le principe de cette construction est de disposer $2/3$ de l'espace à l'intérieur du bâtiment et $1/3$ du volume

Chen Zhen
Working Drawing 3 (A) and (B),
October 1993

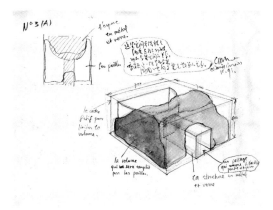
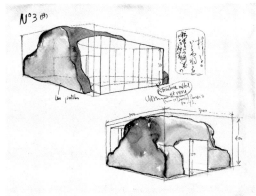

à l'extérieur de l'institution. L'aspect des murs de cette boîte transversale sera de même nature que celui des murs d'origine du lieu (si cela est possible techniquement et ne dépasse pas le coût de production), c'est-à-dire que l'on va essayer de construire un bloc comme s'il existait déjà dans cet espace. L'intérêt de cet espace est de nous emmener de l'intérieur vers l'extérieur du bâtiment et de renforcer le lien entre ces deux espaces par l'inter-médiaire d'une deuxième intervention intérieure. Les matériaux utilisés sont la brique, le métal et le verre. (voir le dessin no. 2 A et B).

3. L'espace sculptural.
L'espace proposé ici est un élément indépendant dans un lieu. Il peut se déplacer selon les besoins du commissaire et la disponibilité spaciale de l'endroit. L'idée de construire cet élément en créant deux parties, l'une étant un espace vide (en métal et en verre), et l'autre un volume plein (en paille), met l'accent sur l'ambiguïté de cette sculpture-espace elle-même. Les matériaux utilisés sont le métal, le verre et la paille (voir le dessin no. 3 A et B).

Bien entendu, je vais concrétiser tous les détails techniques dès que l'une de ces trois propositions aura été choisie par le commissaire, et je pourrai interférer, en cas de besoin, ces trois dispositifs au niveau de la structure, du matériau et de l'accrochage dans l'espace, avec toutes sortes de suggestions techniques, matérielles et budgétaires venant du commissaire et de l'institution.

...

2. Proposition définitive envoyée le 1 mars 1994 : "La grotte de l'introspection – la bouse, la chaise, le masque"

Nouvelles données :
Titre de l'exposition: "L'œuvre a-t-elle lieu?"
Lieu: Witte de With, center for contemporary art, Rotterdam
Technique: paille, métal, plexiglas, bouse, chaises, masque à gaz
Dimensions: 7 x 7 x 4 mètres

Contexte développé
Conformément au concept de Daniel Buren, ma première proposition a consisté en deux éléments "évolutifs": première-ment, laisser au commissaire d'exposition la liberté de choisir une des trois propositions soumises ; deuxièmement, dévelop-per les éléments intérieurs de mon espace et définir le titre lors de la prise de connaissance avec le lieu.
Finalement, Witte de With qui se trouve en Hollande concorde parfaitement bien avec l'une de mes propositions – l'espace plexi-métal et la paille, projet choisi par Daniel Buren. Le contexte du pays est fortement lié à l'esprit de la campagne, à l'agriculture, aux vaches et au problème des bouses que j'avais rencontré lors de mon précédent séjour ... Cette con-cidence extraordinaire entre l'espace imaginaire fait pour une proposition d'exposition dont le lieu n'était pas connu d'avance et la mémoire du passé acquise par l'expérience per-sonnelle, me pousse à les rallier afin de créer une dimension multipliée qui dépasse en fin de compte la matière et l'espace mêmes de mon projet.

Bouse, chaise, masque
3-4 m³ de bouses, 12 chaises de récupération et 1 masque à gaz composeront une installation dans cet espace-grotte. Ces trois composantes engendreront une série de réflexions liées au conflit nature-homme, à la confrontation entre la ville et la campagne, à la matière, à la bouse – qui constituait le materia prima, synonyme de fécondité et de prospérité ; elle était aussi bien utilisée comme engrais que dans la médecine mais tend aujourd'hui à devenir une pollution menaçante ..., bref, une série de réflexions liées au comportement actuel et à la nature originelle de l'homme lui-même.

3. Résultat de la veille du vernissage, le 8 avril 1994 : "La grotte de l'introspection."

De l'installation intérieure il ne reste qu'une chaise cassée. La pièce était positionnée en biais contre la fenêtre reflétant un panorama de la ville.

Chen Zhen
30 août 1994

Chen Zhen
La grotte de l'introspection
(The Cave of Introspection),
1994

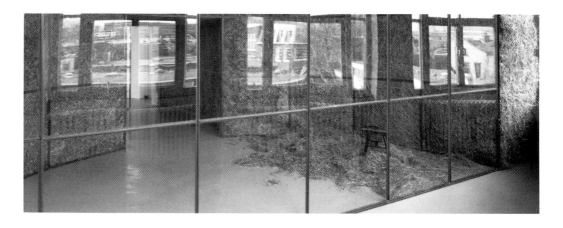

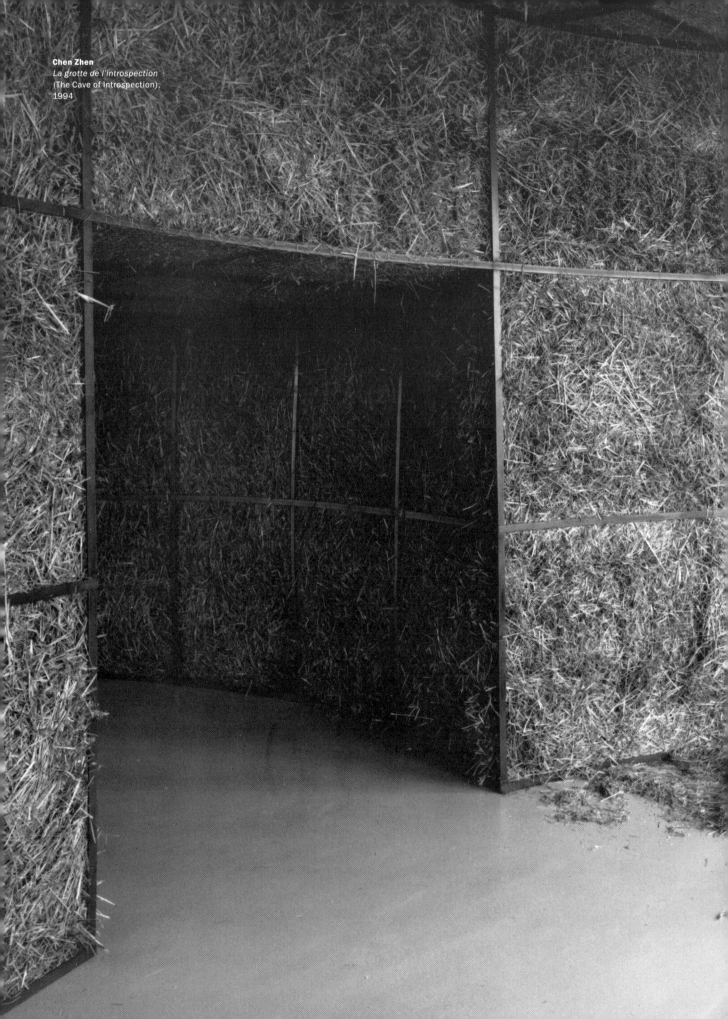

Chen Zhen
La grotte de l'introspection
(The Cave of Introspection),
1994

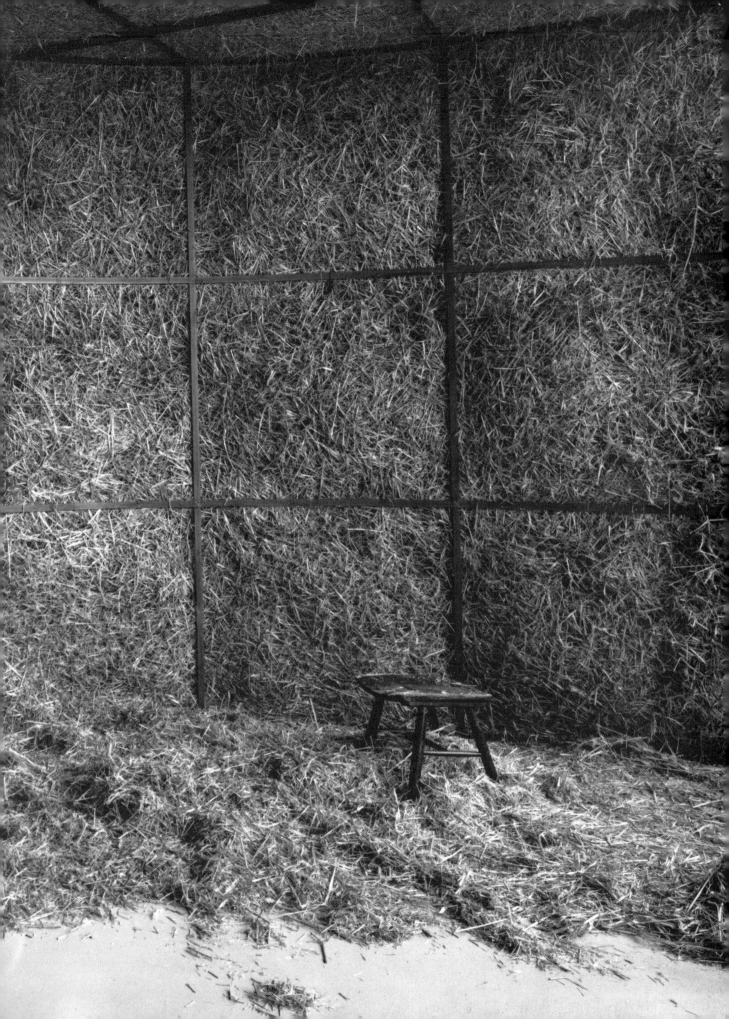

Sylvie Amar

A Few Reflections on *L'œuvre a-t-elle lieu?*

Invited by Witte de With to curate an exhibition, Daniel Buren invited eight artists in his turn. Rather than contributors to an exhibition, they were to be participants in an inquiry that has been nourishing Buren's œuvre since the late sixties: the question of the site.

The story of this exhibition begins with a rather unusually formulated letter of invitation,[1] drafted by Daniel Buren and sent to the eight artists he had chosen. To each of them – Giovanni Anselmo, Michael Asher, Stanley Brouwn, Patrick Corillon, Jacqueline Dauriac, Krijn de Koning, Thierry Kuntzel, Chen Zhen – he communicated a certain number of technical conditions and constraints which their projects would have to take into consideration. The counterpart of these precise indications was a voluntary masking of the name and location of the institution where the exhibition would be held. It was only after acceptance by the artists, as signified by receipt of their projects (a further condition stipulated in the letter), that this place, Witte de With, was revealed to them. Soon afterwards they also learned that *L'œuvre a-t-elle lieu?* (Does the Work Take Place?) would be the title of the exhibition in which they were participating.

Reversal of a Concept

L'œuvre a-t-elle lieu? is a title but also a question, open to multiple approaches as soon as it is brought into relation with the oeuvre of Daniel Buren.[2] The exhibition presented eight projects, eight works conceived for a place which was both specific in terms of the maximum dimensions that each artist could occupy (7 x 7 x 4 meters) and imaginary in terms of its nature or its aspect. Each of the works had its own unique connection to the creative development of the eight artists who accepted the "rules of the game" laid down by Buren. But they seemed above all to pose a completely unexpected question concerning the concept of in situ, as formulated by Daniel Buren himself at the very beginning of his artistic career. One of the most precise definitions that Buren has given of this concept allows us to gauge just to what extent the knowledge of the site is, for him, a foundational element of the work:

> On the in situ work.
> Used to accompany my work over some fifteen years, this phrase does not only mean that the work is situated or in a situation, but that its relation to the site is just as determinant as what it implies for the site where it is located. ...
> Taken as closely as possible to my own understanding, the phrase "in situ work" could be translated as "a transformation of the place of reception". ... Finally, to my mind "in situ" means that there is a voluntarily accepted link between the place of reception and the work that is done there, presented there, exhibited there. This holds for my work without any exceptions, here and elsewhere since 1965.[3]

For Daniel Buren's work, the identification of the site is a preexisting dimension, indeed a sine qua non. Above all, the site proposes a context that defines the work and situates it in its environment, which is artistic, historical, social, political, urban, etc. A knowledge of this ensemble of givens, an analysis of them, and a response to them all come together in the composition and installation of the work. But when Buren takes on the role of exhibition curator, when he steps through the mirror as it were, this affirmation is reversed to become a question. "In my mind," Buren said in an interview with Koen Brams, "*L'œuvre a-t-elle lieu?* asks, what is the work's place? When there is no place, does the

1. See the letter of invitation to the artists, originally sent on 23 August 1993, drafted by Daniel Buren and published in *Witte de With - Cahier # 2*, pp. 200-205.
2. Up to this day, Daniel Buren's work has been an attempt to reveal the place of exhibition (museum or gallery) in its defects, contradictions, and particularisms. Thus each proposition is elaborated in accordance with a defined space (in situ) and accompanied by a description, explanatory notes, and plans.
3. Daniel Buren, *Les Écrits* (Bordeaux: capcMusée d'art contemporain, 1991), vol. III, p. 100 (text concerning the work carried out at the Centre d'Art Contemporain in Cadillac in 1985).

work exist?. … Can one create a concrete thing for an imaginary place? Obviously the guests [artists] are the ones who must answer these questions."[4]

Thus his choice fell on "guests" whose interest in a "transformation of the place of reception" was familiar to him, particularly since he has exhibited with some of them on several occasions (Asher, Anselmo, and Dauriac, for instance). To put this interest to the test, he withdrew any contextual indication from their field of operations, and thus implicitly proposed that their work be primarily an attempt to answer the question above. The work suddenly became the condition of this hidden place, taking away the unique status and the forefront position that the site has occupied for over twenty-five years.

A "U-topian" Proposal

The immediate result of this reversal of the in situ concept was that in the elaboration and then submission of their projects (plans, drawings, or descriptions), the artists also had to make an important change in their customary working conditions. And it is interesting to underscore this change, because it appeared in a clearly readable way, as much in the form as in the meaning of certain works.

The most striking example was no doubt the project of Krijn de Koning, who, as he said himself, would never have imagined a totally white work that the public could move around in, had he known the exhibition site before conceiving his project. In general his sculptures work with different intensities of color and remain at the limit of an architectural scale, impenetrable for fear of becoming a decor.

The artists thus accepted to respond to a proposal that is "u-topian" in the true sense of the word. A proposal based on an absence, a withdrawal of the topos, the place. The constraint not to occupy a space larger than 7 x 7 x 4 meters gave the artists a dimensional frame for their works, but no contextual element that would allow them to take hold, to anchor themselves somewhere. The imaginary alone could fill the gap. With this, the "studio" – the utopian site par excellence at the time when Courbet claimed the independence of the artist and the artistic act against the system of commissions and public salons under Napoléon III – became once again the privileged site of the work's creation. A blind work, since it has not been accorded the possibility to see and to foresee its placement; but an emancipated work as well, freed of all attachment to a defined space.

Whiteness and Transparency, Pathway and Passage

By shifting the priorities of interest back to the artist's projects, L'œuvre a-t-elle lieu? showed them in full fragmentation. This fragmentation was due on the one hand to each artist's interpretation of the constraints, and on the other to the voluntarily discontinuous installation in the spaces of Witte de With. Nonetheless, it was quite surprising to see that certain commonalities emerged from the ensemble.

The predominance of whiteness or transparency is one of the first aspects to be emphasized. The pure white project of Krijn de Koning was already mentioned above, but we may add the piece by Patrick Corillon, an opaque white box whose entry could only be found by circling around it; the work by Thierry Kuntzel, a double tomb whose two wood-toned doors framed in light were the sole elements to stand out from the shadows; and the proposal of Stanley Brouwn, a simple sheet of white paper inscribed with a short description of the work.

The use of transparency also took different forms according to the projects. Jacqueline Dauriac

4. Daniel Buren, "Een tentoonstelling is een plaats om tentoon te stellen," *De Witte Raaf* no. 50 (May 1994) pp. 24-25 (and in English "An Exhibition is a Place to Exhibit" in *Witte de With - Cahier # 3*, pp. 48-57).

used plexiglass plates hanging in space to recreate the walls she could take no support from during the elaboration of her work, while Giovanni Anselmo operated at floor level, leaving the transparency of the air to define a virtual height for the 7 x 7 meter square of earth. The slide-projection piece by Michael Asher sketched out a luminous space between the projector and the wall that received the images. Buried under straw, Chen Zhen's cave included a back wall of glass and thus revealed itself to be entirely open, transparent to the visitor's gaze.

Beyond the whiteness and transparency of the works, there was also the whiteness and transparency of the exhibition space itself. Because each artist occupied a clearly delimited space, the curator's decision to use both floors of Witte de With inevitably left empty galleries. But when one visited the exhibition, these empty spaces rapidly proved to offer the breath of fresh air needed to go from one work to the next. Transitional spaces, these empty white galleries became transparent white volumes in their turn, as if by mime.

Faced with the utopian conditions of the projects' elaboration, the whiteness and transparency in a sense provided the informal, ambient site in which the work rediscovered in situ conditions. In this space that again became identifiable (an art institution's walls are almost always white!), Krijn de Koning's and Patrick Corillon's projects, for example, reached a physical osmosis with the reality of Witte de With. As to Stanley Brouwn, by placing his work at the juncture of two 7 x 7 meter spaces, he manipulated this marginal zone in such a way as to multiply the space he occupied, outwitting the rule imposed by the exhibition's curator.

"According to the concerns of each of the artists," said Buren, "solutions were found not only with respect to the stated rules of the game, but

naturally also with respect to their own work."[5] Spaces where fiction sought to rejoin real life, these works were also chambers, in the diversity and richness of meanings that the French film theoretician Raymond Bellour gives to the expression.[6] They were passages where perception is a living act. The uncovered trail traced by Anselmo, the door left ajar by Kuntzel, Chen Zhen's cave, Dauriac's numbered itinerary, de Koning's false labyrinth, Corillon's pathway, Asher's projection, all called for the gaze or the body to cross through them. Lacking the benchmarks provided by a given architecture, by a place with a proper name, it was the spectator himself who made the works exist in a specific way, through his presence and movement in and around them.

Buren clarifies this in *Les Écrits*: "When one speaks of a place, it must be understood that this place is inhabited and visited. ... Whether it be a gallery, a museum, a street, a public square, a private dwelling, it all comes forth from the place and the beings who are there."[7]

The Language of an Exhibition
The question of the site brings up, on the rebound, the question of a relation between the works and the public, and the question of a perception which is clearly linked equally to the forms and to the envelope of their presentation.

During the period of technical preparation, one of the major efforts of *L'œuvre a-t-elle lieu?* consisted in preserving the works from all attempts at adaptation to the site, and thus sometimes in preserving them from the artists themselves. Conceived and decided on the basis of plans, the disposition of the pieces underwent no modification during the actual installation (a rare, even exceptional outcome). In this way, spaces for reading the works

5. Idem.
6. Raymond Bellour, "La Chambre," *Traffic* no. 9 (Winter 1994) pp. 45-75.
7. Op cit., note 3, p. 43 (text from 1985, concerning the work carried out at the Gewad in Ghent in 1984).

appeared spontaneously, in a manner that no traditional "organizer" could ever have imagined. For example, the installation sometimes created corridors between the architecture and the works that became so narrow that visitors had difficulty getting through them, and occasionally deliberate detours were required to find the entry to a piece. At the time Buren said, "This is irrefutable proof that here the organizer does not manipulate. The works take their place at their will ... up to the maximum possible space. ... I think one perceives that here the position of the works in space is neither the goal nor the rationale of the exhibition in any way. It is the result of a process controlled entirely by the author of the work being presented."[8]

Thus revealed by the creation and installation of the artists' projects, the space of Witte de With took on a consistency that no other exhibition had ever given it before. As soon as the pieces were installed, the site that was hidden and withdrawn from the conditions of the work's existence surged forth again even more strongly, genuinely transformed by the works themselves.

This observation, unexpected to say the very least, opens in its turn upon a question of a critical order: after twenty-five years of evolution, of acknowledgement by various currents of contemporary art, and in the face of a current context which is still favorable to it, what has become of the in situ concept? Has it worn down to the point where a single questioning of its foundations can allow for a renewal of its pertinence? Isn't it particularly significant that this question should be posed by Daniel Buren?

In these few lines, Buren takes the observation and the question even further:

Though I did not invent the term "in situ," at least I was the first to use it in the titles of my works. This term clearly implied a very particular concept which was the concept of the work I carried out, period. There's nothing pretentious in saying that, since I was the only one to use the term. With time, the term began to cover a whole slew of different concepts, used by a considerable number of agents of all types. Thus becoming a trendy and therefore "vague" notion. ... Though the questions remain almost the same, the manner of approaching them, of asking them, can no longer be as it was. ... These questions remain current: Where does one exhibit? With whom? How? Who extends the invitations? What are the places where something can be done? And consequently: What is the importance of the site? The importance of the people who invite? The importance of the other artists invited, with whom one will be confronted? ... How should one let one's work be manipulated? Under what conditions? By whom? ... [These questions] are more and more important to me, and not just a sweet and steamy memory of youth.[9]

Thus "L'œuvre a-t-elle lieu?" is hardly an innocent question, and its various subheadings signal its complexity once again. As for the exhibition, it not only raised the questions but also offered the beginnings of answers, by causing the site to reappear in the perspective of the work and vice-versa. The work gained in timeliness because it could claim to be presented in a time that was its own, even while it was allowed to exist in a totally new and specific fashion. The work incited us to assess time and context once again. And the site invited a relearning of the work.

8. Op. cit., note 4., p. 25.
9. Daniel Buren, "Een tentoonstelling is een plaats om tentoon te stellen," De Witte Raaf no. 49 (May 1994) p. 20 (and in English "An Exhibition is a Place to Exhibit" in Witte de With - Cahier # 3, pp. 48 57.

Koen Brams

An Exhibition is a Place to Exhibit

Interview with Daniel Buren

As a guest curator invited by Witte de With, Daniel Buren organized the exhibition *L'œuvre a-t-elle lieu?*. The exhibition was shown in Witte de With from 9 April until 22 May 1994. Parallel to this exhibition, Daniel Buren presented at the Museum Boymans-van Beuningen in Rotterdam *Placement déplacé - travail provisoirement situé*, a work dealing with the problem of specificity for permanent installations.
This interview, conducted by art critic Koen Brams, has been previously published in Dutch in *De Witte Raaf*, (May 1994, no. 49, p. 20, and July 1994, no. 50. pp. 24-25).

KOEN BRAMS: I would like to speak with you about your two undertakings in Rotterdam, the work *Placement déplacé – travail provisoirement situé* at the Museum Boymans-van Beuningen and *L'œuvre a-t-elle lieu?* (Does the Work Take Place?), the exhibition of eight artists carried out under your direction at Witte de With, center for contemporary art. I'd like to read these two exhibitions from the fundamental viewpoint of your work, namely in their relation to context, the temporal and spatial context. Let's try to cover these two projects in our discussion, or maybe take the lids off them.

Time: Now (Then)

KB: The first contextual element is the relation of these projects to what is happening right now. How would you qualify this moment? What are the political and ideological challenges brought by this contextual element on the one hand, and the artistic challenges on the other?

DANIEL BUREN: I think the two parts of the question are certainly interconnected. Among the characteristics emanating from the artistic domain one has always struck me, the one reflecting the future of the dominant political mood in the societies where this domain develops. Clearly one shouldn't leap to generalizations. You can't read these things like an open book. But it can be said in a summary way that before having any artistic interest, or in other words, before having any real thought, the dominant currents – that is, those accepted from the moment of their emergence by a certain elite, thanks to whom they take the high ground of the art media, those that can be said to be "in style" – have a plastic significance whose real underlying political ideology one can take a stab at deciphering. For example, look at the totally regressive or downright reactionary side of the dominant art (I mean dominant in the art media, the galleries and the Museums) all across the eighties. The return to the most worn-out painting, the return to anecdotal figuration, the return to the object, the return to national values and other charming characteristics of these last fifteen years were in fact, politically speaking, "in advance" of these societies (if you can put it that way!). The sense of these works, of these movements, actually gave us a foretaste of the situation where the European societies in particular find themselves today, which is reactionary to say the least, or seems to be leaning dangerously that way. I won't give up the idea, all the more because I've always said so even before having the proof, that there is a direct link between the pictorial "return to order" of the transavantgarde in Italy, for example – the suddenly discovered love for works by de Chirico from the thirties and the renewed currency of certain ideas from the futurists, who

were so close to the fascists from the moment Mussolini came to power, as everyone knows – and the sudden victory of someone like Berlusconi. If only by this most negative possible aspect, the artistic domain produces a multitude of signs that are extremely instructive. Still you have to know how to read them and even better, how to interpret them. Given the nationalist-type expressionist upsurge that could be observed in West Germany at the same period, one can only hope that future political events in that little corner of Europe won't confirm my pessimistic reading of the artistic domain. It's quite clear on such a basis that there is a challenge to be met, a heightened vigilance to be developed.

KB: How does this analysis influence your works?

DB: It's difficult to say because I myself can't monitor how these influences enter into my own work. It's easier to indicate that when I speak or write than in the work itself. In the work you touch on problems that are much more vast, much more general than the epiphenomena I just mentioned. The difficulty and the interest in this respect is to try to operate in such a way that the work isn't influenced by these very negative things that can be perceived and that nonetheless are part of the mood of the times. To oppose "the mood of the times" is obviously to risk being left on the sidelines. The influence that I can perceive in my work with respect to the attitudes, ideologies, and forms I'm wary of no doubt appears as the reverse imprint of everything that resists them, visually and in a most evident way. Just because for over ten years, during the eighties, many people went back to an idiotic kind of painting, to things or objects, painted or not, which could easily be sold, and just because it could be done easily, cynically, doesn't mean it had to be done or still has to be done. That's a resistance, a resistance to the mood of the times. The really major difficulty, the one that caps it all off, is when the mood of the times is a little your own mood! I'll give an example if you like. Though I did not invent the term "In Situ," at least I was the first to use it in the titles of my works. This term clearly implied a very particular concept, which was the concept of the work I carried out, period. There's nothing pretentious in saying that, since I was the only one to use the term. With time, the term began to cover a whole slew of different concepts, used by a considerable number of agents of all types. Thus becoming a "trendy" and therefore vague notion. At that moment there is a very real difficulty to continue using the concept for one's own work, when nobody really knows what it covers anymore. It's as if someone dispossessed you of your air supply in one quick blow. I have quite a few other examples of the same register which, from the minute they confront me, give me a bizarre feeling of disposses-

sion, much more than a feeling of pride to see a certain success of my ideas. Dispossession, not because of any proprietary feeling I might have towards my work, but because of the feeling that the work, which still needs to be carried on and isn't yet finished, far from it, has already been vulgarized by the predators of the art world who have figured out how they can make a profit on it by shamelessly stealing it, with of course a few little modifications thrown in. The challenge today is precisely to continue trying to do something in this same milieu despite these spin-offs, something that still involves exploration and questioning. But today you have to be much more careful and attentive, given the huge changes in the situation. Though the questions remain almost the same, the manner of approaching them, of asking them, can no longer be as it was. We're not where we were twenty-five years ago. Twenty-five years ago there were almost no contemporary art museums, for example. Today there are probably too many. Twenty-five years ago there were relatively few galleries, today there are thousands. Twenty-five years ago there were very few group exhibitions, today there are dozens every month.

KB: How have these changes influenced your works?

DB: Here the influence on my work is likely to be much more direct, therefore more visible, because these phenomena of the place and the milieu in which the work is made and shown are directly linked to one of the conceptual bases of my work. Someone like me who began his work by thinking about simple things which at the time were rarely considered, but above all never implied any corresponding change in the work even if they were, can hardly remain insensitive to the changes inherent in this milieu. Even today these questions remain current: Where does one exhibit? With whom? How? Who extends the invitations? What are the places where something can be done? And consequently: What is the importance of the site? The importance of the people who invite? The importance of the other artists invited, with whom one will be confronted? Can one exhibit with any artist on the simple pretext that he defines himself as such? How should one let one's work be manipulated? Under what conditions? By whom? How to keep a third party from manipulating one's work? This was a whole series of questions that I asked myself very intensely, theoretically, trying to answer by a specific practice where all these questions come into play – questions which are more and more important to me, and not just a sweet and steamy memory of youth. Maybe the positions I took twenty-five years ago were more violent, no doubt because they had a tendency to generalize: but remember, the artistic situation of the time was also much more easily generalizable than today.

KB: Is today's situation more complex?

DB: It's much more complex. When I spoke twenty-five years ago about the extravagant influence of the Museum which ipso facto defined everything exhibited there as Art, including even what opposed the Museum, that wasn't something obvious for everyone to accept because it meant that an entire dialectical aspect of the work was blocked by the Museum system, and few at that time wanted to admit that kind of loss, although it was difficult to contradict the foundation of such a stance towards the Museum. Today, on the other hand, such a position is widely shared, and the Museum no longer fulfills the role it used to have. Now this is a "novelty" of the first importance, and a very interesting one in my opinion. The Museum has lost its meaning, its institutional authority has flown to pieces. Today, the Museum alone can no longer define everything it exhibits as necessarily being an artwork. The change is considerable. We find ourselves in an interesting situation where the Museum has lost what distinguished it: its authority, its absolute power. This is one effect among others of the multiplication of Museums. I know that I have to reckon with this new given to carry out my work.

KB: What other developments have taken place?

DB: For the 1972 documenta I wrote a text addressed to everybody which was particularly inspired by Harald Szeemann's way of doing things. In this text I said that we artists were in the process of being dispossessed of our own territory. The artist was in the process of disappearing, to the benefit of the sole artist of a group exhibition: its organizer. This warning, which was considered exaggerated at the time, has today become the common lot of all group exhibitions with a very few exceptions that no doubt confirm the rule, and I must say the situation has been accepted by the artists themselves. My criticisms of the documenta directed by Szeemann, though justifiable, were addressed to someone of very high quality, a veritable "inventor" of a new way of doing exhibitions and, as such, very respectful of the invited artists. The unfortunate thing is that he opened up a tendency which, in the hands of people who were less intelligent, less sensitive, less inventive, and above all absolutely unrespectful of the invited artists, was going to become the dreary everyday reality of today's artist, who is a producer of visual merchandise used for the illustration of every imaginable discourse and its opposite. For me the worst recent example, a real caricature, was the last documenta under the direction of Jan Hoet. It was the worst illustration of the organizer who becomes the sole artist, the veritable demiurge of the exhibition. It can be said that in these mega-exhibitions the shadow cast by the

"artist-organizer" is such that it totally covers all the works exhibited. When this shadow is high quality, the whole exhibition takes its flair; when it is mediocre, that is to say, when the "artist-organizer" is mediocre, the exhibition becomes completely mediocre in turn. This was the case at the last *documenta*. An exhibition organizer certainly must have a few ideas, but these should not annihilate the production of the invited artists, nor mix them all up in a single discourse. How can you go on exhibiting if, even before the work is made, the discourse of the organizer already presents you as a circus animal that has to attract the attention of the hundreds of the thousands of spectators needed to make the operation profitable?

Place: (There) Here

KB: When were you asked to do the work you have carried out at the Museum Boymans-van Beuningen?

DB: That's a very long story. I was invited by the Boymans-van Beuningen to do an exhibition in 1986. Little by little, stopping over once every couple years, discussing the possibilities, it was finally proposed that I transform the entry which has been a problem since the remodeling. They have a problem of cohabitation, with the cafeteria, the books, the entry and the work by Richard Serra, then the cash register. I was interested in doing a specific and perhaps definitive work, in any case a permanent one, but in order for this work to be understood I absolutely had to have one or two rooms in the Museum at the same time, depending on the possibilities; that is to say, the exhibition couldn't just be a kind of architectural touch-up. I had several ideas for doing an exhibition in the Museum and then suddenly there was another problem. They are very far behind on their work schedule because they are supposed to be putting the cafeteria in place of the bookstore and vice-versa, and therefore the specific, definitive work in the entry hall can't be done. Not having the possibility to do a permanent piece, I suggested that instead of doing an exhibition with works specific to the room, I could play precisely on the problem of specificity, but in the very walls of the Museum. I think the importance of the context can be perceived within the same Museum, within the same city, and practically within the same moment. I'm talking about a piece that has been conceived but can't be built, and so I build it in an almost absurd way in a place that isn't made for it. And I try to show what it is going to mean in this place which isn't made for it, and then two months later, or six months later, you'll see what it says about the place that is made for it. I could almost have taken the same title for my solo exhibition at the Boymans as the one I found for the exhibition at Witte de With, but that's just an acci-

dent, because my first idea for the Boymans exhibition wasn't exactly that. Another way of seeing things: in the room where it is now, I think it can be said with the customary words that it's an artwork, it's a sculpture, it's more of a sculpture than anything else. When it's in its definitive place you will no longer know if it's a sculpture or nothing at all, or a wall that exists anywhere in the Museum. Is everything shown in a Museum a work of art? In fact I'm doing the opposite of what I did twenty-five years ago when I said – and I think it was "true" – that whatever was in the Museum was an art object, if not a masterpiece. Today, because there are too many Museums, everything that is in the Museum is not necessarily a work of art. But is it possible to ask questions within the Museum about art, without giving the answer that it is art, since that is also one of the very important problems of the Museum? If you admit that the outer envelope of the Museum defines everything that is shown or done inside it as a work of art, anyone who poses the problem of the work's existence, of its nature, is confronted by an equation which is no doubt very delicate to resolve, but also extremely difficult to pose. That said, I think that today there are the means to do it and I try my best to use them.

KB: Could you describe the work that you made for the Boymans?

DB: I began with the fact that the main entry (for the moment, since it isn't the original entry) is a disaster and that it seems absolutely necessary to separate Serra's permanently installed work, *Waxing Arcs* (1980), from the cafeteria and the bookstore that flank it. In other words, I put back – in my own way – a wall where there was one before the remodeling, and practically in the same place.

This decision being taken, I then resolve all the other very simple formal problems: the size of the wall, the height of the wall, the thickness of the wall, and then the way this wall is to be treated on both sides. On one side I glue a mirror over the entire surface, a mirror which without any doubt is going to change the space that it reflects, and on the other side a color which will be a little like the colored ground of the two spaces that come up against it, the bookstore and the cafeteria. Having defined this separation, this wall, it still must be possible to get from one side to the other by passing through it. Therefore I decided to make a series of openings beginning from the central axis, openings whose size, whose width, happens to be the minimum accepted by the safety codes. This width is then repeated in height to obtain a square. The choice is therefore founded on an outside requirement, safety, and not on a personal decision of an aesthetic order. Then these openings are re-

peated symmetrically from the center line, which gives us five complete doorways in all and two cut short by the adjacent perpendicular walls. The fact of placing the mirror on the side of the Richard Serra piece helps us open up a space for it, since it is too close to the entry and for that reason seems to be choked off everywhere. What is more, by cutting the entry in this way, the Serra piece will again resemble a work in a closed space and no longer an entry screen to camouflage a Museum, which is the case today. It is clear that by making such a forceful change in the current aspect of the space, the apprehension one now has of the work by Serra will also be changed.

KB: Very much so, I think.

DB: I agree. But then it's also true that the work I do is not that of an interior decorator or of a designer, but of someone who creates a work, to no less a degree than Richard Serra himself. This work is a Museum work. And in a Museum, by definition, the works cohabit.

KB: However, you're working not only with the room, but also with the piece by Serra.

DB: Exactly. Yes. But, as you know, that's a very common practice in my work. For me, given my attachment to places and their meanings, to be in a Museum is not to be in an ideal, neutral place, or even less in a place that only exists because of its architectural form and its function.

It also exists, and I would even say essentially exists, because of the works it encloses. The works that give it its history, its specificity. When I participate in the hundreds of group exhibitions I'm invited to, I do so not only with regard to the theme, if there is one, to the place of course, but above all with regard to the other participants. This is also the best way to see where you are with your own work. It's additionally a very clear way to become conscious of the works' lack of autonomy and all the consequences of such an observation. Here, particularly, since there are only two works, we are in just such a case.

KB: Did they consult Serra as well?

DB: I don't know!

KB: Of course that's also quite interesting, I think.

DB: The very fact that Serra did not demand that his piece be removed when they removed the wall and made a cafeteria proves that it isn't his problem. That's my response. If I do a piece, let's say specifically in a place, and the piece is permanent and I know it only works in the situation in which it

was made, and then I'm told that someone is going to remove two walls and asked if the piece can be left or not, either I change the piece or I say no, because the piece is destroyed by the modifications. Did they ask and did Serra say yes? I'd really like to know the answer.

KB: So if in the future any changes are decided for the entry, which I foresee, not because your intervention is a failure but because there are still many other problems, should you be contacted?

DB: After it is finally installed in its intended location, it will be a so-called permanent piece in the Boymans collection. Therefore, as with all the pieces that no longer belong to me, there will be a certificate, a kind of instruction manual with clauses and a program to be followed. I must also say that in this kind of contract I take care not to close off too many possibilities. It's like a public square, it would be absurd to freeze everything definitively and for the rest of time. The rules impose a kind of spirit to preserve through a number of formal possibilities. If the entry is changed inside this new piece, they will have to contact me, if it's a matter of a new entry to be pierced in addition to the five I've already constituted. If on the contrary the decision is made to use one of the other four openings that exist in my wall instead of the central one that I foresee for the moment, that can of course be done without asking my permission.

KB: What did you learn about the Boymans as a context, while working on this piece?

DB: At this moment the Boymans is in a difficult transition because they have a structural problem. They also have the problem of deciding how people move around in the Museum. When you enter the Boymans you don't know where you are, and in the middle of it you don't know whether to go upstairs or to turn somewhere. What I understood is that they are now in the process of discussing whether they should retransform the entries and exits. I personally think that the original entry is very good, and they don't use it, maybe for security problems or for problems that are completely beyond me.

KB: That's the reason why I think there may still be changes that would affect your proposal.

DB: I think so too. It's interesting to the extent that when you work in a Museum you work with something very strict, but which still depends on the life of the Museum. In that respect, I'd say that my work here is a little like what can be done outside, in public space. You always have huge constraints

that don't exist in the Museum, in general. Here they do exist a little.

KB: The Boymans work clearly shows your experimental attitude. You put things into question, you experiment.

DB: I agree completely. But it is not studio experimentation, it is an experimentation coupled with the spectators as direct witnesses.

KB: This experimental attitude is demonstrated in many cases by displacement, by a way of relating spaces, by a confrontation of interior and exterior, using the same materials, the same tool. Perhaps there is also a somewhat anecdotal side to this, but an interesting one nonetheless: many of your in situ works are not described and commented in the places where you do them, but in other places or other countries, even other continents.

DB: In many cases that happens by necessity. On the other hand the first part of your question is quite perceptive, I think, because many of what I believe are my most incisive works are often founded on a displacement. Here at the Boymans it's quite particular, and even though the idea of displacement is at the center of the work presented in this first stage, the way of approaching the problem has no precedents in my work. Here the displacement is made before the placement, which appears contradictory at the very least, and truly paradoxical. One can make use of the paradox nonetheless and speak about displacement, because the origin of the piece is known and this spatial origin is not the one where the work is shown initially today. What is questioned is therefore the status of such a work, and I think it is all the more forceful because the questions arise from the same place.

KB: The work you did for the exhibition *Chambres d'Amis* in Ghent was also founded on displacement, but perhaps in a different way?

DB: Yes, exactly. But that is one of my regrets.

KB: That piece is a regret?

DB: No, no, but great efforts were made so that the piece could remain in the Museum van Heden-daagse Kunst in Ghent – it could be taken apart like a decor – and so that the piece in the home of Annick and Anton Herbert, the collectors, could remain active. Jan Hoet and the Herberts had agreed to both buy part of the piece so that it could remain a public piece, always between private space and public space.

KB: A changing part and a fixed part?

DB: And with a rule at the same time, which was that if the part fixed in the Museum was in storage, no one would go visit the guest room, the changing part. But in the end my work was not bought.

KB: In this piece the experimental variable was time.

DB: I have lots of works that operate in relation to several moments of reading. If we can speak of memory, I play on visual memory and what it changes, but in a relatively controllable time-span, not over historical time. In this guest room it was also a question of memorization. To go to Annick and Anton Herbert's and then to the Museum, or vice-versa, also meant remembering if the diagonal was like this or like that, if it was top to bottom, left to right, or vice-versa, if it was the same size. Of course the piece was also very critical of the exhibition *Chambres d'Amis*.

KB: Your proposal was very critical because you, the inventor of the in situ work, found yourself in both a private room and a Museum.

DB: It was a work in several moments, but also an in situ work in the full acceptation that I give to the term. In the site but also related to the spirit of the site, of the sites. It was also a critique of one of the aspects of this exhibition, which was to make the world believe that by opening the doors of private homes, the Museum was finally opening itself up! What is more, an attempt was made to convince us that private space would be more public than the museum space itself, which is a public space par excellence. There was a highly ambiguous discourse about how the Museum was unnecessary, completely rigidified with age, at the moment when its director was organizing and setting up in the most spectacular possible way a very questionable game of "now you see me, now you don't," using all the logistical resources of the Museum. The following anecdote is well known and it emphasizes the illusion that my work was trying to denounce: the success of the exhibition forced some of the people living in these houses to give them up over the summer and leave them open at certain hours, confiding the visitors to the habitual personnel of the Museum itself! There is no question that it was a Museum exhibition, which explains why it was important for me to have a part of my work anchored within the Museum.

KB: All your works are in situ, even if they take place in a Museum? A work is in situ as soon as it engages with the space in which it takes place?

DB: Of course. The in situ work was there at two different levels. The "true" in situ that started things off was obviously the "true" guest room, the

one forming part of the Herbert's home, as transformed by my efforts. The other was "in situ" in relation to the theme of the exhibition and to my contradictory proposal. As to the object installed in the Museum here, perhaps for the first time in all my work, we can speak of a Museum piece in the traditional sense. That is to say, a piece that can move around in the Museum like an ordinary object, one that would or could be found anywhere else, possessing its own content in itself alone. Seen from the outside it was an object, and as soon as you came inside it, it was like a theater decor. A perfect illusion no doubt, but one possessing all the elements required for its reading and comprehension. There was a need for all this reversal, for all this very obvious artifice, and for the perfect success of the reconstituted "decor," in order to say that even though this piece was the only one to be installed directly in the Museum for the duration of the exhibition, the exhibition as a whole was in every respect a Museum exhibition, the latter having incorporated in its corpus the envelope of some fifty other places that were indispensable to it. We were being led to believe that we were going outside, whereas we were really in a Museum system, something which is not criticizable in itself on the one condition that there be an awareness of it and that no one try to make us believe the contrary by saying the Museum is no longer interesting, that it's too small for his ambitions, too closed off, reserved for specialists, while the house is open to everyone!

The other critique which I implicitly directed to the ensemble of *Chambres d'Amis* by forcing people to go back inside the Museum – since it was most definitely from there that the whole thing emanated – was a critique of the cultural tourism that such an exhibition opened up. This kind of voyeurism was no doubt the principle reason for the success that the exhibition scored in terms of the number of visitors. The real affair at the bottom of it all – under the pretext of exhibiting art works – was that you were finally going to be able to enter the neighbor's house with impunity.

Just like a voyeur, you were able to penetrate an intimacy, a private space, in principle off limits to any public. This kind of collective rape of a private space under the pretext of art is without any doubt what accounts for the success of the exhibition, especially given that most of the works were in every way similar to the ones their authors usually present in the space of Museums, with greatly mitigated public acclaim, to say the least.

But what you experienced here was your neighbor's private space, thanks to the duplicity of the Museum, the sole public force that could successfully allow itself such an intrusion.

KB: What is the title of the Boymans piece?

DB: The title is *Placement déplacé – travail provisoirement situé, première etappe* (Displaced Placement – provisionally situated work, first stage). Situated works are works that don't have a single possible space but can utilize an indefinite number of spaces, on the condition that they respect a few precise rules. Each time they are precisely situated, not just "hung" on a wall according to the whims of their owner or the Museum director or the gallery. "Provisionally situated" reinforces the idea that even though the work is specifically in place, it is not definitive. At the second stage, when it is placed in the room where the Serra piece is now, redefining that room's limits, it will then be in situ. An in situ work, made in situ, seen in situ, executed at the location, and generally in a specific relation to this very location.

KB: You've already mentioned that this piece can be seen in relation to *L'œuvre a-t-elle lieu?*.

DB: That is quite true, but it's almost a coincidence. In fact the schedule problem I mentioned above kept me from immediately carrying out the work in the Serra room and at the same time creating a completely different work in the room reserved for the exhibition upstairs, and it was because of that problem that I had the idea of this "displaced placement" outside the initial or specific site and all its constraints. Therefore I could have used the same title for my personal exhibition, but the meaning that could then have been given to it would have been very different. The fact is that I worked on my exhibition in the Boymans without any reference to the one that I was organizing at Witte de With. It can be said that the Boymans exhibition is "my" exhibition, whereas *L'œuvre a-t-elle lieu?* is not my exhibition but one done in common by eight different persons.

KB: But even if this relation was not foreseen, it now exists.

DB: It exists anyway, yes, at the same time it is quite limited, but it does exist. The relation only exists with respect to the title. But that is also because the title is extremely abstract and open. In my mind, *L'œuvre a-t-elle lieu?* asks, what is the work's place? When there is no place, does the work exist? At Witte de With I'm truly posing the problem of the place alone. Does the place have to be known for the thing to exist? How is the work inscribed in the place, if the place is known? Can one create a concrete thing for an imaginary place? If this imaginary place is put into a precise one, does the imaginary place lose all interest? Does the exact place take prominence over the imaginary one? Obviously, the invited artists are the ones who must answer these questions. For some, Witte de With takes promi-

nence, for others not, and that's very interesting in the response of each artist.

Place: Here (There)

KB: What do you call the kind of work you have done at Witte de With?

DB: I have already been involved in making exhibitions of other artists. When I did it, two or three times, I wasn't the sole organizer. For example, in Paris we held an exhibition entitled *A Pierre et Marie* (organized conjointly by Michel Claura, Sarkis, Selman Selvi, Jean-Hubert Martin, and myself). For over two years we changed the exhibition once every two months, adding other artists to the ones invited, who in their turn were invited again to change or continue their preceding work, and so on until the abandoned church that had been lent to us was demolished. Therefore organizing and inviting is not new to me. What is new on the other hand is that for the first time I have invited without exhibiting. I explain why in my letter of invitation to the artists [see: *Witte de With – Cahier # 2*, pp. 200-205]. Not because I wouldn't be interested, on the contrary, but because the only common bond between all the artists was their total ignorance of the exhibition site, and since I, of course, was the only one who knew the site, it was impossible for me to exhibit, given the rules of the game. In fact, I demanded they carry out a work that could not exceed seven meters by seven meters by four meters high, and could not go beyond a given budget. I then promised to reveal the name of the institution only after all the projects were handed in. As you can clearly see, there are very different people in this exhibition. I also quite deliberately chose two persons who work only in relation to a precise place (Michael Asher and Jacqueline Dauriac). I was curious about their reactions, just as I myself would have been interested in such a problem if it had been proposed to me. It's interesting to see people's reactions towards a process that's in principle very destabilizing.

KB: And then what did you do as the organizer?

DB: After having invited the artists and their works, in most cases the organizer makes use of both at his convenience. He juxtaposes the works according to the kind of discourse he wants to put out, much more so than the discourse proper to each work. With all those materials he makes the plastic composition of his choice. It may be good or bad, but in both cases it is beyond the participant's control. Since most often the organizer is additionally the author of the catalogue accompanying the exhibition, its meaning as divulged by the text sticks to the direction sought by the same person. I state and repeat

that under such conditions, the work of the artists invited is nothing more than a decorative element, a charming illustration of a discourse which nine times out of ten is completely foreign to it. What I don't like are manipulations after the fact. When you say beforehand: "This is the framework of the exhibition I'm inviting you to, this is my idea or this is the theme, these are the points that I subscribe to," then the person who receives such an invitation has all the necessary information to say "yes" or "no." From that point on the organizer has nothing left to do, no more decisions to make beyond the strictly logistical organization. The entire visual and plastic realization is in the hands of the participants. If a catalogue enters the discussion, it should be the one desired by the participants, not by the organizer. The latter is the one who sets the exhibition in motion, and then immediately afterwards – whatever the consequences may be – he is at the service of the exhibition, which is to say the exhibitors. Not the opposite. He should not intervene in the production of the works, not in their placement. If someone asks me what I think about the exhibition after it has been set up, I can say what I like about it without any difficulty, or on the contrary what I don't like. What I can't allow myself is to say what I don't like, and demand that it be changed. It's up to the invited artist to take his responsibility, all his responsibility.

KB: In response to the presentation of a project of an Imaginary Exhibition you said that you liked the idea of organizing an exhibition with various artists, but that if such a role were proposed to you, your work would consist only in inviting artists and not in asking them for projects. Yet this is what you did for *L'œuvre a-t-elle lieu?* [see: *The Art of Exhibiting in the Eighties, L'Exposition Imaginaire* (The Hague: SDU Uitgeverij, 1989) – editor]

DB: My exact idea was to ask the invited artists to take the whole enterprise into their hands from the moment they accepted the rules of the game. In this exhibition I have not asked for any project and that is precisely why the place was not indicated in advance as is usually done, because for me, knowing the place where the exhibition will unfold means that a project is already strongly indicated, though nothing is said. By only giving a maximum volume that can be "filled" or used at will, almost blindly, the inherent weight of the site in the conceptualization of the work is lifted and it seems to me that a much larger opening is left to the imagination, without eliminating what the site, in any event, will add or take away from the works once they have been realized. But in my opinion, even this last aspect can be calculated in the conception of a work whose anchor point has yet to be defined.

KB: Did your before-the-fact manipulation also

consist in refusing some of the projects that were submitted?

DB: We just gave indications for those who had several ideas. But nothing at all was refused. Chen Zehn, for example, said "I have three different ideas, which one seems interesting to you and which one seems possible?" He obliged us to choose, but the choice was easy to make because it was decided by the cost of the work to be realized. The project that fit the budget was the one accepted.

KB: The only givens for the artists were the dimensions of the space and the budget. But are these constraints the only ones that artists should be aware of? Aren't there loads of other things whose existence one should know in order to make a work? In the course of your career you have always pointed out the details of the context that are necessary to understand your proposals. Are you now convinced that the two pieces of information you have extended are sufficient to carry out a work?

DB: When I formulated this request I didn't expect anything precise. You can see that some of the artists play with the abstract indicative volume almost word for word, while others completely make light of it, like Stanley Brouwn, for instance. Giovanni Anselmo plays with the indicated size on the floor, for example, and leaves all the rest to the visitor's imagination. Michael Asher wanted to do something with books – strictly speaking it could have been anywhere there are books to be found – which was a smart way of using a place in a specific manner without having any knowledge beforehand. It was like saying: "You don't want to tell where it is, but since it's an artistic institution there are necessarily some books somewhere or something like a bookstore, and I'm going to do something with precisely this context." Which proves that even without precise indications of the site – I only indicated that it was a widely reputed institution – one can incorporate notions that will be found in the institution wherever it is, if that happens to be the center line of the work. Jacqueline Dauriac built up fictive walls with transparent panels. According to the concerns of each of the artists, solutions were found not only with respect to the stated rules of the game, but naturally also with respect to their own work. That proves that the game in question was not only something that meant: "Make a box and show your painting or your object inside it." I think that all artists should always watch over the form in which their works are presented wherever they are exhibited, and in my opinion too few do so. What's lacking in this exhibition, but it's just a matter of bad luck, is a real painting-painter.

KB: Like Gerhard Richter, for example?

DB: Like Richter, whom I invited but who said at the last minute that there wasn't time, and then it was too late to invite someone else, so that's how it was. I would have liked to see someone like Robert Ryman or Michel Parmentier or Richter, artists who make paintings which by definition are manipulated by any and everyone.

KB: There are still other elements that were not communicated to the artists but which are nonetheless very important, as you yourself have shown: contextual elements, elements of the frame in which the artist's works are exhibited. For example, the fact that this exhibition unfolds beneath the mantle of the Association Française d'Action Artistique (A.F.A.A.)? Surely this condition influences the reading of the exhibition?

DB: But they didn't know that either! I agree that all the elements of an exhibition come into play for the reading one can make of it, and of course the question of the backers is not to be neglected. The problem here is that we only knew very late who would be the institutions or persons helping with the realization of the exhibition. Therefore we couldn't speak of it beforehand. The A.F.A.A. gave a little money, just enough to cover part of the travel. More important was the help of Nina Ricci which we couldn't speak of at the time of the invitation, because it wasn't planned on. As far as the A.F.A.A., what's positive is to note that this institution which usually promotes French art is supporting an exhibition which is not French but international, and which is based on an idea and an invitation that the A.F.A.A. is in no way responsible for. Thus the A.F.A.A. comes in quite late and I find it very interesting that the usual partitions are mixed up here.

KB: During the exhibition *Prospekte 74* in Cologne when Hans Haacke's work was censored, you showed the strategies that are sometimes employed by the organizing bodies. For the exhibitors it is therefore sometimes very important to know who is involved with the organization of an exhibition.

DB: In the letter I wrote, I indicated clearly that the exhibition would be organized by an important, well-placed institution. And in the second letter after the artists had proposed their projects, I told them right away that the exhibition was going to be organized by Witte de With and that it was located in Rotterdam. But I agree with you. As to the sponsoring, it wasn't yet precisely known.

KB: Another element is knowing which artists are participating in the exhibition.

DB: Exactly. But they also knew it immediately when I revealed that the exhibition was going to be organ-

ized by Witte de With. The only thing really missing was the mention of the A.F.A.A. and Nina Ricci.

KB: Would you have accepted such a proposition?

DB: I think so. I'm sure, in fact. In relation to my work I would have accepted it right away, as a challenge: How can I deal with that, what questions does it raise?

KB: Maybe also because you would plan on always being able to pull out or to react in your own way, right up to the last day before the exhibition?

DB: Yes, it's a possibility, which is what Stanley Brouwn did a little bit. I'd say that the a priori rules of the exhibition didn't leave much chance for that. If someone had answered: "I accept this proposition, I'll do everything on the last day," I think I would have replied that the game was different. If I'd have gotten that answer, I'd have felt uncomfortable or said no. And I don't know how I would have responded myself. Nonetheless, I think I would have liked to play the game all the way to the end.

KB: What are the challenges of a group exhibition, and what did this exhibition teach you?

DB: The fundamental interest of a group exhibition is to be able to judge – when you're not completely lost in your own ego – how your work stands up amid other works done in the same period. After that there are general parameters for the group exhibition. If a group exhibition is very mediocre, everyone is mediocre. Something is lowered. In the same way, if for many different reasons a group exhibition is a success – because of the idea, the quality of the curator who has done great work, the artists who have really given magnificent pieces, the overall spirit – then even the mediocre pieces look a little better than they really are. A group exhibition also allows you to work with a reality of confrontation that you only find there. *L'œuvre a-t-elle lieu?* has no theme, but if there is a theme, it's definitely a theme of exhibition. An exhibition is above all a place to exhibit, more than an idea to exhibit. Of course, the eight people in question are the ones who make this exhibition, because you can't see the exhibition as a grouped thing. You can make connections between one work and another, but in this exhibition you can see neither the group nor even the idea of a grouping. In a sense the works come by chance to this place, to the point where almost half the spaces are empty. So neither is this a place filled to the last square centimeter with works. We said it would be an exhibition for eight persons, because there was enough money for eight persons. There are fourteen or fifteen possible spaces, almost twice as many, so there are six or seven spaces that aren't

filled at all. I think that in this way this exhibition tries to pose the problems of the group exhibition. Physically, we're more or less in front of eight works put in the corners. It's their disposition and the empty spots that give the impression of eight distinct works.

KB: There are eight works, not one work.

DB: I hope so anyway.

KB: Why did you put a question mark in the title?

DB: Because I didn't know the answer, at least not when I proposed this exhibition. It's an open question that doesn't claim to foresee the answer if there is one, or the answers if there are several, or even whether such a question can be asked!

KB: By using a question mark, aren't you signaling that you're involving other artists in your experimentation?

DB: You can put it that way. You can also put the question a different way. Where does the work take place? Where is it found? Does the work take place outside the place? By opening up the play of possibilities, perhaps one can ask questions about this problem.

KB: The exhibition visitor can also broach what might be a fallacious reading, by asking how the works are placed, whether they are well installed.

DB: That reading is not impossible. I hope that in that case the answer would be: "No, they aren't well placed." In fact, it's a much less fallacious question than it seems. You can see that these works are not at all badly placed, which is something quite different. What's more, I think this is very logical, considering the rules of the game. They induce this kind of result. Never under other conditions, that is, under the usual conditions, would a wall be made the way it is for the work of Patrick Corillon, for example. The space wouldn't be taken just like that, it would be arranged otherwise; but that couldn't be done, because what had to be respected above all was what he asked for without knowing the real space. It is when you enter the space he created that his work begins to exist outside all habitual logic related to the reception space. You can say the same about Krijn de Koning's work which takes the maximum possible space and leaves very little free play in the surrounding area.

KB: But the question is fallacious in the sense that it anticipates a certain snobbism that has taken root in the (more or less professional) visitors who evaluate an exhibition on the basis of the way the works are installed.

DB: What you're saying there is exactly what I tried to say earlier. This is irrefutable proof that here the organizer does not manipulate. The works take their place at their will, that is, according to each person's ideas, up to the maximum possible space; or on the contrary, they don't take any place at all, neither offered nor existent, in the case of Stanley Brouwn, for example. The manipulation of works in exhibitions is so widespread today that it's hard to see how to fight such a state of things. Today you hear observations like this: "It's a good painting (or a beautiful work, a beautiful object) – but the person who installed it went wrong, it's badly done, the room is too small, or too large." In all the different cases the commentary bears on the mode of presentation, and but for exceptional cases this is never the doing of the artist but of someone else, usually the exhibition organizer. I think one perceives that here the position of the works in space is neither the goal nor the rationale of the exhibition in any way. It is the result of a process controlled entirely by the author of the work being presented.

Time: Then (Now)

KB: At the beginning of the interview you spoke of all the changes that have taken place during the twenty-five years you have been active in the world of art. Perhaps this attitude that we've remarked is very new, this hypersensitivity to the installation of the work. At the very start of your career in particular, you demanded some attention for the conditions under which artworks are exhibited. At that time the attention seemed almost nil, by comparison with the current hypersensitivity to the mise-en-scène. Now the conditions are all that can be seen, people only look at how it's installed.

DB: What you say is so true that I myself am often trapped by it. Not because of the fact that many artists are working on the same subject, though fortunately in very different ways; that's something I always predicted, and the subject is so new and vast that it leaves room for many people. But much more when I'm invited to participate in exhibitions where the theme is part of my own work. Participating then means illustrating myself or what I'm trying to question, while surrounded by a selection of artists who in some cases are there precisely to do illustration, to carry out stylistic exercises, like in the days when artists were invited to take part in competitions on general themes (the landscape, the portrait, war, etc.) which made it possible to select among the competitors and see who came out best in relation to the given theme. Certain exhibitions today function on exactly the same model, though they're not declared as competitions. They take a theme which is usually that of an inquiry specific to one or a few individuals, and they throw it out as

fodder for a whole group where the majority don't have anything to do with it. In this way the museum system destroys the questions that could be at the heart of the problem, making them formally academic through a lack of discernment in the choice of participants. We then fall into vulgarization pure and simple, just a step away from academicism. There are themes of reflection that interested me intensely and that I had not yet even finished exploring but which I can't touch any longer, since the situation has laid them to waste either by bringing them into fashion or by vulgarizing them in completely inappropriate or spectacular exhibitions.

KB: But do you agree with my analysis of the developments?

DB: Absolutely. The "installation," as they say today, has become in itself the synonym of the modern work. This affects paintings, objects, sculptures. Allowing oneself to generalize a little, it can be said that a characteristic of the eighties, contrary to the characteristics of my generation, is that young artists come out of the academy to exhibit and whatever their product, whatever it is they do – photos, paintings, furniture, sculptures, bricolages, environments – everything is characterized by a perfect finish, an irreproachable technical quality. It's a change that has to do with the technique of exhibition. Since the early eighties it can be said that on one side there are artists who produce extremely well-made works and on the other side there are exhibition technicians who accentuate this well-made aspect of the work by a spotless and if possible spectacular presentation. Those two things put together produce a plastic uniformization through the meeting of two mutually supportive techniques, one of which lets itself be benevolently manipulated by the second, while on the other hand they produce an academicism of the "well made" which can't help but strongly recall all the characteristics that were associated with mass- appeal and/or academic art in the nineteenth century.

Since in addition the number of Museums is always growing and it is not possible for originalities to multiply in the same proportions, the general tendency is toward uniformization and boredom by repetition and perfectionism. Distinction then comes from the staging (the organizer) or the decor (the architecture) that accompany the exhibition in a given place. The artist having practically given up his role, his work becomes an interchangeable plaything in the hands of the professional manipulators (curators, critics, gallerists, collectors) and to do this, the sole clear link to be seen among all these objects is that they must be technically perfect, wellmade, odorless if possible …

(To be continued …)

On May 16, 1994 Daniel Buren presented a selection of films and videos in the series "Film From Stock," a program on artist's film and videos, organized by the Rotterdam Arts Council. Around 1957 Buren started to experiment with film in *Petites Esquisses*, shot in Mexico. It wasn't until 1967 that Buren presented his first audio-visual installation at the Paris Biennale as part of the group presentation "Buren, Mosset, Parmentier and Toroni." In 1969 he presented *Interruption* in the Galerie Yvon Lambert in Paris. The installation consisted of eight super 8 films entitled *La critique et la loi, Températures relevées sous abri et évolution probable du temps, Biographie, La Parti de cartes, Mise au point, Que'est-ce qui essentiellement est à dire?, Petites Annonces*, and *Topographie*. After his collaborations with the German filmmaker Gerry Schum, initiator of the Fernsehgalerie Gerry Schum (*Identifications*, 1970; *Recouvrement – effacement* (covering-effacing), 1971; *Projection*, 1972 and *in situ*, 1973) Buren became interested in the image of television as an artistic tool. For Buren video became an instrument to produce specific work: video could be the work itself. It can behave like an installation. On the other hand film behaves like a documentation which shows only certain aspects of the works or are additional to the works or complementary. It is not a work by itself but a fragment of the work presented. Few exceptions exists like *Couleur*, 1984 or the work made for *Identifications*, these are works itself.

In the beginning of the eighties, Daniel Buren was offered a third possibility: the network of television itself which takes the work beyond the limits of institutions normally associated with art. In all of his audio visual works, Buren transforms the frame of filmic or electronic image just as he transforms the frame of the conventional work of art.

**Bert Jansen
Michel Bourel
Daniel Buren
Jean Marc Poinsot**

**Contemporary Art
and Its Public**

A discussion

This essay is based on a
discussion, entitled
*Contemporary Art and Its
Public*, between Michel
Bourel (director of educa-
tional and cultural services
at the capcMusée d'art
contemporain de Bordeaux),
Daniel Buren (artist), Jean-
Marc Poinsot (director of the
Archives de la critique d'art
and professor at the Univer-
sity of Rennes), and chair-
man Bert Jansen (art critic).
The discussion was held in
Witte de With, on 10 April
1994, at the occasion of the
opening of the exhibition
L'œuvre a-t-elle lieu?
curated by Daniel Buren, the
exhibition ran from 9 April
until 21 May 1994.

In April 1994, a discussion was held in Witte de With on contemporary art and its public. The participants were Jean-Marc Poinsot, Michel Bourel, Daniel Buren and myself. Prior to the discussion, Poinsot remarked on the significance of it having been an artist – and especially Daniel Buren – who inspired the idea of a debate devoted to the relationship between art and its public. His remark can be traced to Buren's writings, collected by Poinsot and recently published by capcMusée d'art moderne in Bordeaux.[1] Michel Bourel, member of the Bordeaux museum's staff, also participated in the debate.

Since making his start in 1965, Buren's work has been accompanied by texts vital to its perception. In this way he articulates how and why he shifts attention away from the sanctioned art object to the "package," to the attendant practical concerns a work needs to address lest it alienate itself from the world in which it is meant to exist. The dimensions and other aspects of the gallery space, for example; a museum's pseudo-neutral white walls; the political implications of a given commission; the ideological context; the personal ambitions of group-show participants; the strategic objectives of the exhibition maker. Though Buren doesn't say so explicitly, implicit in the enumerated conditions under which a work of art is thought to exist is the ever-present public factor. In terms of publicness, it's the conditio sine qua non.

While a tautological connection exists between the juridically precise writing Buren composes in response to an exhibition and the work he creates for it, the image is never superfluous. Buren doesn't replace the image with text, and it is the visual aspect that creates the necessity for a concrete public. Given the respective visual solution, and using the creator's text as a tool, the public – and that includes everyone other than the creator – can resolve how the problem was formulated. To see and understand the work means that the distance between idea and image is again reconcilable, only in reverse. In other words: recognize the external factors that helped determine the image.

Buren's insistence on the implicit connection between art and publicness can also be found outside his work, in his conception of the studio as a false space, a fictitious place where the artist fashions a superficial freedom. In an interview he relates an experience that had a profound effect on him before he began practicing as an artist. In 1955 he visited a number of artists in their studios in the Provence. Later, when he came to see their work in galleries in Paris, he realized that everything in the studio that could be recognized as having been a motive for the work was lost in the gallery. His subsequent work as an artist seems to be inspired by a desire to avert the loss of the work's *raison d'être*, by exposing the factors that may cause this to occur. It is interesting to recall Buren's earlier experiences now that he has been a guest curator at Witte de With. With the inquisitive title *L'œuvre a-t-elle lieu?* (Does the Work Take Place?) and by omitting the name of the organizing institution on his invitation to participants, Buren emphasized the need to consider the situation as an abstract theme until the work was completed. Inverting his own working method, Buren sent participants back to their studios. From some of the results it appears that the process of departing from a concrete situation regarded as an abstractum has indeed increased the amount of attention paid to the work itself. In relation to the physical exhibition space, the work and surrounding area remained intact, neither being lost in the other.

Aside from his work and writings, there was yet another reason to take advantage of Buren's presence in Rotterdam and to engage him in a discussion about art and its public, and actually the reason was a negative one. It had to do with the dismissive and recurrent way his name is mentioned in the growing criticism aimed at contemporary art as a whole.

For a number of years, articles have been appearing in the popular press as well as in cultural magazines, from liberal as well as conservative camps, in which writers position themselves as representatives of the silent majority. In many of these articles Buren is given the dubious honor of being connected to such diverse personalities as Joseph Beuys, Andy Warhol, Robert Ryman, Yves Klein and Piero Manzoni, and indeed just about every artist whose work has been collected by modern art museums over the past twenty years under the rubric minimal or conceptual art. In a recent publication, *Artistes sans art?*, Jean-Philippe Domecq, representing the French intellectual quarter, ostentatiously transcribes the opinion of a certain "quidam" – one of the innumerable tourists from France, Pakistan, Holland or Japan – who wanders around the Centre Georges Pompidou "looking for art that is purported to be there."[2] Visiting the Niele Toroni exhibition showing at the time, try as he may, he fails to discover any art.

Domecq rhetorically questions whether we have the right to retain some power of discrimination without in turn being accused of intolerance. "We are forbidden to make any value judgments whatsoever; we're even forbidden to be bored." Domecq switches intentionally from the third person singular "quidam" to the first person plural "we" form and, in this way, positions himself as spokesman for the silent majority.

Ridiculing artists and what they make has been a popular sport since the beginning of modern art, since the days of the impressionists. But it is no longer limited to cartoons and the occasional outburst of a popular daily or weekly. Many of the books and articles published today appear to be written by those who have, seemingly, immersed themselves in the subject over which they are writing. References are made to theoretical and artistic points of departure expressed by artists and art critics only in order to mockingly cite quotations. Such misunderstandings, categorical drivel or malicious perversions are born out of an unwillingness to accept the basic assumption that it is the observer who finishes a work of art and that the work calls for this. Apparently – from the succession of artists who continue to be grouped together, though their work differs dramatically, and who agree with the notion of the responsible observer – this is the breaking point.

Given the growing stream of articles to this effect, the question remains whether museums and the media, with their respective educational programs, theme exhibitions and art supplements, haven't merely fostered a quantitative growth in public turnout, higher "attendance figures," a swelling tourist public looking for illusions and representations that aren't there. And furthermore: whether, in doing so, the art world hasn't admitted the Trojan Horse.

During the discussion, Jean-Marc Poinsot added a new dimension to these questions by placing them within a historical context and thereby putting them into perspective. First of all, he wondered whether the question concerning the relationship between art and its public should be so strongly postulated, and why those associated with contemporary art are so worked up about it; and, furthermore, whether there is just cause for the emerging criticism. Within this context he cited a number of facts. First, he pointed out that the crisis in the relationship between contemporary art and the public isn't limited to a single country, but is evident everywhere. That means, if we are to trace probable causes, we mustn't limit ourselves to circumstances peculiar to a single country but that we must examine the general characteristics associated with the current state of contemporary art.

Poinsot maintained that the most vehement criticism can be heard coming from intellectual quarters, and that it is being launched at a time when the art market, after a decennium of exceptional prosperity, is in a period of decline. Likewise, it is coming at a time when the number of exhibitions of contemporary as well as earlier art, offered by spectacular new and renovated museums alike, has grown enormously while the overall number of visitors has declined. Thus, the background of the current crisis is formed by the end of an especially prosperous period. In art historical terms, this is interpreted as the end of the avant-garde. From an institutional standpoint, in the West where governments subsidize art and assume responsibility for its public dissemination, it has been translated into the establishment of museums and other public institutions. Poinsot maintained that the changes that began taking place in the early 1960s in the United States and Europe with regard to the diffusion of the visual arts through the media have been underestimated. The rise and fall of the avantgarde only mock the transformation of the relation between the visual arts and society that was brought on by the art institution's accessibility to a greater public. Prior to this socialization process of the arts, a public for the arts never existed – and even less so for contemporary art.

The rupture that has been brought forward by the change in exhibition conditions is comparable to the effect that the invention of printing had on the book. According to him, these changes constitute the last phase in a process that began in the nineteenth century.

In other words: the rise and fall of the avant-garde is merely a symptom of a more fundamental change in the relationship between visual art and society-at-large, stimulated by increased public access to art institutions. Poinsot reminded us that before this period, during which art became integrated into society, art – let alone contemporary art – had no public. So, historically speaking, the public for art hasn't declined but rather has risen gradually over the years, growing explosively between 1960 and 1990.

The next point broached by Poinsot was the public's heterogeneous composition. It's impossible, he thinks, to generalize about this public. Consider, for instance, the various ways people fixate their memories of a museum visit. Some retain memories via postcards or by way of an illustrated book. Others buy the catalogue. The next question is: who reads the texts, who studies the biography and bibliography? Here Poinsot underscored the importance of text in the perception of visual art. Artists read about other artists and the work they're doing and perhaps uncover starting points or subjects for their own work. The public also has access to written material: texts written by artists or texts about artists describing the attributes of their work, catalogue texts for example.

The appreciation of text as a means to convey something visual needn't be thought of only in terms of conceptual art. The use is much more widespread. "One cannot fully understand the work of Claude Lorrain without some knowledge of mythology. That was true at the time and it's true today. In this regard, nothing has changed. And this type of knowledge can only be obtained by reading. While the public doesn't necessarily take the time to read what artists have to offer, one can hardly conclude that no relationship exists between artists and the public. One can only say there's something wrong with the relationship the public chooses to have with art."

Poinsot went on to mention the exhibition's role in fostering the relationship between art and the public. "That contact goes beyond the obligation to buy an entry ticket. It's successful not only when the exhibited work is interesting but when the exhibition is determined to be in the right place at the right time. And that's a curator's responsibility."

Daniel Buren didn't want to go into the sort of articles mentioned above. "The problem with these reactionary articles," he said, "is that they're so trivial. Art criticism needn't be scientific, but clearly the writers campaigning so fiercely against contemporary art know little about the subject over which they are writing. They talk about art the way everyone on the street talks about art. With demagoguery they reach a large public that has never accepted modern, let alone contemporary art. We know nothing about the quiet public that attends exhibitions on a regular basis and that can't identify with these writers." For this reason, Buren finds it difficult to say anything sensible about the subject of a contemporary art public. What he chooses to emphasize, and what he considers even more dangerous than these mocking texts, are exhibitions like *Portrait, Still Life, Landscape*, curated by Robert Wilson for the Museum Boymans-van Beuningen in 1993. Buren finds this sort of exhibition more worrisome than text because it's more physical. And they're dangerous, according to him, because they reinforce the idea that anyone can be given carte blanche to do something creative with works of art.

"Wilson created a sort of street with display cases to the left and right where works of art had been arranged. The lighting was unidirectional and the work could only been seen from one side, which in the case of sculpture is incorrect, of course. A sculpture by Rodin, of a naked walking man, was placed in a theatrical setting strewn with reddish-brown leaves and suchlike, lending an autumnal effect and summoning a nostalgic mood. A painting by Dali, of a barren, desert-like landscape, was placed in sand and surrounded by objects that resembled the objects depicted in the painting. A piece by Donald Judd stood like a queer surrealistic object in a romantic mise-en-scène. Lastly, a veritable theater was constructed where the public could sit on benches and watch a sculpture of a dancer by Degas rotate to music."

According to Buren, exhibitions like this, where static works of art are surrounded by the kind of ephemera that figures in product advertising, are as demagogic as the sort of articles discussed earlier. In both cases, the question of how far one can remove oneself from a work of art and its creator is rarely addressed. Exhibitions by artists like Robert Wilson are causing these tendencies to slip into the art world as well. On this point, however, Buren made a distinction between the exhibition made by Joseph Kosuth on Wittgenstein at the Paleis voor Schone Kunsten in Brussels[3] and *documenta 9* by Jan Hoet. "The difference lies in the signature. In the case of Kosuth, the exhibition can be seen as an object signed by Kosuth, as something that engenders discourse. In the case of Jan Hoet, the hand of the curator is present as well, however inconspicuous. Ultimately, the curator places responsibility for the work with its maker."

The next question then is, how is something like this possible? The answer, according to Buren, is that most art created today is noncommittal and therefore open for manipulation. Buren doesn't claim that one shouldn't question established twentieth-century values. "But we mustn't forget that those permitted to do so now in rather bizarre ways are in turn being supported by a form of art making headed in the same direction."

Michel Bourel spoke from his experience at the capcMusée d'art moderne in Bordeaux. To begin with, in concurrence with Buren and Poinsot, he underscored the fact that generalizing about the public leads nowhere. "As a museum," he said, "you're meant to be concerned about the physical make-up of the public. It's important because, as a museum of contemporary art, you facilitate the encounter between art and the public." And therein lies his guiding principle: respect for the work means respect for the public.

Making the encounter between art and the public possible means that the museum must recognize that visitors are neither uniform nor anonymous. Everyone brings different interests and experiences with them.

Despite the fact that the museum in Bordeaux knows what many of its visitors are interested in, it's not possible to provide a conclusive definition of the public. There are art historians and students, scholars and young children. Aside from the normal visitor, there is an active group of members of the museum who become involved in its activities. "A museum, therefore, has to offer various levels in conjunction with the experiences and preferences of its visitors."

Part of the relationship a museum has with the public issues from the task of teaching people how to look. Furthermore, by way of its capacity as a museum of contemporary art, the museum functions as a studio for exhibiting artists. For this reason the museum in Bordeaux doesn't approach its public solely from an art historical perspective. "People come to look at contemporary art and that means: work that belongs to contemporary culture. Based on the notion that a work of art has meaning in the world, at the capc-Musée we also work with writers, philosophers and other scholars. The art historical approach is one of many possibilities. The museum lends further meaning to the work via its exhibitions policy, its method of presentation, its catalogues and other publications."

Nevertheless, Bourel made it clear that, within the whole program entailing a work, the museum is, first and foremost, the place where the work can be seen. "The visual dimension of a museum is very important, more important than the chronological presentation. Because the museum is a place where various works of art are brought together, it's sometimes a good idea, with contemporary art, to confront or draw comparisons between two artists, if doing so contributes to the expressive form of the work. The problem, however, is that, in a given space, most visitors look at each work individually and don't consider relationships between the works."

As far as solo exhibitions are concerned, the museum in Bordeaux asks the artist to engage all the museum's services and activities in accordance with its public taxonomy. In doing so, it makes the point that art can be approached and understood in myriad ways and on various of levels. "In the teaching packets for schools we also want to show that there are a variety of ways of looking at art. In this manner we are trying to change how the museum is utilized, from collective to individual use."

Conclusion: Bourel's final remark about the need to stimulate individual as opposed to the collective use of the museum can be regarded as the central point of the discussion. Each of the three participants are averse to the idea of generalizing about the public and construing it as statistical data. That this is practiced by subsidizing agencies, governments, museum staff members and artists intent on winning the favor of a large public leads only to dull artwork and dull exhibitions. Works of art propose various levels of meaning simultaneously, at any rate suggesting the notion of what could be called multi-vocal. The placement of paintings and sculpture in a *tableau vivant* is beautiful as far as the theatrical effect is concerned perhaps, but it adversely affects the rich complexity of the work.

The capacity of artwork to function on a variety of levels is consistent with the taxonomy of its public. No one belongs to the same group as ten years ago. One's own experience; what others write and hold to be true, changes in the world outside the arts, all give rise to greater expectations with respect to visual art and transform everything held to be true about an artist's work. That question marks are placed alongside some expressions of contemporary art is not meant to suggest that these works are inadequate. Indeed, the essence of contemporary lies in the on-going discussion over what a work of art means in relation to the world in which it was made, which in turn alters expectations based on earlier experiences. Though exhibited and collected by museums, contemporary art doesn't yet belong to art history. That takes place during the art historical debate that precedes and follows the exhibition, wherein the opinion of a certain quidam, whose expectations remain unspoken, is no matter for discussion.

1. Daniel Buren, *Les Écrits, 1965-1990* (Bordeaux: capcMusée d'art Moderne, 1991).
2. Jean-Philippe Domecq, *Artistes sans art?* (Paris: Éditions Esprit, 1994), p. 73.
3. *The Play of the Unsayable: A Preface and Ten Remarks on Art and Wittgenstein,* held in the Paleis voor Schone Kunsten in Brussels from 17 December 1989 until 28 January 1990.

Images Sans Serif Observations on Willem Oorebeek's Monolith

The work of Willem Oorebeek was presented in the solo-exhibition *MONO-LITH, lettered rock* at Witte de With, from 5 June until 24 July 1994. The exhibition will be shown in the Winnipeg Art Gallery from June – August 1996. Oorebeek was invited to elaborate in this Cahier on the works he had specifically conceived for this exhibition. The book *MONOLITH, between echo & HOPE,* designed by Willem Oorebeek, was published in conjunction with his exhibition. Witte de With invited the Dutch philosopher Hugues Boekraad to comment on the concept of the book.

Hugues Boekraad

1. Willem Oorebeek, MONO-
LITH, between echo & HOPE
(Rotterdam: Witte de With,
1994). In this text I shall refer
to the book as MONOLITH and
the exhibition by its full title.

In the summer of 1994 Witte de With staged a sur-
vey of Willem Oorebeek's œuvre. Some fifty works
produced between 1986 and 1994 were exhibited
under the title of *MONOLITH, lettered rock*. To
mark the occasion, Witte de With published a book
entitled *MONOLITH, between echo & HOPE*.[1] The
simultaneity of the show and the eponymous publi-
cation might give readers the idea that the book is a
catalogue. They would be mistaken. Although re-
productions are combined with commentaries and
interpretations in *MONOLITH*, it is not a cata-
logue.

MONOLITH documents neither an evolution
(the œuvre), nor an event (the exhibition). As re-
gards both it is a new element, a work sui generis.
Insofar as it documents existing (autonomous)
work, the surprising manner in which it does so is
closely related to Willem Oorebeek's modus oper-
andi of recent years. What the book documents is
not the work, but its reproduction in earlier publi-
cations.

MONOLITH is special in that its theme is the
function of a catalogue, and in that it allows new
works to emerge from the production process of the
book itself. *MONOLITH* is an artist's book which
experiments with a genre.

Between echo & HOPE

The book's subtitle is instructive in reflecting
Oorebeek's ironic view of himself and his work.
The words "between echo & HOPE" would seem
to refer to the ambivalent position of art and the
artist. Doesn't the stereotype image of the modern
artist cast him in the mould of a person caught be-
tween self-repetition and self-renewal? The spe-
cialist of innovative form fights the echo of his ear-
lier work. Art's function for society as a whole is
characterized by ambivalence too: art is situated
between tradition and innovation, echoing our cul-
tural heritage but at the same time giving form and
nourishment to our hopes for a different future.

This social and psychological construction of
art and the artist is deconstructed in *MONOLITH*,
and not only by the subtitle. Though a well-inform-
ed nicotine addict, *echo* and *HOPE* are two cigarette
brands which are unknown to me. The packs are
reproduced on the inside covers of the book. Has
graphic artist Oorebeek donned the cap of the
graphic designer and come up with a new brand for
an imaginary tobacco company? Or are they *objets
trouvés* brought back from a journey? The latter,
apparently.

It is not the artist who is caught *between echo &
HOPE*, but the body of the "catalogue." The book's

subtitle is a variation on the expression "between
hope and fear." By transferring hope and fear (of
repetition) to the banal level of commercial visual
culture, the cliché of art and the artist is ques-
tioned.

Incidentally, Oorebeek is not interested in ush-
ering the emblems of popular culture into the mu-
seum. Campbell and Coca Cola entered the holy
precincts of the museum gallery a long time ago.
The soup that is ladled out here was cooked by a
visual culture in which the distinction between high
and low culture is no longer taken for granted, and
in which human emotions are exploited in order to
position products.

The artist is not wedged between psychological
categories, but between the images of mass culture.
The special thing about Oorebeek's strategy is that
he declines an escape into the safe precincts of an
aesthetic stance which finds pleasure and justifica-
tion in formal innovation. He enters the field of
mass communication in order to select images suit-
able for incorporation and reproduction in his own
world. He does not regard repetition as an artistic
evil to be avoided at all costs, but as an ideal means
of investigating and corroding the signifying proc-
ess in visual culture.

What Is a Catalogue?

At a first glance, *MONOLITH* apparently epito-
mizes the exhibition catalogue. The structure looks
familiar. The book starts with the title and the art-
ist's name; image is followed by text, text is fol-
lowed by image. Identity, creation, interpretation:
the art machine in full throttle. Art and the artist
are presented and confirmed: the catalogue awards
the seal of approval.

Examining the function of the catalogue for
contemporary art more closely, we see that the cat-
alogue sets the stage for a double act. Downstage
we have the artist, who presents his work and con-
firms its authenticity by having his name on the
title page, an echo of his signature on the work.
Upstage we have another signature, the institu-
tion's mark on the back of the work, its endorse-
ment. The institution presents the artist who pre-
sents his work. And through the channel of the ex-
hibition and catalogue it inducts the artist and his
work into the art world, making them part of a hier-
archy and a ritual, of a code and a pattern. Signed,
sealed and delivered to Witte de With, center for
contemporary art in Rotterdam, and the Winnipeg
Art Gallery. Two logos, with but a single thought.

The double act I have just described is regis-
tered typographically on the title page, where

2. I disregard the design of catalogues of modern art here. The reader is referred to Walter Nikkels's lecture "The Catalogue: An Ordered List of Works," Witte de With – The Lectures 1992 (Rotterdam: Witte de With, 1993), pp. 31-42.

3. Le songe de Poliphile III appeared in 1982-83, Hypnerotomachia – The Strife of Love in a Dreame IV in 1984, Le Chemin Perdu and Sapient Precept III in 1985.

4. Figures sur bois, 1985.

5. A recent critical edition is Francesco Colonna, Hypnerotomachia Poliphili, ed. Giovanni Pozzi and Lucia A. Ciapponi (Padova: Antenore, 1980), parts I and II.

6. Willem Oorebeek, artist's page in Hard Werken Magazine no. 10/11 (1983).

7. Willem Oorebeek, artist's page in the 30th anniversary number of Kunst & Museum-journaal (spring 1986).

everybody can see it. But the denouement of our little drama is enacted at the end of the acknowledgments at the back of the book: "Witte de With is an activity of the Rotterdam Arts Council and is supported by the Dutch Ministry of Culture." Oorebeek's work, produced between echo and hope, is brought into circulation under governmental auspices.

A catalogue's function is ostensibly conjunctive.[2] The artist's name is yoked to that of the institution administering – temporarily or permanently – his work. Closer scrutiny reveals a threefold inscription in the catalogue: objects and ideas are inscribed in the artist's biography; the artist is inscribed in the annals of an institution of the art world; via that institution the exhibiter is inscribed in the registers of the city and country.

MONOLITH's Structure

Leaving aside the cover, preliminary matter and acknowledgments, MONOLITH consists of four sections.

The first of these (pages 6-51) is a survey of Oorebeek's work – work which has been illustrated in catalogues, that is. It contains reproductions of reproductions of earlier work, printed over each other. Perhaps it is better to say that what is reproduced is not an artwork but the page on which it was reproduced. The page numbers, then, are identical with those in catalogues containing illustrations of his work. The section's structure is thus determined by page numbers in some twenty catalogues carrying reproductions of Oorebeek's work.

The second section (pages 52-61) consists of ten black pages of negative or black-on-black reproductions of individual works. This section contains isolated images, regardless of their place in the original catalogues. Some of them are not even by Oorebeek. Their order of appearance is determined by their suitability for graphic treatment. Their meaning plays a role as well.

Book and exhibition come closest together in this section of the book. The latter featured a wall-filling work, made to measure for one of the galleries at Witte de With. It was constructed along the same lines as the second section in MONOLITH (images looming up from a black background), but used different images. This work and part two of MONOLITH form two parallel series.

Section three (pages 63-113) contains a text by the Austrian critic Herta Wolf, entitled "Willem Oorebeek's Doubles" and printed in Dutch, English and German. The three versions are set in three

slightly different sans serif typefaces: Univers, Futura and Bertold Akzidenz Grotesk. The typography is the work of graphic designer Felix Janssens, who acted as a go-between for the artist and the printer and assisted Willem Oorebeek with printing technicalities in the production of MONOLITH.

The fourth section (pages 114-143) is a succession of spreads. A photograph is printed over two pages or two contrasting or complementary images are printed on facing pages (opposite a photograph taken in New York at night, showing the illuminated sign of the Vertical Club, we see an untitled work: Oorebeek's copy of a cloud). The images are miscellaneous and their order associative: old work and new – quite often hybrids consisting of (a fragment of) old work, studio and exhibition photographs, quotations, photographs on which a finished work or a work in preparation is based.

At times this section, too, overlaps with the exhibition. One-third of its thirty pages refer directly or indirectly to (elements of) Oorebeek's Vertical Club, the first version of which was installed at the VIII Triennial – India in New Delhi in 1994, the second at the exhibition MONOLITH, lettered rock in Rotterdam that same year.

Hypnerotomachia Poliphili

Oorebeek himself arranged and designed the book. Although it was not printed on his own lithographic press, it definitely qualifies as one of the graphic artist's autonomous works.

It was not the first time that Willem Oorebeek elected to use the book as a medium for his visual explorations. Between 1982 and 1985 he published four little books[3] in a limited edition and a portfolio of prints[4] as instalments in the series Hypnerotomachia, named after a book written by Francesco Colonna in 1499.[5] An artist's page in the Rotterdam Hard Werken Magazine[6] and in the Kunst & Museum-journaal[7] also belonged to the series. Published by Oorebeek himself, the little books were folded lithographs of enlarged reproductions of illustrations from Hypnerotomachia Poliphili. Leafing through such a little book, one sees only a fragment at a time. Rendered inaccessible by enlargement, the image is occasionally accompanied by a quotation from the text.

Colonna's book describes a dream. The illustrations are therefore essential: the dream generates images by processing images received by the senses. If the image conveys a false reflection of reality, the dream conveys the truth of the image. Deciphering the hieroglyphs and ideograms bestows wisdom upon the soul.

8. The significance of the type and graphic design and illustrations in this book in the history of book typography is discussed by J. Blumenthal in *The Art of the Printed Book* (New York: Pierpont Morgan Library, 1973), pp. 10 and 11. See also A. Bartram and J. Sutton, *Atlas of Typeforms* (London: Lund Humphries Publishers, 1968), p. 30 and Stanley Morison, "The Type of the Hypnerotomachia," *Gutenberg Jahrbuch* (1925).

Hypnerotomachia Poliphili was printed on the presses of Aldus Manutius, a Venetian scholar and printer, in a typeface designed by Francesco Griffo. The book is a typographical gem, exemplary in the history of book typography for its elegance, legibility and well-balanced text and image.[8] For us, living as we do in the age of offset, it is a peerless example of the harmonious correlation of the proportion and drawing of the illustrations to the printed text. The loss of this felicitous union of text and image – under the supremacy of text – is rendered manifest by Oorebeek's intervention and manipulation.

Oorebeek is also preoccupied by the book's content. The title of one of his typographical works of 1994, *Schlafend wird der Geist klüger* (sleeping improves the mind), is a perfect rendering of the tenor of *Hypnerotomachia*. (As a matter of fact it is borrowed from the title of an article about the book.) If reality is but a dream, then dream is reality. What we perceive with our senses is – in Colonna's neoplatonic-Christian vision – merely a dim reflection of true reality. Only by taking images seriously *as* images can we gain an insight into what we might nowadays call the structure of reality.

In *MONOLITH* a quotation is printed from (an old English translation of) the *Hypnerotomachia* – captured in, and made somewhat illegible by, a multiple grid. It is the subtitle of the book, which sums up the leitmotiv of the text as follows: "Wherein he showeth, that all humaine and world-lie things are but a dreame, and but as vanitie it selfe. In the setting foorth whereof many things are figured worthie of remembrance."

Seen in terms of image reproduction, there is something dreamlike about the first section of *MONOLITH*: superimposed reproductions of earlier work form a veritable palimpsest of images. The overlapping images produce a new one which, when fathomed, can bestow wisdom upon the reader. He will not understand what the images mean by reverting to their dubious referent, but by studying their connection in the newly produced image in front of him. What is depicted is not reality but its cryptographic concealment in the image. Unlike Colonna, though, Oorebeek is not driven by the hope of revealing the truth of the image.

Method

Oorebeek's point of departure for the making of *MONOLITH* was the same as in his other work. He employed the same method, too – except for having *MONOLITH* printed by Rosbeek Printers instead of on his own lithographic press. The edition of 1000 left him little choice.

What is this *method* which Oorebeek has been employing since 1987? Since that year, "classical" lithography has functioned as a model for his working process, meaning that each work is built up from the whole run of a print – the "internal edition" method. He draws most of his *motifs* himself,

pp. 20-21

with occasional borrowings from existing graphics (such as the bottles in *Tartan*, 1987).

In 1991 he abandoned the internal edition method. Since then his choice of motifs has been governed by the principle that an image *already exists in print*. We could call it the *external edition* method. Until 1993, his motifs were preferably, but not exclusively, obtained from reproductions of his own work from previous years. An example is three anagrammatical works of 1992 which are based on *Muscae Volitantes* of 1987. In 1993 he picked up the thread of *Tartan* again, using motifs from commercial communications.

The method he adopted in 1991 is implemented in a number of phases:
1. the point of departure is always an already printed image – a scrap of visual culture,
2. a reprographic reproduction is then made,
3. this reproduction is then manipulated (e.g. enlarged and/or isolated),
4. the manipulated image is transferred to the stone,
5. and the printable image is then duplicated on the lithographic press.

The entire process starts by intervening in the flood of images from print media.

In selecting his external images, Oorebeek is guided by considerations of content, technique and stance – in that respect nothing has changed since 1987. A new factor is his interest in how a photo-graphic image is reproduced. He creates an aloofness from visual culture by resorting to the method by which its images are reproduced. His knowledge of the conditions under which images are produced renders him immune to the spell that the visual end products are meant to cast.

Oorebeek brings delaying tactics to bear on the print media, which are characterized by a tendency towards an exponential acceleration in reproduction time. Not only the time needed to reproduce the (already reproduced) image in his own studio is slowed down; the delay is especially noticeable in the ultimate image: not only has the locus essendi been changed, so has the time-order to which it belongs. Under Oorebeek's treatment the image comes to a halt, is quiescent. Its meaning has changed with regard to the initial image. This is because the coordinates of its spatio-temporality have shifted: the image enters a different problem space, becoming part of a different visual argument from the one in its original domain.

Index

MONOLITH is not the first example of Oorebeek's interest in the catalogue phenomenon. In 1985 he published another heterodox variant of the genre, entitled *Index*.[9]

Index is a gallery catalogue. Oorebeek drew the titles of works exhibited in the Van Kranendonk gallery on stone and printed them on transparent

pp. 52-53

10. op. cit., note 2.

11. Now and then Oorebeek cheats by not using a reproduction or by moving it, a deliberate flaw in the scheme. For instance, biography and bibliography are combined on pages 30 and 31, where they weave a tangled web of exact data. The organizational scheme was departed from here due to the formal and semantic effect of superimposition or juxtaposition.

paper. These prints were used twice. The lithographed titles were framed and hung alongside the works, works in their own right. The lithographed text is just as much the artist's work as the lithographed image.

The sheets on which the titles were lithographed were also used for a private publication in an edition of twenty copies. The cover of *Index* is blank. Besides a title page and acknowledgments added in typewriter lettering, the booklet contains six titles of works. Via a lithographic detour, Oorebeek returns to the essence of the catalogue: a list of works, preceded by the artist's name.

The book is based on a number of inversions. The first one was carried out for practical reasons. The text is printed in mirror-image on the back of transparent paper. For the sake of convenience, Oorebeek had drawn the letters the right way round on the stone, so that they were printed in reverse. The text becomes legible when the transparent paper is folded in two.

Another inversion is the relationship between content and contents. The little book contains nothing but a register, the list of contents being identical to the content.

The relationship between work and title is also inverted. The book presents a series of titles *as* works – the varied typography places text and image in the same register. The title abandons its subordinate position – printed in small size in the margin or on an otherwise blank left-hand page facing the page with the reproduction. In *Index* the titles themselves are full-page reproductions on the right-hand pages, preceded by the luxury of unprinted paper.

The difference between original and reproduction is eliminated here. The small catalogue – no different in this aspect from the works it lists – consists of (cut and folded) lithographs, printed by Oorebeek on his own lithographic press.

Finally – and here *Index* resembles *MONO-LITH* – the distance between œuvre and catalogue is eliminated. *Index* fulfills its catalogue function faithfully, but at the same time it is an autonomous work with a place in the œuvre of which it documents a part. The new work *Index* results from a strict interpretation of the catalogue function.

With this little book Oorebeek returns to the essence of the catalogue: a list of titles printed in a simple typography and in a modest format. One and the same gesture counteracts the pretensions of the exaggerated formats and lavish full-color catalogues of the eighties. The catalogue, degraded since the sixties into a commercial product and

prestige machine,[10] has been appropriated by the artist as his own medium.

Reproduction of Catalogue Pages

Let us return to the first section of *MONOLITH*. It experiments with the index-function of the catalogue, but in this case the index is not a list of works whose titles are reproduced typographically, but a series of reproductions of catalogue pages illustrating the artist's work. Oorebeek has taken the step from representation to reproduction – arriving at a new "original."

The point of departure is not the individual works but the manner in which reproductions of them are distributed. Mixing method and chance, Oorebeek reproduced all the catalogues containing reproductions of his work, printing identically-numbered pages over one another. Pages 6 to 31 of *MONOLITH*, for instance, are overprinted with the corresponding pages from the catalogue *Willem Oorebeek*, which documents his solo show at the Museum Boymans-van Beuningen in 1988. Pages 7, 8, 13 and 26 of the two publications are identical, only one source having been available for these pages. All the others show overlapping images, composed of two or more "originals."[11]

Unity in all this is created by the recurrence here and there of works which have appeared more than once in catalogues from group shows. *Opolka* (1987) and *Tartan*, both printed five times, lead the field. Tying for second place are *Muscae Volitantes* and *Tierscheibe Gamsbock* (1990), both reproduced four times. But unity is due first and foremost to the circumstance that elements from new compositions complement or contradict one another. The individual works (often composed of identical elements) act as constructive elements in a still recognizable imagery.

Productive Destruction

What is the rationale for the method of presentation adopted by Oorebeek in the first section of the book? In the first place, the idea of the original is negated. As we have already seen, the initial works do not refer to an object in reality. Nor do their reproductions.

Secondly, the idea of chronology – an arrangement that hinges on the idea of an author as the source of the work – is suspended. The works are not illustrated in the order of their making but in the order of their – synchronous – appearance in the library: what we see is how the images were processed in the reproduction machine. Identical page numbers result in the simultaneity of images.

12. Jan van Adrichem points out that a lot of organization goes into Oorebeek's lithographic works. See J. van Adrichem, *Negen* (Rotterdam: Witte de With, 1991), p. 36.
13. These concepts are central to the history of ideas. Foucault subjected them to a critical analysis in his famous lecture of 1969, *Qu'est-ce qu-'un auteur?*, reprinted in Michel Foucault, *Dits et écrits*, vol. I (Paris: Editions Gallimard, 1994).

The principle of their arrangement moves from the temporal to the spatial order: what is the reproduction's *place* in the reproduction machine?

The deliberate superimposition of images ignores the isolated status of the works and the diachronous order of before and after. (In his early lithographic work Oorebeek was already employing a double-print process derived from photography.) Now and then this procedure produces astonishing results: on page 32 of *MONOLITH* two reproductions of *Opolka* overlap almost completely – fusion creating a unit once again.

Finally, Oorebeek employs the principle of re-utilization. Since 1992 his maxim has been that all images reproduced in catalogues should be recyclable, and some catalogues contain images which he included for the explicit purpose of reutilizing them later as printed reproductions.

This recycling principle is based on far-sighted planning.[12] It breaks with the strategy of constant image innovation, a strategy employed in the worlds of economics and art alike. In both, (image) innovation is the cause and the reverse side of (optical) obsolescence. Originality is constitutive for modern artisthood and is regarded as the hallmark of artistic authenticity. It is linked – not even latently – with the need for the permanent innovation of the capitalist economy's products and processes. Paradoxically, in recycling his visual material Oorebeek actually does achieve image innovation – unlike commercial imagery, which is characterized by the endless repetition of a repertory that has not essentially changed in recent decades.

The crux of the matter, as I see it, is that Oorebeek wreaks double destruction in the first part of *MONOLITH*. He dismantles the idea of an *œuvre* tied to an *author*, and the idea of *development* as the be-all and end-all of the creative artist.[13] This destruction yields new images which, by combining elements from the artist's vocabulary of forms, produce complex visual sentences. A similar paradox can be observed in the artist's biography, for the publication of *MONOLITH* does after all mark a stage in its maker's development.

In *MONOLITH* Oorebeek no longer defines the catalogue as the paper counterpart of the actual exhibition, but as a medium sui generis. It is characterized first and foremost by the manner in which visual information is conveyed. The properties of the medium not only determine the form in which information appears, but its content, too.

Compared with earlier catalogues containing examples of his work, Oorebeek treats *MONO-LITH* as a medium on a metalevel. *MONOLITH*

retroactively defines the modus operandi of the visual information machine which it is examining.

Typography and Initial: Two O Works

Although distrustful of the notion of authorship, Oorebeek is fascinated by his own name and in particular by its first two letters. In *Au Pair* (1987) – his first "O" work – that fascination resulted in a special kind of typolithography.

For *Au Pair* Oorebeek employed the "internal edition" method he adopted in 1987. His O, self-made but without a trace of handwriting, is composed of two elements which are repeated once, in a different position. The top and bottom halves and the left and right sides of this O are identical, but mirror images. It is assembled from four sheets; the entire work – showing two O's – consists of eight.

Why this duplicated O? It refers to Oorebeek's surname, which in contravention of current Dutch spelling rules has a double O in its first syllable. But in view of the letter's shape, its duplication acquires another meaning. Abstracted from its typographical metamorphoses, O refers to the circle, the perfect form. Doubling that perfect form undermines its very perfection, for after all, perfection implies that no addition is needed. Duplication flaws O's perfection, moving it into the semantic field of deficiency. It connotes an omission or a void, asking to be filled.

The two identical O's are placed on the surface in such a way that they cease to be the first two letters of Oorebeek's name. Their duplication denies the initial. What we see does not suggest a unique individual but the idea of a series of clones.

The surname, of course, always takes precedence over the individual. That is not what *Au Pair* is about, though. The O's seem to initiate a chain of signifiers which extend into a present without a past or a future.

Whereas the two O's in *Au Pair* were placed upright, parallel to each other, black on white, *MONOLITH*'s cover displays a different constellation. A centrally placed O is bordered above and below by two horizontal lines. The O, derived from a sans serif typeface, is tilted and divided into three bands: red, black and green. Have two O's moved so close together as to overlap, producing a third, black O on their common ground? Or are we looking at one O which has divided, producing two colored likenesses on its inner and outer peripheries?

The answer is supplied by the thin red and green lines above and below the O. They, too, are doubled, as well as being slightly staggered. This framework, demarcating a typographical space, is

14. Marianne Vermeijden, "De drukpers is voor graficus Oorebeek kwast met kuren," *NRC Handelsblad* (9 June 1994).

unstable. The lithographer has appropriated an O from the typographer's desk and tilted and doubled it. He then reduced the distance between the two O's, actually sliding them into each other. Four print runs create the illusion of one letter in three full colors.

What is the dénouement of this typographic drama? "The O," says Oorebeek, "is the most abstract letter of all."[14] By abstract he means that it has none of the bits and pieces by which we identify other letters. Even in an alphabet with serifs, O has none. It must confine its decorative inclinations to playing with its inner and outer circumferences and to varying the thickness of its upstrokes and downstrokes. Its shape seems to change with the material conditions of its reproduction to a lesser extent than that of other letters.

In terms of typography, by overlapping two "sans serif" O's, Oorebeek creates the illusion of a "serif" O, practising calligraphy on the printing press. Or: typographic blackness is outshone by the color system of electronic letter and image reproduction. Oorebeek, however, is not concerned with the aureole which forms around the inviolable shape of the O. That aureole, as we see from the divergent lines of the area they define, is the result of a slip or a misprint. He is concerned with the two O's as they draw closer together. The shortened distance between the two O's in the graphic space points to the distance travelled since *Au Pair*, the

ever closer mutual involvement of the elements of his work. The sign on the cover of *MONOLITH* is a condensation of two elements whose optical unity is produced by reproduction and imagination. The triple O evokes a tendency to unification, but at the same time a difference which cannot be eliminated. It suggests the illusory character of the unity of the individual to which it refers.

Genius and the Artist's Name

Closely linked with the cult of the artist's name is the notion of the uniqueness of his work and person. This notion is undermined by the alphabetical list of artists, ranging from Louise Abbott to Annebet Zwartsenberg, printed across the double page 118-119 of *MONOLITH*. Here text, not image, is reproduced. The list comes from an otherwise unspecified catalogue marking the tenth anniversary of a feminist exhibition space. The names form an endless procession – which in turn debases the concept of authorship, the notion of the unique artist. The "chronology" – the word appearing at the end of the page – is not filled in. The names, set in the synchrony of the type area, have become purely graphic elements. Artists without work – the footmen of the artistic class. Because their work is not reproduced, the artists have become anonymous, despite being on the record. The God of art also preserves the names of those who inhabit his world in the palm of his hand.

pp. 114-115

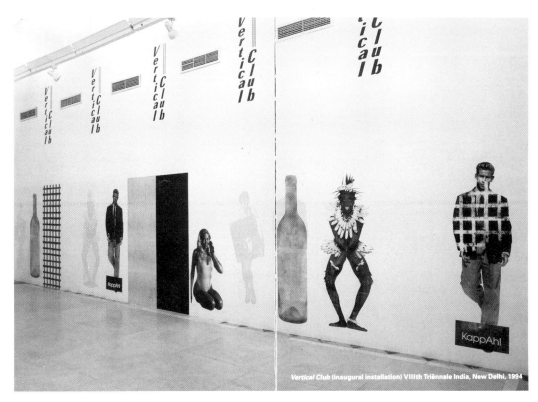

Vertical Club (inaugural installation) VIIIth Triénnale India, New Delhi, 1994

15. Ernst H. Gombrich, *Norm and Form: Studies in the Art of the Renaissance I* (London: Phaidon Press, 1985) (1966), p. 110.

This double page – let us call it *Chronologie/Chronology* – is a purely typographical work. As regards content, the spread may be seen as a counterpart to another purely typographical work, *Hand should he mask* (1987), with which the first section commences. "… tell him that we desire and long for nothing but a work by his genius, … if only we can have an example of his unique art." This is an extract from a letter written by the Duke of Mantua to an agent, asking him to procure a work – any work – by Michelangelo. The fragment, quoted by Ernst Gombrich in *Norm and Form*,[15] is regarded by art historians as evidence of "the rise of the notion of art as an autonomous human activity," for the duke actually relinquishes his status as a patron. All he wants is a work of art, his only stipulation being that Michelangelo sign it. Is not that signature the true object of his desire? And is not the notion of genius a masquerade for the desire for another man's name?

Marcel Broodthaers had already addressed the theme of the multiple name as the hallmark of value – the signature's role in autonomous art. Willem Oorebeek follows suit in employing the means of technical reproduction to deconstruct the name's magic in *Hand should he mask*.

Vertical Club

Part four of *MONOLITH* opens with a photograph of the first installation of *Vertical Club* at the Trien-nial – *India*. The photograph is printed over two pages (114-115). A reversed out caption documents the place and year of this premiere. The piece was repeated that same year at Witte de With in Rotterdam, in the exhibition *MONOLITH, lettered rock*. Here we had Oorebeek bringing brand names, images and concepts from the hub of the capitalist world to the capital of a third-world country. In this respect art, too, runs parallel to the economy. The photograph documenting that movement was then displayed in the metropolis.

Vertical Club is a wall piece. Man-sized sheets of paper are pasted together to cover the surface of a given wall. The sheets are of identical size, and show an extendable repertory of figures and motifs, a sequence of upright elements, some of them old, most of them newly made. From left to right we see the *tableau de la troupe*: an Indian female singer, a bottle, a coarse grid the height of a man, a female model bedecked with Chiquita bananas, a male model captioned KappAhl, two upright rectangles, a female model holding a telephone to her ear, the same Indian singer holding her own portrait, the same bottle, the same Chiquita model, the same KappAhl young man, now overprinted with an ikat pattern. A selection of repeated or overlapping motifs.

The selection of figures appearing in *Vertical Club* is governed by several criteria. In the first place they are taken from printed advertizing mat-

pp. 124-125

16. As well as in *Vertical Club*, the Chiquita model makes two appearances elsewhere in *MONOLITH*. She figures in the center of a photomontage for which a photograph of a Tokyo street provides the setting. In the penultimate spread, a detail of her photograph is coupled with a detail from Oorebeek's *Hand should he mask* of 1987.

17. The Chiquita model is a persiflage of showgirl Josephine Baker, who took Paris by storm in the 1920s and 1930s when she appeared on stage clad only in a skirt of bananas.

18. The ikat motif results from a weaving technique in which the threads are dyed before being woven. The weaving process produces irregularities of pattern which do not tally with the original design. These irregularities are characteristic of ikat.

ter. Secondly, they are looking into the camera, thus establishing a quasi-relationship with the beholder. The beholder has eye contact with each of them, but the figures have no connection with each other. Thirdly, the figures have neither a distinct identity nor a traceable history. Fourthly, they lend themselves to being enlarged to human dimensions, although the size of the work is defined by (a multiple of) the sheet of paper printed on the lithographic press.

The first installation, in New Delhi, featured four models, three women and a man. The Chiquita model is bizarre.[16] Bananas swing from her head, neck, hips, ankles and wrists. The image is printed once on the back of the paper and once on the front, resulting in different degrees of clarity and brightness. The photograph comes from an advertizing campaign launched around 1980 but aborted after protests from feminists.[17] Also present in the Club are the young man representing KappAhl (a Swedish clothing label), the telephoning girl from an advertizing campaign of the German telephone company under the motto of "Erreichbar …" (reachable), and the Indian singer who is hoping for a career as a film star.

The human figures are interspersed with abstract elements – another form of separation. One of them is an ikat motif.[18] Another element separating the figures is a mansize bottle, familiar from earlier work by Oorebeek. The version presented here is less pronounced than the "original."

The work looks like an enlarged version of a photo-storybook. The principal actors are introduced, but there is no plot. Oorebeek plans to add one figure to the cast every time he installs *Vertical Club*. This could result in a post-Christian version of the Way of the Cross – the Via Dolorosa served up as pleasure. Fourteen stations but no Redeemer.

Vertical Club both continues and breaks with Oorebeek's earlier work. The first images from the outside world to be incorporated in his graphic world were inanimate objects: bottles as containers for wine. They were followed by animals: a chamois, a fox and a pig, taken from hunting scenes on shooting targets. Human figures – professional models – made their first appearance in *Vertical Club*; and yet Oorebeek continues the packaging theme.

Again, reproduction is the point of departure. In *Vertical Club* he expands the concept's frame of reference. Recognizable images from the mass media are given lithographic treatment and serialized. This changes the viewpoint, the critical aspect now coming to the fore. Oorebeek's visual argument becomes more direct, the finer details of the pictorial-

ism and handwriting that gave the lithographic works their charm now giving way to a mischievous change of tone. Having turned typography into an autonomous image, he has no qualms about introducing legible reproductions of commercial brand-name typography to *Vertical Club*. The intention, to undermine meanings by changing the medium and the context, remains unaltered. Oorebeek has no scruples about importing stereotypes from visual culture: *models* in advertisements, intrinsically anonymous. He searched for lifesize human figures or for photographs which could be blown up to the requisite format. The models no longer appear in full color, which suggests the warmth and hues of the living body, but are reduced to a black-and-white grid. Whittled down to their graphic skeletons, they are crossed with other components from Oorebeek's graphic universe.

The actors in *Vertical Club* appear in a sequence. Not a procession, for the figures do not move in a particular direction or towards a goal, nor are they linked by a ritual. They are all depicted frontally. This gives them a monumental aspect which contradicts the ephemeral and temporary nature of their original medium: the illustrated magazine, brochure or billboard. The figures, separated by rectangles and objects, are creatures from a multinational visual universe, monads without identity and without reciprocal relationships: parallel individuals, silhouettes gathered together at the same time in a graphic space. They gaze at us as if from a lifesize paper concertina. Messengers bereft of a message, they display bodies which themselves have become empty signifiers – links in a chain.

Why has the artist crept into the world of media? What are his intentions or options? Does he want to irritate, imitate, criticize? The bodies in *Vertical Club* are copies of bodies, lifelike and immaterial at the same time. Not in the way Yves Klein had bodies leave their traces on canvas – the ultimate attempt to play off presence against representation and restore the links between the body and the message. (An attempt, incidentally, which was foiled as soon as his work was circulated in the media.) By contrast, the body-images in *Vertical Club* have been removed from visual circulation. Originating in commercial printing, they were mediafied, scanned and digitized from the very start: *corps trouvés* in the era of electronic image-reproducibility.

Communication: the Body-Image and the Name

Commercial communication couples an image with a name. The name belongs to a brand or a

19. Cf. Walter J. Ong, *Orality & Literacy. The Technologizing of the Word* (London: Methuen & Co., 1982; London/New York: Routledge, 1988)

20. *Roland Barthes par Roland Barthes* (Paris: Éditions du Seuil, 1975), translated by Richard Howard under the title *Roland Barthes by Roland Barthes* (Berkeley: University of California Press, 1977), see under "the mother tongue".

producer, the image displays a product, often partnered by someone demonstrating or using that product. In *Vertical Club* two figures perform this function: the Chiquita model and the young man from KappAhl. The "reachable" girl with the phone comes from the same world, but Oorebeek has reproduced her without the original logo. (Like the Indian singer, who wants to insinuate not only her voice, but also the image of her image, into the media.)

Script uncouples the body from the message. It makes the message independent of the speaking subject.[19] The visual media reverse that uncoupling on an imaginary plane. Uniting text (brand-name, slogan) and the picture of a body (the photo model) in one image – a combination typical of most commercial communication – may not restore language to the speaking subject, but it does conjure up a picture of the unity of language and body that is denied to him in essential areas of his life by a culture dominated by the printed word. The magic image cannot exist without the magic of the word. By surrendering to both, the subject regains the pleasurable state in which language was experienced as an immanent force in his body.

Uncoupling the body from the message has consequences not only for communication, but also for the body itself. Roland Barthes touches on the connection between language and the body: "Sometimes, when he hears French people in the street, he is surprised that he can understand them, that he shares a part of his body with them."[20]

On a growing number of fronts, professional communication is replacing direct verbal exchange between people living and working in close proximity to one another. The loss of intimacy and closeness, the loss of power and the concomitant discomfort, have to be compensated by professional communication on the imaginary level. This is particularly true of the body-image. The models who populate the world of professional communication restore the sensoriality that was destroyed by the transmitter-receiver setup. Nevertheless, they are not what they seem: travellers in a global or virtual world of abundance, where wishes are granted if you know the magic word. They are signs in search of a receiver. They give a face to institutions without identities. The world inhabited by their silhouettes is the vacuum between a brand-name and the nameless masses.

A Graphic Shiva

In our times the idea of a feasible society has been renounced. Not the idea of feasibility itself – that has grown stronger. Feasible for example is corporate identity, the institutional image. But individuals, too, have acquired feasible, post-human bodies. Since time immemorial, physical glamour has been the object of subtle skills, including cosmetics; nowadays, even anatomy can undergo a metamorphosis. Body-building is a literal manifestation of this development. In an attempt to conform with ideal images, the body is submitted to physical dressage.

A graphic Shiva illustrates the dreams on which this animal practice is based (on page 116 of *MONOLITH*). A graphic procedure generates a twelve-armed dancing Shiva – based on photographs of three female body-builders found in an Austrian magazine. The positive figures are printed in magenta, the negative ones (in mirror-image) in cyan. The mirroring produces symmetry. The result is a twelve-armed dancing demon, reproduced in a coarse grid. The sublime, built up from material found in the cellars of culture.

A Global Vision

The fusion of several local cultures in such images is typical of visual world unification. Another demonstration of the same process is given on pages 124 and 125 of *MONOLITH*. A montage of three photographs with the structure of a triptych shows (1) a work by Oorebeek, *Au Pair*, reproduced from a previously published book – the organizational principle of the first section of *MONOLITH* is resumed here; (2) a snapshot taken in a Tokyo street; (3) a double print of the Chiquita model, with a third eye – the superimposition of two eye dots.

Each element of this tripartite composition is characterized by duality or doubling.

The two O's are the epitome of perfect duplication. Mounted in the street photograph, the lithotypography again loses its original proportion, scale and objecthood. The O's have become floating signifiers, freed from their traditional carrier.

The street photograph is dominated by two billboards. The one on the right shows a lady with a huge telephone on her head and touch-buttons on her tank top; she comes from the same family as the "reachable" German telephone girl, displaying the same mix of communication euphoria and telephone sex. On the left we see a young Japanese woman in a white wedding dress, looking at us through the right-hand O of *Au Pair*. Walking along the bottom of the picture are three white-helmeted Japanese men, overshadowed by the billboards above their heads.

The cynosure is the Chiquita model: doubled, she parodies the pair. The bunch of bananas on her

21. "And do you see the bottle printed over it? That's me. I'm allowed to barge in wherever I like." Oorebeek, quoted by Marianne Vermeijden, see note 14.

22. Jean-Paul Sartre, *Critique of Dialectical Reason* Vol. I, *Theory of Practical Ensembles*, trans. Alan Sheridan-Smith and Vol. II, *The Intelligibility of History*, trans. Quintin Hoare (London/New York: Verso, 1991). In this rarely quoted work, Sartre develops the category of the series, which in my opinion is important for a theory of mass communication.

head corresponds with the mega-telephone sported by the Japanese model.

This montage is Oorebeek's version of global consciousness. Three spatio-temporal worlds merge. Distance and duration are abolished in this coalescence. Japanese and Latin script, an Afro and a Japanese female: what we see is everywhere. Or: by seeing, we are everywhere. The extension of our senses by global information networks leads to the globalization of visual culture. The sterility and pseudo-vivacity of the models in this photo-montage make us aware of what is totally absent: a genius loci and the reciprocity of subjects.

Reachable with Bottles

A little further on (pages 128-129) we recognize another figure from *Vertical Club*: "Reachable," the telephone girl, projected onto a background of an existing work by Oorebeek: a lithograph with seven bottles.

"Reachable with bottles" combines two figures from the bachelor's machine: the bottle – a metaphor for the artist himself, according to him[21] – and the telephone girl. Seven bottles and a lady. The work immediately qualifies as a bachelor's machine.

The original bottle piece is a lithographic work consisting of four times two sheets. The bottles are printed in black and white, becoming grey when contrasted with the colorful blackness of "Reach-

able:" a cliché of a four-color photograph, printed in magenta, cyan, yellow and black – four-tone photography in black and white with the impact of a prewar copper gravure.

This work is all about series and serialization. The technical procedure generated a series of identical elements: the bottles. The series was assembled into a unique work which deals with a mass medium.

Since the introduction of telephone sex, the telephone has assumed the functions of a transmitter, a channel and a medium: telecommunication threads a daisy chain of anonymous callers. Their ears receive the same voices, making them brethren in listening. Henceforth Jean-Paul Sartre's analysis of the radio in *Critique of Dialectical Reason* applies to the telephone.[22]

René Magritte's spirit in the bottle was still a cousin of the elves; his surrealism has become the reflection of a reflection: true communication is promised.

The Yellow Room

Section four also contains reproductions of Oorebeek's own work, but now in the context of exhibition spaces which are themselves exhibited. Not even these spaces can evade the logic of compulsive repetition that has come to characterize Oorebeek's work.

pp. 128-129

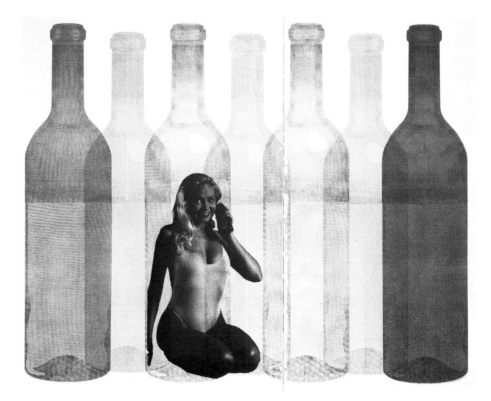

23. Roland Barthes, *Camera Lucida, Reflections on Photography*, trans. Richard Howard (London: Fontana Paperbacks, 1980).
24. Cf. the spread in *MONOLITH*, pp. 110-111.

On pages 130-131 the alienation of a deserted gallery is evoked by a photographic process. In the resulting diffuse light, Oorebeek's two exhibits are blurred, apparently merging with the wall on which they hang.

The autonomy of the forms turns out to be an optical illusion which depends on a correctly performed process of photographic reproduction.

The banishment of photographic blackness softens the contrast of light and dark. That is what the eye sees: the room's structure seems out of focus, objects and shapes are no longer distinctly outlined. Things do not stand out against the space surrounding them.

But something else is blurred – the difference between reality and representation. Reality merges with its photographic representation: a dominant tendency of visual culture. What photography offers us is optical-chemical proof that reality *was there*, as Roland Barthes observed in *Camera Lucida*.[23]

Oorebeek duplicates this proof by reproducing the photograph: the image becomes super-clear in optical-chemical duplication. Proving that *an image* was there.

Here and elsewhere in *MONOLITH*,[24] Oorebeek reveals the uncertainty of the entire process of image-reproduction. The image is translated into four print runs. Reproduced in an edition on the press, an illusion of reality is born of the chemistry of ink, grease and fluid. The separation and synthesis of the colors, the chemistry of grease and fluid on the press, turn out to be manipulable as technical conditions for assigning meaning. Minor interventions at the pre-press stage cause a shift of meaning in the images. It appears that intentional consciousness is not the only thing that controls the signifying process. The control room of the mind can also be situated in a designer's studio.

Here, Oorebeek slips into the graphic designer's role. Although armed with technical knowhow and tackling his job in a methodical fashion, the designer is a gambler, too. He loves the excitement between the premiss and the result. He is fond of experimenting. The specialist in line, form and color may surely indulge in a little flutter. 10% yellow, 50% blue – it's only the density of the hues that's at stake, isn't it? An innocent, indeed welcome variation in a jaded world. Airily, he juggles with the decimal system; as a flouter of mental conventions he is certain of applause.

Grids

Oorebeek shuns the field of graphic technology, the actual printing. It is however the arsenal from which his raw materials come and which he explores. Basically, though, the printed media – which still produce a great deal of our visual culture – are an area in the beyond.

pp. 142-143

25. See figures 9 and 10 in catalogue *Willem Oorebeek* (Rotterdam: Museum Boymans-van Beuningen, 1988).
26. op. cit., note 20.

His increasing preoccupation since 1990 with the photographic reproduction of printed images has brought him into contact with that area. The results can be seen in his fascination for grid imagery.

The individual parallela (1988) heralds the end of lithographic, manual image reproduction in his œuvre. The letters in this work were still drawn by hand. The transition to photographic reproduction introduces the problem of the grid to Oorebeek's field of vision. In *The individual parallela* the grid presents itself by displacement: the grid in the background is not a graphic grid but a textile weave. A piece of cloth is mounted behind glass.

Patterns of checks, found in textile designs, first cropped up in Oorebeek's work in 1987: in *Tartan* and in *Untitled*.[25] Graphically reproduced textile grids reappear in *Vertical Club*, and *MONOLITH* ends with an ikat motif printed over two pages.

Grids occur in more than half the pictures in the last section of *MONOLITH*. They are meant to show that the image in question is a printed reproduction. The grid of the Pirelli tile (*MONOLITH*, pages 52 and 136-37) fools our eyes with its pseudo-naturalistic effect of reflected light on the black rubber studs. The effect is not produced by light, however. Positive and negative are superposed, but are not quite congruent. The "light" is slivers of unprinted paper, a graphic effect.

We see dot grids and linear grids. Shooting-targets are grouped to prompt the association with a dot grid. Textile grids are blown up so much that their geometric pattern reveals a microcosm of irregularities or a starry moiré sky. One of the models in *Vertical Club*, the KappAhl young man, has covered himself, or is covered, with a grid: it obscures his chest and half his face, like a shield and a mask.

Oorebeek has come a long way since his innocent manipulation of a fifties wine-merchant's catalogue and its incorporation into his lithographic work *Tartan*. In that work the objects were first drawn by hand, translated into graphics to be sure, but without a visible grid. The grid was introduced by the artist, who grouped the bottles into a tartan pattern by staggering the sheets that constitute the work.

The Grid and the Eye

The grid thus has several forms and functions. In the era of technical reproducibility of the image, it is the (photo)graphic grid that organizes the field of vision and guides the eye. Like an atom of visual reproduction, it cannot be seen without the aid of a magnifying glass or unless one suffers from paranoia. Rendered visible by enlargement, the grid becomes an icon for the naive and manipulated gaze of the participant in visual culture.

Roy Lichtenstein's grid was simply waiting for the artist who wanted to expand the repertory of painting – nouveau pointillisme – casually wiping out the difference in status between high and popular culture. Oorebeek gives the theme a different twist. His grid is not only an organizational form of what is perceived, but of perception itself.

The Ship Argo

As we have seen, in *MONOLITH* Oorebeek reproduces not only existing images, but texts, too. One of those texts is a fragment from the English translation of *Roland Barthes par Roland Barthes*[26] on the ship Argo. The writer alludes to this mythical vessel three times. The ship, gradually renovated by the Argonauts during their voyage, without changing its name, serves Barthes as a metaphor for his two identically furnished studies (in Paris and in the country) in this book (an anthology of prose fragments whose structure and name remain the same but whose content changes while they are being written), and for the changing meanings of a lover's unvarying verbal utterance "I love you." The statement repeats the form of the signifier, but not of the signified. "This ship Argo," says Barthes, "is extremely useful: it supplies the allegory of a pre-eminently structural object which is not created by genius, inspiration, perseverance or evolution, but by two modest actions: substitution and designation." The Argo's only identity is her form.

The two aspects of the Argonauts' labors are fully congruent with Oorebeek's work. Replacing substitution by reproduction, we identify the key to his method. Photo- or reprographic reproduction are the ideal means of preserving a form's identity. As for a name's identity: the original objects or works willingly lend their names to their reproduction (does not one and the same name designate Rembrandt's painting *The Jewish Bride* and its reproduction on a postcard?). But the author – who is the author of an œuvre with constantly changing contents – retains his name, too. Willem Oorebeek's works sail under the same flag, but with a different cargo on every trip. At the same time the work retains nothing of its origins.

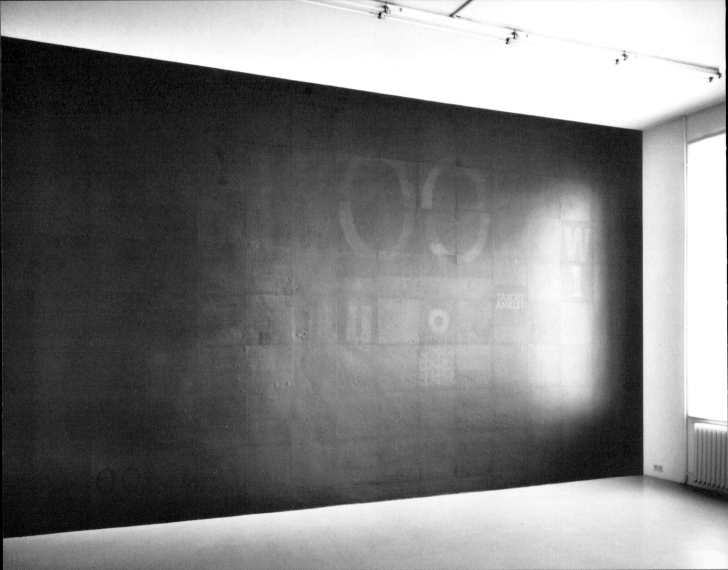

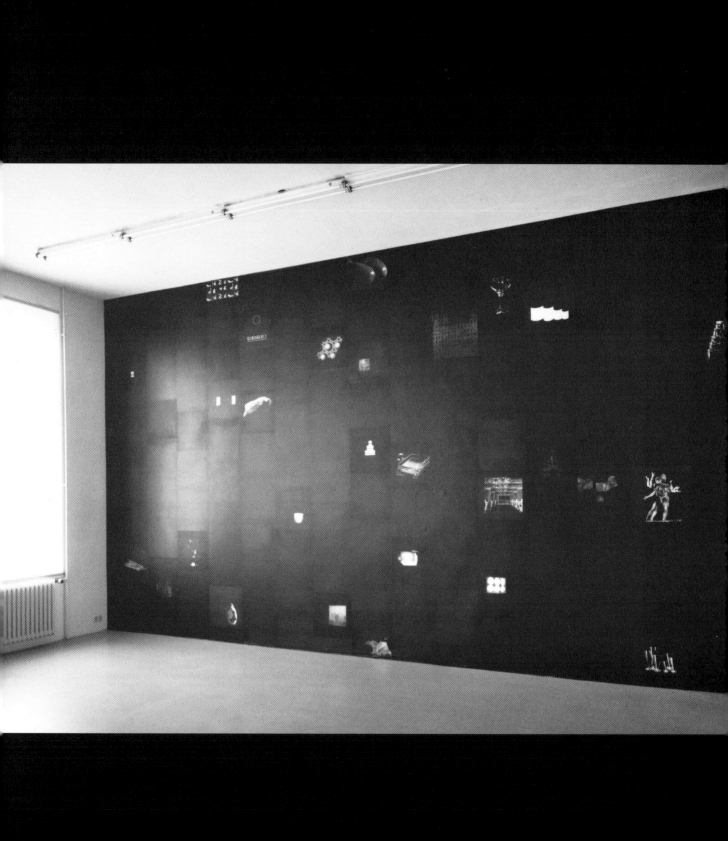

Willem Oorebeek
MONOLITH Appendix, 1994
project for *Witte de With – Cahier # 3*

MONOLITH

APPENDIX

Willem Oorebeek

DILEMMA AU PAI
LUX ECHO&HOPE
PHOSPHOR PRISM
ELECTRA CLARA
UNTITLEDBOTTLE
HALF BOTTLES
ETC DE LAATSTE
VERMANING THE
LAST ADMONITIO
GROTESK SET DE
ROOS MANNLICHE
OPOLKA TARGET
ANKLET TARTAN
ESTILO INDOLA
AUX ANTIQUES
OHNE TITEL UN
COCTEL DE COMP
TENCIAS Y TALE
NTOS GOOD THIN
S LOTS OF THEM
SENZA TITOLO

The Machine in the Museum or The Seventh Art in Search of Authorization[1]

Bruce Jenkins

This essay is based on the lecture Bruce Jenkins gave at Witte de With, on 30 January 1994 at the occasion of the 23rd Rotterdam Film Festival, held from 26 January until 6 February 1994. Bruce Jenkins is the Film and Video Curator at the Walker Art Center in Minneapolis.

...I don't believe in film as a medium for visual art.[2]

JAN DIBBETS

...one attends the cinema en passant...[3]

ARNOLD HAUSER

1. I wish to dedicate this essay to the memory of Paul Sharits (1943-93), an American artist and filmmaker who created a body of extraordinary moving-image works for both the gallery and the screen. I wish to acknowledge the Jerome, Dayton Hudson and General Mills Foundations for a travel and study grant and the Cité International des Arts in Paris for providing me a residence during the grant period. Finally, I wish to thank Chris Dercon for the opportunity to formalize these ideas into an essay and critic Nelly Voorhuis for her good counsel and for the translation of the Jan Dibbets quotation.
2. Wim Beeren, "Jan Dibbets filmt niet meer." *Film als beeldend medium* (Amsterdam: Nederlandse Kunststichting, 1974).
3. Arnold Hauser, *The Social History of Art*, vol. 4, *Naturalism, Impressionism. The Film Age*, trans. Stanley Godman (New York: Vintage Books, n.d.), p. 250.
4. Francesc Torres, "The Art of the Possible," *Illuminating Video: An Essential Guide to Video Art*, ed. Dough Hall and Sally Jof Fifer (New York: Aperture Foundation in association with Bay Area Video Coalition, 1990), p. 208.

Despite the precise parameters that define their rejection of cinema (as a medium for visual art or one for critical contemplation), the Dutch artist Jan Dibbets and the Hungarian cultural historian Arnold Hauser give voice to a much broader, systemic disavowal of the medium: film is undoubtedly visual, but is it art? This, of course, as Walter Benjamin understood more than a half century ago, is the wrong question. The right one asks rather how the existence of film has redefined the very way in which we understand the work of art. More than fifty years after Benjamin's death and nearly a hundred years after the birth of cinema, however, film continues to reside – now in the company of video, holography, and new forms of computer-based imaging – on a fault line discernible only well below the surface of the art-world infrastructure. It periodically rises to the surface, as when it is briefly embraced by artists who, in their youthful defiance of the procedures and proprieties of art making, intuitively take up moving images for their disruptive potential. But intrinsically difficult to display, market, or collect in the manner of more traditional art forms such as painting or sculpture, these experiments invariably recede into an art historical netherworld in which they may be occasionally viewed, "en passant."

On the eve of the centenary of the cinema, it is perhaps an appropriate moment to reassess the place of the moving-image arts within the wider body of visual-arts practice and to examine their access to the institutional resources of the museum. This inquiry is less about the actual presence (or more frequently absence) of film, film departments, or screening facilities within particular museums – although it is this, too – but is rather a reflection on the hoarse whisper of the cinematic (and in more recent times, the videographic) voice within the aesthetic discourse of the museum.

The desire for inclusion within the museum, for parity with contemporaneous visual and plastic arts, rarely has been articulated by filmmakers themselves, although they have often wrestled and sometimes succeeded in subduing some of the most challenging aesthetic concerns facing the visual arts. Even among video-installation artists, relatively recent arrivals on the art scene who have on occasion found a measure of institutional acceptance, frustration often outstrips theory. Typical is the succinct syllogism of the Spanish installation artist Francesc Torres, who rather baldly assesses matters as follows:

> Despite the tools available to art through technology, the art world hangs on to its conventional practices and aesthetic strategies. Thus technology-based art exists in a marginal area in a technology-based society. Seen in light of this century's history, science and technology are perceived more as deliverers of death and ecological crime than as purveyors of insight and well-being. Within this perceptual frame, technological art is seen in an unflattering light while the traditional arts are viewed as a redoubt of the human spirit.[4]

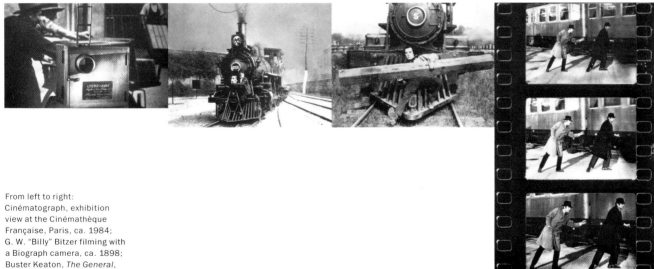

From left to right: Cinématograph, exhibition view at the Cinémathèque Française, Paris, ca. 1984; G. W. "Billy" Bitzer filming with a Biograph camera, ca. 1898; Buster Keaton, *The General*, 1926; Marcel Broodthaers, *Ein Eisenbahnüberfall* (A Train Robbery) (detail), 1972, Galerie Heiner Friedrich, Munich

5. Gilles Deleuze, *Cinema 1: The Movement-Image*, trans. Hugh Tomlinson and Barbara Habberjam (Minneapolis: University of Minnesota Press, 1989), p. 173.

Before the electronic age and the array of technology it has made available for art, however, there was the machine age, which gave rise to the cinema and its photographic predecessors. Film emerged in the final years of the nineteenth century and exhibited an endemic interest in the increasingly machine-laden landscapes of the twentieth century, as the links between the kinetic and the cinematic, between this new communications medium and new modes of travel, forged a natural partnership. This fascination seemed to culminate in *The General* (1927), Buster Keaton's sublime reflection on the pitfalls and possibilities of the individual ("a minuscule dot encompassed by an immense and catastrophic milieu")[5] in a mechanized world. Nearly half a century later, the artist and cinéphile Marcel Broodthaers reflected on this fundamental aspect of early cinematic practice by producing in 1972 a film fiction (a parallel to his museum fictions) in the form of a movie poster for an unmade film, *Ein Eisenbahnüberfall*. This work, appropriately produced as a multiple, consists of still photographs framed by sprocket-holed borders that picture specimen scenes in which the artist and an accomplice, in frock coats and hats, wait alongside a railroad crossing for the eventual arrival of a train.

Throughout the history of modernism in the visual arts, the machine has served as subject matter, but for the machine-based media (for example, photography, silk screen, metal fabrication, assemblage) institutional acceptance within the museum has been achieved only through a most ingenious array of disguises and dissimulations – elegantly abstracted in the photography of Paul Strand, caricatured in the sculpture of Jean Tinguely, appropriated as cultural iconography in the large canvases of James Rosenquist, in ruins and exhausted in the metalworks of John Chamberlain, and most recently, expressionistically caricatured in the sculptures of Anselm Kiefer. A revealing history of modernism could be told in the elaborate strategies employed by artists and institutions to counter and deform the machine and mass-produced culture in general.

There have been less than successful attempts, however, at bringing the cinema into the gallery and into the museum collection. Like still photography, film is a mechanically reproducible medium, but, unlike the photograph, a film is not detachable from its machine source. Rather it can be seen only if it remains tethered to a version of the apparatus that originally produced the work. Unhooked from its machine, a film is lifeless and empty, as Joseph Beuys demonstrated when he created a multiple of lead-clad reels from Ingmar Bergman's *The Silence*. The occasions on which film has entered the collection of the art museum often find the ludicrous specter of its elements similarly exhibited in vitrines like moon rocks or relics from some alien culture, reduced to an objecthood ontologically at odds with its true aesthetic nature (be it Jean-Luc Godard's "truth twenty-four times a second" or Stan Brakhage's "visionary experience").

From left to right:
Jean Tinguely, *Homage to New York* (self-destroyed), 1960; James Rosenquist, *F-111*, 1965, private collection, New York; John Chamberlain, *Norma Jean Rising*, 1967-81, collection Dia Art Center, New York; Anselm Kiefer, *Poppy and Memory* (detail), 1989, collection Marx, Berlin

6. Hollis Frampton, "Meditations around Paul Strand," *Circles of Confusion: Film, Photography, Video: Texts 1968-1980* (Rochester: Visual Studies Workshop Press, 1983), pp. 129-130.

7. Ibid., p. 130.

Film as a mechanical medium has been less than readily accepted within the museum or within the art historical discourse of modernity perhaps because of the ominous associations that Torres described in connection to the uses to which allied technologies have been put in this century and perhaps because of mainstream cinema's undeniable complicity in the wholesale transmission of repressive ideologies dressed in the glamour of the silver screen. Beyond these global dispositions, however, there are a number of structural, systemic biases that hinder its advancement in the art world. Curiously, it is precisely these structural "deficiencies" that have become points of departure for advanced film practice.

Illusionism. As a camera-based art form, film is defined by the indexical illusionism of the medium and as such remains, as the American filmmaker and theorist Hollis Frampton noted, "ontologically manacled" to its referents:

> We are accustomed to deny them [photographs], in their exfoliation of illusion, the very richness of implication that for the accultured intellect is the only way at all we have left us to understand (for instance) paintings. To put it quite simply, a painting which may be, after all, nothing but some paint splashed on canvas, is comprehended within an enormity which includes not only all the paintings that have ever been made, but also all that has ever been attributed to the painterly act[6]

A photograph, however, is just a photograph, and by extension the products of the other camera arts are merely films and videotapes rather than, as Frampton posits for the plastic arts, "abundant metaphor[s] for one sort of relationship between the making intelligence and its sensed exterior reality."[7]

Marcel Duchamp's *Anemic Cinema* (1926) seized precisely on this aspect of film – its aesthetic void – through an extraordinary hyperbolization of both the spatial illusion of depth it achieves and the flat screen space of its projection. *Anemic Cinema* literalizes and cartoons the material workings of silent cinema – its mix of palpable three-dimensionality and the obligatory book-space passages of intertitles – suggesting a Faustian bargain in which the medium sacrifices interpretive depth for the visceral illusion of depicted depth. For Duchamp the cinema is a bloodless body, a spectral presence that has been robbed of both interiority and aesthetic dimension.

The legacy of Duchamp's critique can be seen in a number of underground films of the sixties and, in particular, in the interest in "expanded cinema" forms that developed powerful renunciations of the necessity of illusionism. These films activated the space of projection and by emptying the content of the image focused attention on the presentational rather than the representational. Tony Conrad's stroboscopic *The Flicker* (1966), for example, which had its origins in the arena of Fluxus and concrete music, introduced a singularly

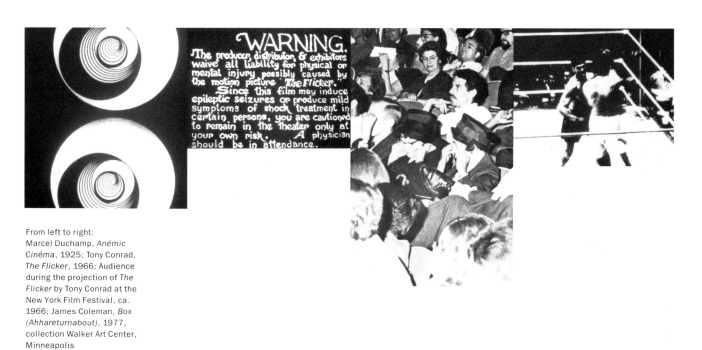

From left to right:
Marcel Duchamp, *Anémic Cinéma*, 1925; Tony Conrad, *The Flicker*, 1966; Audience during the projection of *The Flicker* by Tony Conrad at the New York Film Festival, ca. 1966; James Coleman, *Box (Ahhareturnabout)*, 1977, collection Walker Art Center, Minneapolis

non-illusionistic and yet powerfully kinetic film form. A similar cinema was referenced in Peter Kubelka's ironic, imageless "portrait" film *Arnulf Rainer* (1958–60). The imageless cinema has remained an area of particular interest to both visual and conceptual artists beginning with the "white films" of Takehisa Kosugi and Nam June Paik in the sixties and continuing with more contemporary works such as a totally overexposed "landscape film" by the Belgian artist Mark Luyten or the late English artist and filmmaker Derek Jarman's sublimely monochromatic autobiography *Blue* (1993).

Such film projects may have engaged issues of representation and materiality germane to the visual arts, but they have entered the museum only occasionally and, of course, "en passant." On rare occasion, a film has managed to make it intact into the gallery – in the form of an installation, of course – as is the case in the Walker Art Center in Minneapolis with the recent acquisition of a piece by the Irish artist James Coleman entitled *Box (Ahhareturnabout)* (1977). The work consists of a continuous projection of a five-minute film loop made by adding segments of black leader to appropriated newsreel footage of a 1927 boxing match between Jack Dempsey and Gene Tunney. By adapting some of the extra-cinematic aspirations of expanded cinema, Coleman's rectified found footage creates a compelling metaphor for the experience of the medium. The presentational assaultiveness of the flicker highlights the materiality of the

projection while the representational assault captured on the original footage metonymically references the *Core*-narrative of all illusionist cinema in the conflict of the boxers. But *Box* equally describes its own physical dimensions, which mime in miniature the specifications for all cinemas: the piece's sculptural dimension as a spatial configuration – an installation, a container, a "box" – brings spectator and spectacle together. It is here that the final element, the work's soundtrack, comes into play, introducing both the mediating figure of the artist (whose hoarse voice and breathing are heard throughout the piece) and the presence of the machine (given voice through a rhythmic thud marking each shot transition). Together, these announce the work's attempt to realize an enduring metaphor of avant-garde cinema in which this most exterior of art forms provides access to the depth of an artist's interiority and consciousness. In *Box*, as we watch an external historic moment flash past, we are simultaneously privy to the excited, libidinous voice of the artist responding to the imagery in a manner that is powerfully suggestive of the process of inner speech – that ongoing inner dialogue that gives voice to consciousness and maps the moment-by-moment attempts to interpret actuality within the matrix of memory and anticipation. At such moments, we are accorded an aesthetic experience as rich and varied, as visceral and intellectually engaging as those proffered by the paintings and sculptures in the adjoining galleries of the Walker Art Center.

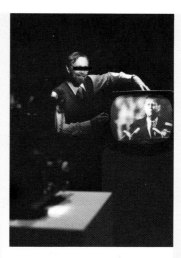

From left to right:
Portrait of Jack Smith, 1972; Joseph Cornell, *Andromeda (Sand Fountain)*, 1953-56, collection Walker Art Center, Minneapolis; Bruce Conner, *Television Assassination*, 1963-75, installation view at the Walker Art Center, Minneapolis, 1988; Chieko Shiomi, *Disappearing Music for Face*, 1965-66

8. Margaret Morse, "Video Installation Art: The Body, the Image, and the Space-in-Between," *Illuminating Video*, op. cit., note 2, p. 166.
9. Ken Jacobs, "Program Notes," *Films That Tell Time: A Ken Jacobs Retrospective*, ed. David Schwartz (Astoria: American Museum of the Moving Image, 1989), p. 16.

Temporality. Film is as much a temporal art as it is a visual one. Within the simplest linear narrative, there are at least four determining temporal layers including the story time, the time of its telling, the time of production, and the actual running time of the film. This multiple temporality is shared by video and remains one of the fundamental constraints on the reception and integration of film, video and their installation forms into the galleries of art institutions. Media scholar Margaret Morse notes that "as a spatial form, installation art might appear to have escaped the ghetto of time-based arts into the museum proper," but even with the privileging of the visual over the temporal and the reduction of video elements to brief repeating cycles, moving-image installations maintain a temporality at odds "with the dominant mode of perceiving in museums and galleries."[8]

One of the first artists to address the issue of de-temporalizing the cinema was the American Joseph Cornell. In his first collage film, *Rose Hobart* (1939), Cornell attempted to counter the dominant cinema's temporal structures, grounded as they are in Aristotelian unities (space, time, action), theatrical dramaturgy (conflict, repetition, resolution), and the patterned narrative of folktales (equilibrium, disequilibrium, equilibrium). Made by radically reediting a Hollywood B-film, *East of Borneo* (1931), which features the actress Rose Hobart, substituting recordings of Caribbean-style dance music for the film's original soundtrack, and tinting the black-and-white footage a roselike hue, *Rose Hobart* reverses the typical relationship between décor and narrative (where the former is exhausted in its service to the latter) and shifts attention from plot and story to gesture, costume, and set design in creating a de-plotted, reversible meditation on the image.

This interest in film as décor is taken up again in the work of experimental filmmakers in the fifties and early sixties, particularly in the underground films (or what Jonas Mekas presciently termed the "Baudelairian" cinema) of Ken Jacobs, Ron Rice, and Jack Smith. Their work – particularly Smith's notorious *Flaming Creatures* (1963) – met with almost immediate resistance: they were as likely to be banned from the avant-garde circles at Knokke-Heist as busted by the New York City vice squad. This criminality had less to do with the depiction of male nudity and more to do with a full frontal assault on linearity, coherence, and closure. Films like Jacobs's *Blonde Cobra* (1958-63), Rice's *The Queen of Sheba Meets the Atom Man* (1963), and Smith's *Flaming Creatures* were by turns fragmented and endless, obsessive and detached. Jacobs best characterized such work in terming *Blonde Cobra* "an erratic narrative – no, not really a narrative, it's only stretched out in time for convenience of delivery."[9]

A converse development in temporality, which also derived from Cornell, brought visual artists out of the gallery and into the cinema. The American painter Robert Breer, for example, conducted experiments (including *Image by Images I* (1954), a

From left to right:
Fluxfilm loops, viewer and reel, ca. 1966, Yoko Ono, *Fluxfilm no. 16: Number Four*, ca. 1966; Otto Preminger directing *Rosebud*, 1975; Claude Monet at work in his studio at Giverny, 1913

10. Op. cit., note 3.

film loop in which every frame contains a different image) that temporalized his abstract compositions and led him into a career in experimental animation. The West Coast artist Bruce Conner began inserting found film material as objects into his sculptures and subsequently devoted much of his career to the production of collage-based experimental films. In addition to his reinvigoration of the found-footage film (a form that he redefined in his seminal *A Movie* (1958)) and prefiguring by two decades the emergence of music videos, Conner produced a key film installation, also recently acquired for gallery installation by the Walker Art Center, that may well emerge as the missing link between artist film and video art. *Television Assassination* (1963-75) consists of an 8mm film projected onto the whited-out screen of a vintage fifties television set that repeats in slow motion footage of the televised assassination of Lee Harvey Oswald, a shooting that appeared choreographed for the camera and which captured the tele-attention of the United States. Like Andy Warhol's use of serialized imagery in works like *16 Jackies* (1964), Conner probes the formal aspects of the medium – its reproducibility, its endless repetitive potential – to create a work that extends the implied temporality of Warhol's painting into a concrete temporality in the gallery space. By opting to explore these issues within the context of the originating moving-image media, and thereby effectively short-circuiting the art making/art marketing network, Conner anticipates Dan Graham's early work with mass-circulation publications.

Collaborative Production/Multiple Products.

The social historian Arnold Hauser recognized the challenge that film production posed to artists – namely the "unusual and unnatural" situation of an artistic enterprise based on cooperation – and pronounced it "the first attempt since the beginning of our modern individualistic civilization to produce art for a mass public."[10] While Hauser based his speculations on the workings of the commercial cinema, even a noncommercial, independent film made by an individual artist for a modest sized public involves some measure of collaboration at each level of production – from the chemistry of the emulsion on the film stock to the optics of the camera lens to the lab work of developing and printing versions (work prints, answer prints, release prints) of the finished work.

The collaborative origins of the medium are matched in the nature of the finished work, which consists of unlimited multiples. Walter Benjamin prophetically read this aspect of the cinematic enterprise as changing the very nature of the work of art. It did not, however, change the nature of the art marketplace. It is not surprising, then, that film would be embraced most readily by artists associated with a loosely collaborative movement like Fluxus, which often engaged in comic combat with the forces most resistant to the Benjaminian shift, namely the commercial galleries, private and corporate collectors, and art museums. Fluxus impresario George Maciunas, who had overseen the production and assembling of several dozen short

From left to right:
Jerry Lewis, *The Bellboy*, 1960;
Robert Rauschenberg, *Monogram*, combine, 1955-59, collection Moderna Museet, Stockholm; René Clair, *Entr'acte*, 1924; Marcel Duchamp, *Monte Carlo Bond*, 1924, collection Galleria Schwarz, Milan

Fluxfilms, recognized the corrosive potential of film when, in attempting to find something of scale to install within the gallery spaces for exhibitions, he proposed in 1967 a multiscreen film-installation piece, a Fluxus *Film Wallpaper*, which would bring together within a single viewing area loops of the Fluxfilms, works that had already registered a significant assault on convention.

A different type of collaboration is evident in filmmaker Chantal Akerman's massive film and video installation *From the East*. Based on *D'Est* (1993), her feature-length observational film that focuses on aspects of daily life within countries of the former Soviet bloc, the work engages in a dialogue about film and ideology. Although conceived as a gallery-based, artist-produced work, Akerman, in choosing to speak in the language of the cinema, has had to make use of both the technology (cameras, tape recorders, lights, dollies, cables) and techniques of the collaboratively produced film. This is not, therefore, sculpture that contains moving images, but rather a movie (with all that practice connotes) reconceived and deconstructed for spatial contemplation within the gallery.

In the early eighties, the French director Jean-Luc Godard participated at the Walker Art Center in a dialogue about his films in which he screened excerpts of his work along side clips from several Hollywood films. Following the presentation, someone in the audience raised a hand and acknowledged the significance of Godard's work but questioned the logic of including the American films he apparently found sadly lacking – the work of Otto Preminger being dated and boring, and Jerry Lewis seen as silly. Godard responded that the questioner was mistaken and that his own films were barely equal to the ones by the Hollywood directors. He concluded with an analogy, appropriate for the event's setting within an art museum: "Otto Preminger … is Monet," he proclaimed. "And Jerry Lewis … is Robert Rauschenberg."

Such a perspective, however extreme, can lead, nonetheless, to speculation on the expanded exhibitions (not to speak of art histories) possible when film enters the gallery – when René Clair and Luis Buñuel rejoin Marcel Duchamp and Max Ernst; when the kinetic abstractions of Mary Ellen Bute and Oskar Fischinger are shown with the canvases of Jackson Pollock; when Frank Tashlin's satires mingle with Robert Rauschenberg's combines; when Paul Sharits's kinetic film installations are placed adjacent to the lightworks of Dan Flavin and James Turrell; when the works of Hollis Frampton converse with the texts of Joseph Kosuth; when the visual practice of Man Ray, Fernand Léger, Charles Sheeler, Paul Strand, Joseph Cornell, William Klein, Andy Warhol, Wallace Berman, Dieter Roth, Alfred Leslie, Bruce Conner, Jan Dibbets, Marcel Broodthaers, Lawrence Weiner, Richard Serra, Joan Jonas, and Kiki Smith reconnects with their filmmaking; when modernity and postmodernity are animated by the vitality of the seventh art.

From left to right:
Hollis Frampton, *A Cast of Thousands*, 1961, estate of the artist; Joseph Kosuth, *Untitled (Art as Idea)*, 1968; William Klein filming *The French* at Roland Garros stadium, Paris, ca. 1981; Andy Warhol, *Blow Job*, 1963

STAN DOUGLAS

SCREEN OFF-SCREEN

DIANA THATER

The work of Stan Douglas and Diana Thater was shown at Witte de With, from 10 September until 30 October 1994. As the catalogue *Stan Douglas* (published in conjunction with this exhibition at the Musée national d'art moderne, Centre Georges Pompidou) fully documents his works presented in the exhibition, we have chosen to document in this *Cahier* only works by Diana Thater.

The idea of presenting the work of Stan Douglas and Diana Thater together was inspired by both the similarities and the differences found in their work. Their exhibition at Witte de With played off interior against exterior, opacity against transparency, film against video, black-and-white against color, image against sound, and screen against off-screen.

Stan Douglas, who is primarily known for his representation of the history of television and cinema, presented installations in Witte de With that transformed the exhibition spaces into cinema theaters. In his works, which evoke the first film screenings, Douglas speculates upon the relationship between the artwork and reproduction technology and between culture and the world of entertainment.[1]

Diana Thater creates spatial videographic works that explore the relationship between film and architecture while referring to the importance of the nineteenth-century panorama, the representation of landscape in the Western, and the imaginative power of experimental film. She investigates and tests the architecture of the cinema, as described by the French philosopher Gilles Deleuze with the notions of image and movement/image and time, so that spatial time enters, both literally and figuratively, into a relationship with filmic time. At Witte de With Thater's video projections transformed the exhibition space into a Deleuzian "smooth space," into a rhytmic space without size or border.

Stan Douglas's work *Hors-champs* (1992) which literally means off-screen, acted as the exhibition's keynote piece, the works of Thater and other works by Douglas being installed around it. *Hors-champs* presents the performance of four American musicians living and working in France during the revival of Free Jazz. It was shot *en direct* by Douglas in the style of French television productions from the sixties. While such television productions typically used four or five cameras, *Hors-champs* was shot with only two. This accounts for the contrast, almost abstract, composition of the black-and-white images. The takes are simultaneously presented on the front and back sides of a screen. On one side of the screen is the final montage of the footage, while on the other is a simultaneous counter-narrative of the left over images. The expression "hors-champs" is taken from the antithetical film theory term "champs/hors-champs," which can be translated as "screen/off-screen." In an essay comparing the filmic image with the video image, the Dutch film theoretician and architect Maurice Nio defines the term in a way that perfectly sums up this exhibition:

To connect thinking to the outside in order to break through the frame and through the codes of thinking, that is the political economy of longing. To connect the image to the outside in order to break the frame, that is the politics of film.

The longing to "paint the painting and the wall simultaneously" is the longing to film the image and the off-screen simultaneously. To connect to the outside or to the off-screen means: to connect to the imaginary space in which actions, sounds and voices reverberate, to connect to the mythical space of fiction. Fiction is the name of the surface that became volume and of the image that broke through its own frame in order to accomplish an immediate relationship with the outside. Everything depends on the frame. The frame is the intermediary that creates the tension between screen and off-screen. That is fiction. But is that video?

Are fiction, reflection, suggestion, suspicion, all notions that depend on the tension created by the frame, still applicable to video? Or: can a video image be connected to an outside? Gilles Delavaud (in a conversation with Raymond Bellour) says: "What is striking in some videotapes is the absence of solicitation from the off-screen. Movements, for example, that loom up from the center of the image, swelling out as it were, ebb to the edges of the frame. Sometimes you get the feeling that the television screen looks at you and that the entire tension of the gaze is defined by what is shown on the screen in front of you." Two things are crucial here: the privilege of the gaze is lifted (you are looked at by the television screen) and the fictitious space of the off-screen has disappeared (all tension is directed at the television screen itself). The disappearance of this privilege and this fictitious space is caused by the absorptive power of an electronic medium: the video image is implosive, absorbing the gaze even before an off-screen can come into being while the filmic image is always expansive, swelling out to grant the gaze time to observe, and to grant the mind time to suspect. The one absorbs, the other reflects: that is the main difference between a tactile and a visual medium. And with this difference, the stakes change. Bellour already pointed out that it is no longer about depicting a representative or narrative space, but about exploring the internal transformations of the image itself. Filmmakers have always blamed video for this narcissism, this uninvolvement with the outside world (regardless of whether it concerns video art or video clips). The reason why is obvious. Electrons don't dream of connections to the outside.

But if the video image no longer recognizes the off-screen, why do we speak of a screen, of an "inside," of a center or a source from which the movements originate? Because in fact only the frame of the image remains. But how does this look, this image without screen or off-screen? (...)

The screen still accommodated reflection. The off-screen still accommodated desire. That was the scene of the subject and its subjective projections. The screen is no scene, it is a staggering surface; it accommodates disappearance. And it is pointless to position semiotic, psycho-analytic, or filmic definitions against such an emptiness (Fargier's fiction, Bellour's Wunderblock). One only has to shift one's attention to the edges of the screen, to the crystallization points, the focal points of the medium, to understand something about this sensorial sphere in which the video image is conspicuous by its absence.[2]

1. The exhibition of Stan Douglas was realized in collaboration with the Musée nationale d'art moderne, Centre Georges Pompidou, Paris. For a description of the works presented in the exhibition, see *Stan Douglas* (Paris: Musée national d'art moderne, Centre Georges Pompidou, 1994).
2. Maurice Nio, "Video-off," *Skrien*, no. 143 (1985) pp. 40-41.

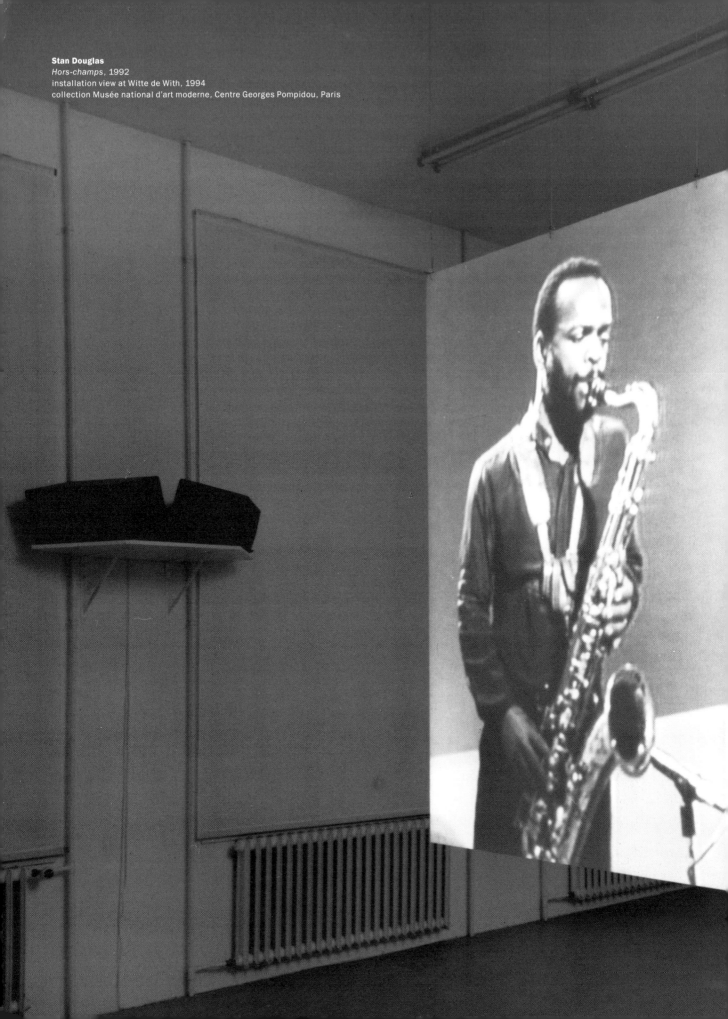

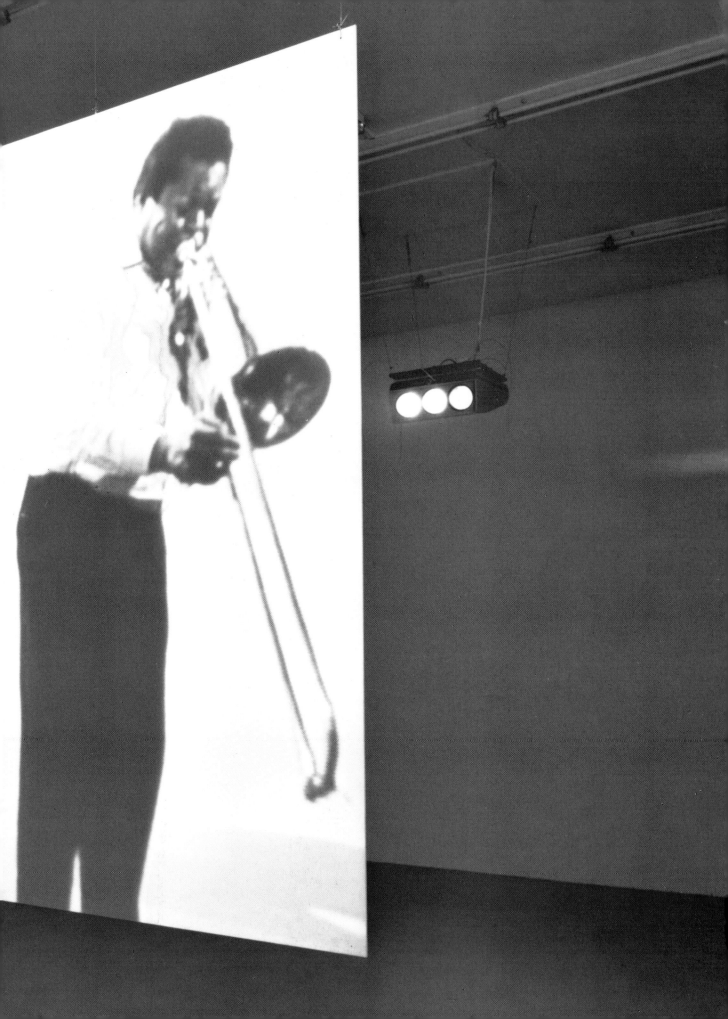

The Bad Infinite
video installation, 1993
3 SONY VPH-1000QM video projectors, 3 PIONEER LD-V2600 laserdisc players, 3 laserdiscs, sync. generator, film gels and existing architecture
30 minutes; dimensions vary
courtesy of the artist and 1301, Santa Monica & David Zwirner, New York

The *Bad Infinite* was made in January 1993 in the Sequoia National Forest in California. The images were shot at the same time by three identical Hi-8 cameras, all attached to a horizontal tripod that was carried through the forest. Thus, the first camera films the landscape ahead of it; the second films the same scene and the first camera; the third camera records the landscape, the second camera, as well as the people carrying the makeshift tripod. Each tape is separately projected in one of the component colors of video: the first is seen only in blue, the second in red and the third in green. The images are superimposed over one another so that certain parts of the images will at times line up while others will not. The resulting image is a cacophony of blue, red and green, each subsequent color adding more information to the image. Each projected color is farther away from the horizon than the one in front of it, so the image recedes away from the viewer into the false depth of video but also appears to recede into the exhibition space, with the objects getting smaller as they get closer to the viewer.
The way in which Thater recorded and then reconstructs in the installation the landscape of the giant Sequoias evokes all of the colors of the video spectrum. Movement and time separate themselves in a work which simultaneously constructs itself and comes apart again before the viewer's eyes.

Pape's Pumpkin
monitor piece, 1994
2 SONY PVM-2130QM video monitors, 2 SONY LDP-3600D laserdisc players, 2 laserdiscs, film gels and existing architecture
1 minute 48 seconds and 10 minutes; dimensions vary
private collection, Philadelphia

This work was made in the National Elk Refuge in Jackson, Wyoming, in February of 1994. The camera follows a large male elk who looks at the camera and then wanders away, revealing two young male elks behind him, play fighting and locking antlers. The original tape was divided into its red, green and blue components, and then the three tapes were edited together frame by frame. Since video frames move too quickly for the human eye to see, the image, though in rotating colors, appears to be in flickering black and white. On the second monitor the same tape is played but at a fourth of its original speed; as a result the color changes are just long enough for the human eye to see.

The Holy Mountain
monitor piece, 1994
SONY PVM-2130QM video monitor, SONY LDP-3600D laserdisc player, laserdisc, film gels and existing architecture
26 minutes; dimensions vary
private collection, Antwerp

This work is made up of a single shot of Mount Wilson in Altadena, California. The mountain divides the screen into thirds: the mountain is the middle third, the sky is the upper third, and the foreground is a golf course.
The red, green and blue component colors of the video image were separated onto tapes. The three separate tapes were then rolled at different speeds. The red plays at normal speed (real time), the blue plays at half speed and the green plays at one sixth of the original speed. When the three colors come together in the final image, everything which is stationary, the mountain and the trees, remains in black and white throughout; while the clouds move, each at a different speed, revealing all of the colors of the video spectrum. Movement and time seem to separate themselves.

Late and Soon, Occident Trotting
video installation, 1993
4 SONY VPH-1000QM video projectors, SONY LDP-3600D laserdisc player, laserdisc, film gels and existing architecture
30 minutes; dimensions vary
collection of The Bohen Foundation, New York

This work was made in the fall of 1993. The recordings show four movements through landscapes in the East and West of the United States: the Brooklyn Botanical Gardens and Blydenburgh State Park, in and around New York; Heckshire State Park on Long Island; and the environs of Malibu, California, after the fires of 1993.

The work is made with four projectors all wired to a single laserdisc player. The projector in the first room is set out of register so that the three lenses do not match up perfectly. This causes the image to break down into its component parts: red, green and blue. The image is visible and readable, but multiple: what is one breaks down into three.

The three projectors in the second room project the same image. Each has only one lens turned on: one projector for the red lens, one for the green, and one for the blue. An attempt has been made to register the three projectors together, so that they form one complete color image. This is impossible because the lenses are too far from each other and only the center can actually be registered. As the image radiates out from the center, the distance between the colors increases. The projectors attempt to reconstruct the image which is taken apart by the projector in the first room: what is three attempts to become one.

The work is named for the horse photographed in motion by Eadweard Muybridge as a part of his series *Animal Locomotion*. Thater films, as it were, from the viewpoint of the moving horse, suggesting that in order to view a work of art which is in motion the viewer must also be in movement through the space and thus through and within the work of art.

Abyss of Light
video installation, 1993
3 SONY VPH-1000QM video projectors, 3 VHS video players, 3 VHS videotapes, film gels and existing architecture
30 minutes; dimensions vary
collection of Wilhelm Schürmann, Herzogenrath

Each projector shows a different tape. In the first act, all three images form a panorama in red, blue and green of Bryce Canyon in southern Utah. The second act consists of one hundred seconds of tape: each second is a separate, iconic image of Monument Valley and the landscapes in the Southwest of the United States. Each projector shows the one hundred seconds at a different speed. The green projector plays them in real time, the red in half time and the blue in one fifth of real time. The work concludes with the three images once again forming a panorama, this time of Death Valley.

This work is meant to quote the desert Westerns by John Ford, who, like no other director, was able to represent the landscape of the West. Thater's images of Monument Valley are shot from "John Ford Lookout." *Abyss of Light* is about the artist's inability to see the West as John Ford saw it. "For me, unlike John Ford, no single shot, no single vantage point captures the West. Every shot is the shot, and I can't decide which is the icon." As in Ford's work, the landscape becomes a theater of memory. In presenting her work, Thater often uses film gels to darken windows. In this way, she makes her projections visible during the day while playing with the transparency and opaqueness of the existing architectural space. The effect is that sometimes the interior seems to become exterior, and that the exterior seems to become interior. After hours the lights in Witte de With, which are off during the exhibition, are turned on so that the gels covering the windows in the colors of the video spectrum are visible from the street, projecting out of the building and coloring its facade.

Indexes, 1990-94

"I never really tried to explain the meaning of the indexes. I guess that's because they are true stream-of-consciousness laundry lists of ideas and people – some are real and some are fake. ... In one of the indexes Mary Shelley gets mixed up with a fictional female explorer of the American West, named Jane Muir, and all sorts of bad things happen. I suppose that the indexes provide narrative lines for the video projections. Movies have to have stories, so these are my stories."
(Diana Thater, August 1994)

Diana Thater
Witte de With Architectural Model, 1994
courtesy of the artist

opposite page:
Witte de With, Rotterdam, 1994

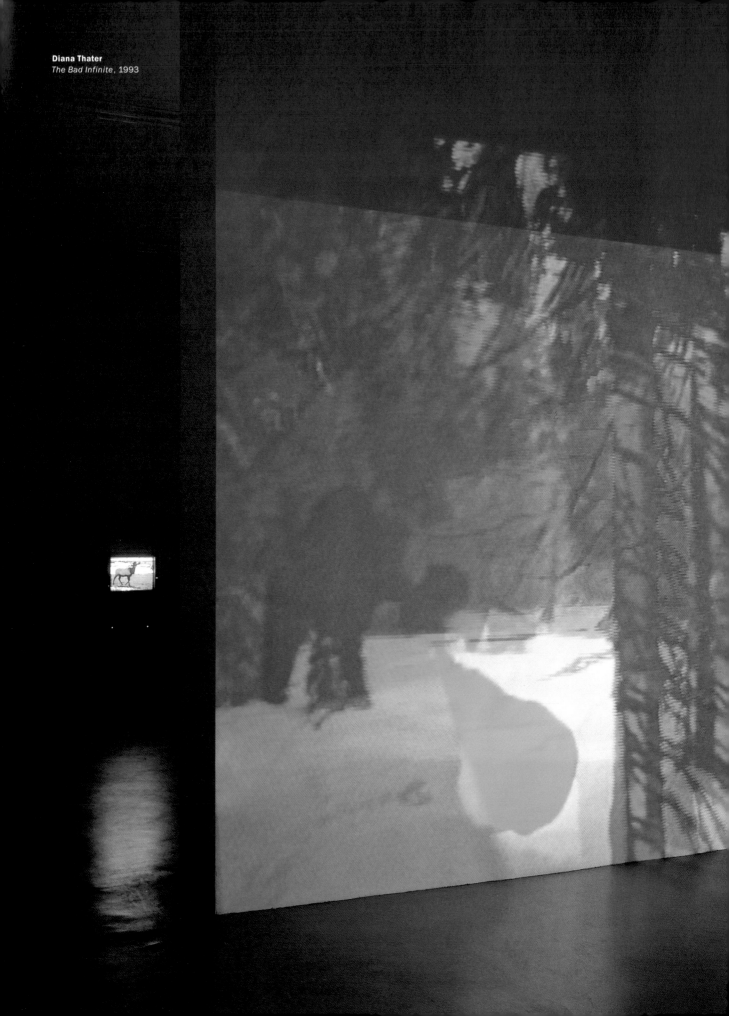

Diana Thater
The Bad Infinite, 1993

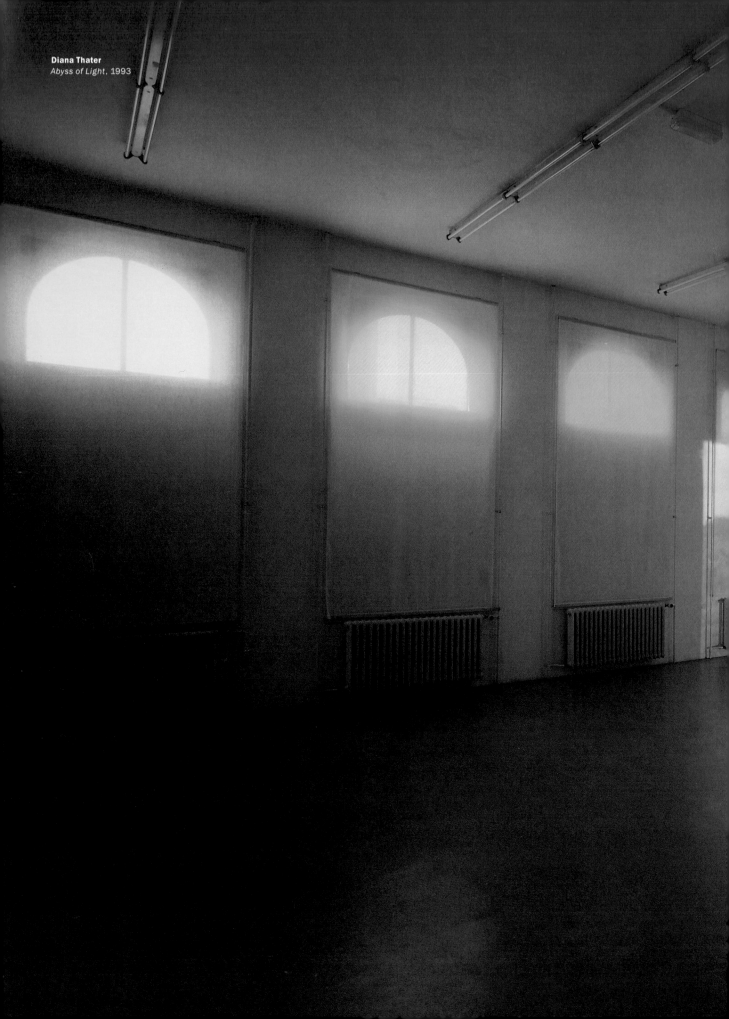

Diana Thater
Abyss of Light, 1993

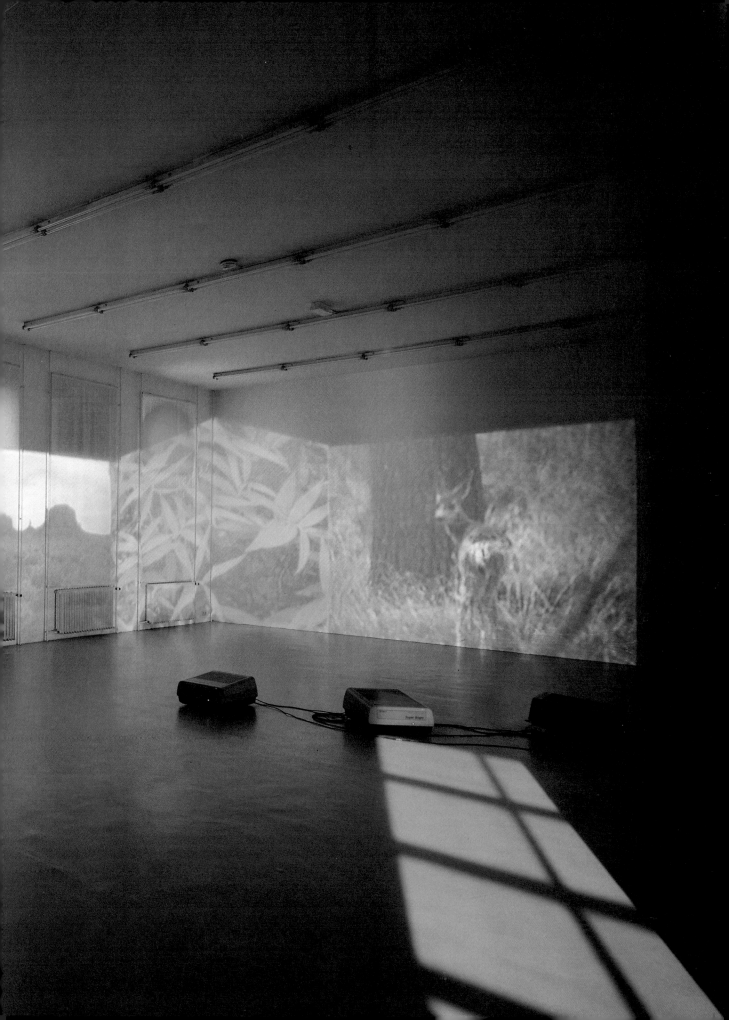

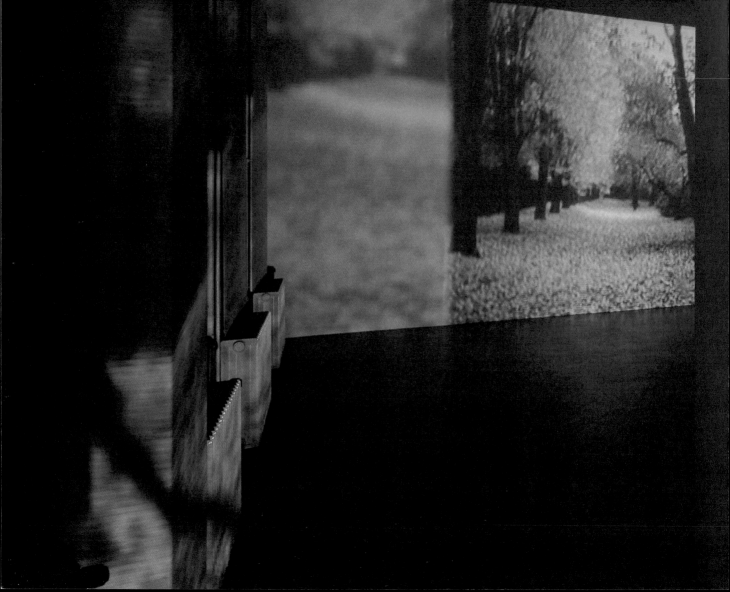

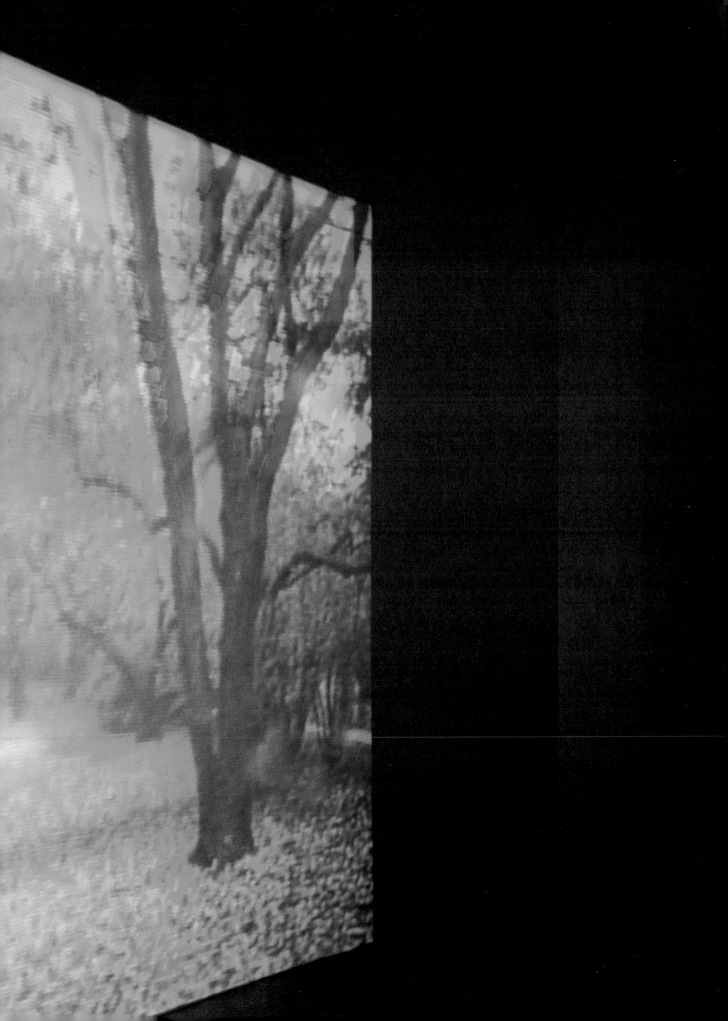

Occident,
cutting,
running,
standing,
trotting,
walking,
backward,

What Cyan said to Magenta about Yellow (Notes from the Apparatus on the Work of Diana Thater)

Timothy Martin

This essay had been originally conceived as a lecture that was to be given in conjunction with the exhibition Stan Douglas & Diana Thater, shown in Witte de With from 10 September until 30 October 1994. Timothy Martin is an artist and writer.

1. Jacques Lacan quoted in Jean-Louis Baudry, "The Apparatus: Metapsychological Approaches to the Impression of Reality in Cinema," *Narrative, Apparatus, Ideology*, ed. Philip Rosen (New York: Columbia University Press, 1986), p. 317.

Knowledge of El Greco's astigmatism, which is typically acquired well after an appreciation for the vertiginous compositions of his canvases, presents the viewer with an insoluble puzzle that becomes permanently entwined with the viewer's perception and judgment of the work. We are told that El Greco never overcame the defect of his vision, and this certainly must be true, astigmatism being a permanent spherical distortion of the cornea or lens that develops as the eyeballs grow. Instead, we are told, El Greco took over his astigmatism and used it, saw with it rather than in spite of it, and somehow this has implications for the peculiar signature of his "vision." If this indeed was the case, we must regard his vision separately from the generalized vision of mannerism. His astigmatic eyes are not just a metonym for stylistic affect, or a symbol of personal affliction, like August Strindberg's bleeding hands; they are a specialized machine. The factuality of El Greco's astigmatism and its (supposed) affirmation in the ocular distortions of his paintings, redefines his affliction as a literal apparatus, one that both "sees" and "projects" from the place of the viewing subject. By virtue of its deformity, the apparatus ceases to be a neutral term in the genesis of the image and cannot be taken for granted.

For all its factuality, however, we cannot actually find this apparatus, much less see with it and describe its function, and a materialist course of reduction will not lead us to it as it would to the paint and support of the canvas. Nor can we infer it formally; we can only imagine it through what we judge to be its affects, a judgment which is likely to be presumptuous if not utterly groundless: i.e., the spherical distortion of the painted image follows from the spherical distortion of the eye. Thus the factuality of the apparatus yields no material evidence or certainty of its function. And interpretation fares little better. Do we dare assume that the ectoplasmic clouds and garments depicted in *The Agony in the Garden* appear qualitatively similar because that is how El Greco literally perceived them, or that his bad eyesight forced him to substitute his understanding of fabrics for direct experience of distant and unfocusable atmospherics? We expect the apparatus to be evident in some form, but everything it might constitute as visual meaning is cast into doubt. Everything, that is, except that a distinctly other viewing subject – perhaps religiously ecstatic and visually impaired – has been proposed in place of our own accustomed point of view.

We can, however, stand in front of the painting and look at it for awhile. In so doing we may occupy the position of the distortional apparatus – albeit, with our own correctional one. The usual condition of transparency, the assumption of the other's eyes by our eyes, is interrupted by what we "know": that the painting is, in a sense, not for our eyes. We are presented with a kind of ontological doubling: one point of view occupied by two constituting subjects. Because we cannot see through this interruption, we move around it and enter a circuit of pursuit and reflection vis-à-vis the grounds of the subject – our own vertiginous swirl – which often seems like a process of splitting. Pursuing the astigmatic apparatus, we address what the image shows us and realize we cannot judge it formally, as that presumes we know what the apparatus does and can distinguish what it does from the formal traits of mannerism in general, which, it is safe to say, were not produced by an epidemic of defective eyeballs. When we eliminate this presumption and treat what the image shows us as phenomena, we realize we will eventually only affirm our own correctional apparatus and discover nothing new. The circuit becomes a knot of analysis and perception. Whenever we try to tether it to a secure starting point, which can be neither material nor phenomenal, we keep returning to the droning restatement of a historical fact: *El Greco had an astigmatism. …* The fact insists upon the actuality of the apparatus and the materiality of its effects – which seems quite reasonable – but it appears we can neither locate them nor trace a causal link between them without first translating the whole analysis into a kind of narrative.

Of course, some of these problems and confusions result from applying the terms of the cinematographic apparatus to a somewhat inhospitable example, and allowing those terms to exercise their reductive tendencies. But, to the extent that the choice of the example and the terms is problematic, it is also deliberate. The confusions that arise from the overemphasis on the apparatus are by no means exclusive to this example. They are part of a general confusion found in the optical model of the subject, which has for at least a half-millenium derived its sense by transposing material for subjective terms, the eye for the self, and of which the cinematographic apparatus is but one recent technical elaboration. When Jacques Lacan writes, "the subject is an apparatus" – a statement seized upon by film theorist Jean-Louis Baudry – it is implicit that the apparatus in question is fundamentally optical in character and that the subject is on some level reducible to it.[1] However, the confusion that arises when a reduction to the material apparatus and a reduction to the "apparatus" of perception are intermingled has special relevance to the subject of this text (the

2. The term "structural film" is usually attributed to P. Adams Sitney, whose book *Visionary Film* (Oxford University Press, 1974) includes a chapter on the films of Michael Snow, George Landow, Hollis Frampton, Paul Sharits, Tony Conrad, Ernie Gehr, Joyce Weiland, and others. The general term "structural" also applies to numerous video works of the first generation including those of Peter Campus and Dan Graham. While it may imply minimalist, deconstructive, and phenomenological methods and concerns, it is not intended to connote a direct philosophical affiliation with French "structuralism" per se, although a number of the artists were conversant with that movement.

3. *Oo Fifi Part 1* was installed at 1301 (gallery) in Santa Monica, California as part of the group video exhibition *Into the Lapse*, 1992.

video-projection work of Diana Thater) because it recalls the segment of experimental film history, known generally in America as "structural film," which is to a significant degree reappraised in Thater's work.[2] Considering Thater's employment of a kind of "defective" optical apparatus and distorted image, the leap to El Greco's astigmatism is not all that great – although it requires rigid distinctions between artistic media to be loosened or put aside, as will many of the points made in this text. In Thater's work one often finds a dividing or multiplying of the place of the subject, keyed in part on the distortion of recognizable images. One also encounters a collision of materialist and phenomenological "reductions" of the medium – virtually encapsulating two dominant and interwoven threads of structural film and video – although this collision ultimately leads to collapse. The terms of both analytics (image-as-material and image-as-perception) are called into question and held accountable to a broader, more heterogeneous definition of the site of spectatorship.

In 1991, while taking part in an artist-in-residence program sponsored by the Claude Monet Foundation, Thater videotaped a series of solo walks through the garden at Giverny. These camera studies, covering three consecutive seasons of the garden, were edited into a feature-length videotape for the two-part projection installation, *Oo Fifi: Five Days in Claude Monet's Garden* (1992). A number of Thater's recurrent strategies and themes are succinctly demonstrated in this work and warrant some description. In Part One,[3] the video projector is placed diagonally on the floor of the gallery with the image frame covering the opposite wall, corner, and adjacent wall, as well as two exterior windows. The window panes are covered respectively with semi-opaque and fully transparent grey theatrical gels, allowing the room to be partially illuminated by natural light and offering, in one window, a clear view of the vegetation outside: a window on the world sharply contrasting that of the projected image. As is often the case, Thater alters the projected image not with an electronic video processor – the weapon of choice for much technophilic video art – but with a screwdriver and some elbow grease. The red, green, and blue projector lenses are taken out of normal calibration, separating – or multiplying – the image into three otherwise identical monochromes. While they illuminate the surface of the wall, drawing attention to its physical detail and materiality, the three proximate moving images are themselves too far out of registration for the most part to be resolved as "intentional objects" or scenes by the viewer, and remain *derealized*. Thus a rift between the "screen," the thing-in-the-image, and the technical apparatus that would constitute it is forcibly maintained, shifting the gage of thingness in the work away from the image, back to the site and to the video apparatus itself.

Diana Thater
Oo Fifi Part 1
installation view at 1301, Santa Monica, September 1992

4. The two parts of *Oo Fifi* were originally intended to be shown as a single work, but had to be separated due to spatial limitations. *Part 2* was installed at Shoshana Wayne Gallery in Santa Monica, California, as part of the group exhibition *Very, Very, Very*, 1992.

5. According to Bertram Lewin, the dream screen is the surface on which a dream appears to be projected. Lewin further hypothesizes, after Freud, that the dream screen is the dream's hallucinatory representation of the mother's breast on which the child used to fall asleep after nursing. Baudry makes the connection between Lewin's dream screen and the cinematographic apparatus. See Baudry, op. cit., note 1, pp. 310-311.

6. Peter Wollen, *Readings and Writings: Semiotic Counter-Strategies* (London: Verso Editions, 1982), p. 197.

Oo Fifi Part 2, installed separately from Part One, was a technical inversion of it, although a similar set of terms was present.[4] An array of three separate projectors running from the same tape source, each with one lens turned on (one red, one green, one blue), project a composite image on an adjacent pair of interior walls. The three monochromes are aligned at the center and within a small area of exact pixel convergence produce a black-and-white image. But, because they are projected from different angles, the images progressively drift out of registration as one moves from the center to the edge, creating a vortex of image and color coherence. The picture – imagine impressionism suddenly drugged with futurism's love of speed – doesn't end with its distortions, however. Besides the blur and irresolution on the side of the image, the distortions produce a distinct sense of flux and ulteriority on the part of the viewing subject, keyed on the three separate horizons created by the projector array. This is at first a haunting effect not readily traceable to the condition of the image itself. The vortex gives the impression of spatial depth that pulls the viewer into the image, particularly when the camera is panning or moving through the garden. Combined with the bucolic allure of the scenery, which is more resolvable here than in Part One, it offers a familiar invitation to cinematic *jouissance* or, as Baudry has called it, "archaic satisfaction:" the pleasure of a secret garden.

The conditions for cinematic viewership and fantasy have often been characterized in these general (infantile) terms: a state of bodily immobility (immaturity, undifferentiation) combined with an acute absorption with the visual (fixation upon the breast or *dream screen*).[5] Under these conditions, the cinematic hallucination may attain the status of the more-than-real, the real of the dream image, or of a fully empowered second consciousness. This, of course, is resisted in Thater's installations with what one might view from a cinematic perspective as degrees of unpleasure, that is, distraction from the dream. What Thater's work gives with one hand, it soon takes away with the other. As in *Oo Fifi Part 1*, the image does not deliver the flower, but a heady phantasm encoded with the conditions of its receivership and production. The work may in a sense be absorbed with the visual – no soundtrack, no conventional narrative – but it is never fixated solely upon the screen or confined to a darkened chamber – no womb-with-a-view – thereby immobilizing the viewer. Freedom of visual egress and bodily mobility are fundamental determinants of Thater's work.

In *Oo Fifi Part 2*, for example, as the three diverging horizons register their inclination toward as many ulterior subjects, the viewer may mentally follow their lead and indulge a sense of being multiple or divided, or of being permeated by the image's multiplicity. Physical mobility contributes to this, although quite differently than the effect of the image horizons. Walking midway between the projectors and the wall the viewer's body casts shadows that never quite block the projected image, because there is always a projector or combination of projectors that remain unobstructed. The shadows, diverging in three directions, appear only as shifts of color in the image, equivocating more than attesting to the solidity of the viewer's body. While the body, triplicated, is permeated by the image or subsumed in it, the image itself is relatively immune to bodily intervention. It snatches the shadow for itself, depriving the body of a clear optical affirmation. Thus a dual phantasm of bodily desolidification and ulteriority unite in confounding the place of the subject and, by the same means, substantiate the autonomy of the image as a technological (unnatural) entity – an effect which occurs in most of Thater's projection works.

It is impossible to internalize or mystify these subject-effects for very long – to be multiple, divided, permeated, etc. – because every mark of difference that triggers them also signifies, diagrams, and rationalizes their genesis. As with film historian P. Adams Sitney's classic definition of the structural film, Thater's work always "insists upon its shape," and keeps insisting upon it. If one interrogates with but the tiniest effort the subject-effects of the diverging horizons and image-permeated shadows of *Oo Fifi Part 2*, the apparatus – the three-headed witness on the floor — confesses immediately and with almost disconcerting sincerity. The three divisions of the subject correspond tautologically to the array of three "eyes," cones of light, and vanishing points of the equipment on the floor. In an instant the sense of the term "apparatus" switches from Lacan and Baudry to the Sony Corporation, and the phenomenal artwork yields to the material one. With the structure of the work so completely disclosed and the link between the subject-effect and the mechanical apparatus so matter-of-fact, the apparent reduction of the former to the latter appears at first quite analytical and convincing, if not conclusive – which it never could be and, as we shall see, it never pretends to be. Convincing, that is, in its evocation of a prior discourse. In terms of the video apparatus, it echoes succinctly the materialist strain of filmic modernism, which Peter Wollen characterized as: "the reduction of [cinematic codes] to their material – optical, photo-chemical – substrate ('material support') to the exclusion of any semantic dimension other than reference back to the material of the signifier itself."[6]

7. See David James, *Allegories of Cinema* (Princeton: Princeton University Press, 1989), pp. 278-279.

As there is no optical substrate to the video image, nothing on the order of the image to be viewed on the magnetic tape itself, Thater's attention to the three color components of the video image and the three lenses of the projector would seem to adequately reference the material of the signifier: red, green, and blue light. Yet, this is not an ideological reduction in Thater's work as it was for ultra-reductionist filmmakers like Peter Gidal, whose "structural/materialist" project resurrected medium-specific essentialism as a political (Marxist) as well as logical imperative.[7] Thater's project is never reducible to its reductions. An image is always attached to the carrier of the apparatus and, by virtue of its direct implications for the place of the subject, has destinations completely contrary to the course of materialist reduction. There is no significance to why the images are separated into red, green, and blue other than this: in the artist's words, "to see the way projectors see." In this simple statement Thater's indifference to dialectical mandates is made plain by virtue of a willful confusion: it conflates the projector's "sight" with the seeing subject. (Granted, this would be a familiar paradox were the apparatus a camera.) Presupposing at best a kind of reversible circuit of heterogeneous terms, and most certainly not a *dialectical* reduction, Thater's reduction-to-apparatus analytic deliberately leads us to impossibilities not unlike seeing the way El Greco sees or taking over an astigmatism with normal vision.

The reversible circuit is not complete within the schema of the video projection itself, however, but extends outside it. Thater subjects her "reductionist" terms to a kind of public hanging – in *Oo Fifi Part 2*, *Abyss of Light* (1993), and other works – by covering the windows of the exhibition space with translucent gels of the "essential" video colors or their compliments: cyan, magenta, and yellow. In *Oo Fifi Part 2*, the window gels take the configuration of a color bar test pattern. The result is an overextension of the apparatus theme to the point of absurdity: the evocation of a building-sized video projector which one may both view as a model and occupy as a subject merely by taking a stroll. From the interior, the view one has of the outside world is colored by the window lens and becomes an "image." The color in turn ceases to be an *essence* and becomes a *quality* of image, just as the colored light spilling in through the window becomes a quality of the interior – the shift from essence to quality being one general clue to where the circuit reverses. At this stage, the apparatus theme is reconfigured as a somewhat magical aesthetic, worthy of "California light and space" artists such as James Turrell, that is, with a strictly sensory connotation given the notion of structural openness. But, like Daniel Buren's stripes, Thater's window gels have a tendency to

Diana Thater
Up to the Lintel, Bliss
installation at Bliss House, Pasadena, August 1992

8. *Up to the Lintel* was installed at Bliss, an artist-run (and occupied) exhibition space in Pasadena, California, 1992. The installation took over virtually the entire house and grounds during its open hours from 6 p.m. to midnight.

become an institution-level code as well, a code in which the reductive analytics signified by the colors are framed as a past and faded romance – yellow, the jaundiced hue, being particularly well-suited to this effect. Even if the gels are read as declarations, as public banners flying the colors of Thater's work, or as a color code advertising free-access to a usually cloistered type of art (banners celebrating video *glasnost*), they ultimately cease to signify anything foundational at all and become a kind of visual speech act: a term with no fixed meaning, only the meaning given to it by its performance and context. This serves to open the structure of the work even further and bring yet another dimension of contingency and extensity to bear upon the apparatus theme.

In *Up to the Lintel* (1992), for example, the color code is again separated from its material origin in the video apparatus and takes the form of an ersatz color bar test pattern projected onto the windows of a suburban house in Pasadena, California.[8] In this guise – with a good measure of irony – it performs as a signifier of the phantasm. Using five projectors placed on the floors of the front room and attic, illuminating their exterior windows and a portion of the walls around them, Thater projected five separate tapes back onto the same locations in the house where they had originally been recorded (attic tape projected onto the attic wall, etc.). The projections, running unedited in real time, correspond to what a passerby on the street would see through the windows of the house if the interior were illuminated, except the interior view (in the projected image) is obstructed by large vertical color bars and can be seen only through the gaps between them. The color bars are not electronically superimposed on the interior scene, however; they are literally part of it, and composed of material comparable to it: standard-sized construction lumber and paint. Thater simply set four-inch square sections of painted lumber in front of the lens, turned the camera on, and *voilà:* color bars, foreground; house interior, background. The trick readily discloses itself. Despite being somewhat blurred, the color bars are noticeably dimensional, tangible, even perspectival. We may at first be tempted by the frontality of the color bars to regard the background scene (of domestic realism, including the comings and goings of the occupant) as existing in a state of mediation by the apparatus-code, and therefore to regard the reality of the apparatus as prior to that of the scene, but ultimately the reverse seems more to the point. The ersatz color bars have by inference derealized the apparatus; they have been turned into a model or (in narrative terms) a character portraying the apparatus. And in this performance it is the only character wearing a costume.

An insistently architectural work, *Lintel* has a way of collapsing the bulk of its referentiality back upon the site itself. Indeed, the whole scheme has an architect's temporal sense to it. Walking up from street, through the room full of whirring projectors and *activity*, and down the darkened hall into the rear room where an illuminated model of the house sits on the floor, one gets a sense of moving backwards in time, through the "before/during/after" stages of architectural genesis. In the world of the architect, the "during" stage is one of contingency and unpleasure – terror would better describe it – and such is the case with *Lintel*. The foundation of the work, the confluence of the site and the projected images, is always shifting in the projection rooms. One gathers that a question of structure is at hand, but which structure? Although the scene being projected leads directly to the place in which it is situated, and the image has a real referent to which it may secure itself, both occur simultaneously and obscure the distinction. To bastardize the philosopher Henri Bergson and Gertrude Stein in a single platitude: In the "during" room, *there is no there there.* That is, everything in the projection rooms is caught up in movement and time, both cinematic and diurnal. The color bar, for example, is unquestionably "there" in the cinematic sense. Unlike the flower in *Oo Fifi*, it has been delivered as an "intentional object." But, to the extent that it is passing for something else, something not made of wood and paint, it is the most phantasmal thing in the house.

Gaston Bachelard said, "consciousness is *housed*," and a good deal of experimental film and video, including that of the structural camp, has concurred and added this somewhat agoraphobic amendment: "… in a darkened chamber." (Thus upholding, under the pretense of uncommon insight, no less than a half-millenium of common sense instead.) Thater's *Up to the Lintel*, like Dan Graham's *Alteration of a Suburban House* (1978) before it, may go along with Bachelard, but adds a quite different amendment. It suggests that Consciousness would benefit by getting out of the house every once in awhile. As the projection rooms are the only occupiable places in and around the house that are *illuminated* – given the installation was open only during the evening – the darkened chamber would no more be the immanent domain of consciousness than the street, the front lawn, or the porch. One stands "outside the house" even in the room containing the illuminated model. The implication appears to be that an ethos of movement, of *passing through*, is of value here, and by repeatedly passing through one acquires a right of passage: through areas in which

9. See Baudry, "Ideological Effects of the Basic Cinematographic Apparatus," op. cit., note 1, p. 295.

others have become mired by ownership – such as the cranial boudoirs so *de rigueur* in art that sets out to deal with consciousness. The advantage, of course – when passing through is not *just* passing through – is how close you can get to your enemies.

Although the end is perhaps the appropriate place to deal with supplements, a worthy supplement is sometimes an enlightening place to begin. There are numerous supplemental elements in Thater's practice, such as the architectural models and window gels which, as we have seen, often act as primary markers as well. The shifting role of the color code from fundament to supplement and back initiates the critical movement of the reduction-to-apparatus theme from an analytic to a kind of narrative. A similar movement occurs vis-à-vis narrative proper in the supplemental indexes Thater compiles upon completion of each work. In the form of a standard book index – single word entries and short phrases set in alphabetical order – they collect a series of related and unrelated, leftover, and stream-of-consciousness ideas pertaining to the work. By Thater's description, the indexes also construct "false narratives" for the videotapes, which are otherwise devoid of conventional narrative lines. These narratives are usually quite cryptic in their index form, but occasionally emerge full-blown around certain key words and recognizable proper names. The most basic form of the narrative is not so much a plot line or story as it is a nascent subject: a character with a name and both a figurative and literal point of view – given the assumption of a camera/projector apparatus. Thus the supplemental index brings a fundamental narrative apparatus for the constitution of subject (the character) to bear on a demonstrably non-narrative apparatus in which subject is constituted (and deconstituted) strictly by optical and mechanical means. On the one hand, this would appear to defeat the purpose of separating the two apparatus in the first place; on the other, it reverses the reduction analytic and asks what kind of meaning can be reconstructed out of the diverging – and already reduced – mechanisms of subject constitution. If the index and the projection are given equal consideration – as opposed to reading one through the other – it seems that the two apparatus must inevitably conflate on the screen, as the terms of the cinematographic apparatus set down by Baudry and others – that the "reality" mimed by cinema is first of all that of a "self" – directly correspond to the first-person and third-person omniscient narratives (if one characterizes them optically). In both cases one identifies less with what is represented, the "spectacle" itself, than with what stages it, what obliges one to "see" what it sees.[9] The history of structural film and video suggests this is no less the case when narrative and cinema are reduced

Diana Thater
The Bad Infinite
detail from video tapes
projected in the installation

10. A consideration of the gender perspective is warranted here. What Shelley has to say about male-dominated romanticism and Thater has to say about male-dominated structural film and video may be viewed as another allegory of *The Bad Infinite*.

to skeletal configurations – as they are in the index and the projection – than it is in (what Alain Robbe-Grillet sarcastically termed) "nineteenth-century cinema" and its literary counterparts.

The conflating of the two apparatus creates a monstrosity in *The Bad Infinite* (1993). The projection scheme is quite like *Oo Fifi Part 2*, except the three projectors are stacked atop one another (running one lens each) and the source material is edited from a walk through snow-bound Sequoia National Forest. The camera technique, however, is radically different. Thater mounted three cameras onto a single length of lumber, one several feet behind the other, carrying it horizontally during the walk in such a fashion that the same scene was shot, but from three slightly different points of view. The first camera captured the scene (through a staggering, wandering eye); the second, the scene and the first camera; the third, the scene and the other two cameras. The tapes were each assigned a projector, thus splitting the overall image into three separate views, each with its own identifying color. As in *Oo Fifi*, a splitting of the subject occurs, only more confoundingly, because it is keyed on a distinctly first-person point of view, the most naturalized and persuasive of ocular subject markers. And because the projectors are stacked together, the configuration of the apparatus in the room produces no immediate analogue of the subject-effect. The viewing subject is lost in a phantasm which neither permits it to integrate its *selves*, nor to console them with reason.

Scanning the index for *The Bad Infinite* yields a number of potential subjects, the most insistent of which may be constructed by this series of entries: "camera; deformity; Mary Shelley; monster ..." The multiphrenic camera-subject of the projection is thus permitted to seize and be seized by a new identity, that of Frankenstein's monster wandering through a frozen landscape. The "false narrative" stabilizes the subject-effect through characterization, but in this newly-acquired stability the subject takes a proper name synonymous with biological monstrosity. Between the index and the projection the viewer is given an interesting choice. One can be divided and in a sense deconstituted as a whole subject, or one can be unified as a (monstrous) subject of parts – and both alternatives are not without their charms. However, if the index and the projection are taken together, there is no real choice to be made – although there is a perception of one – as the two constitutions of subject desire something from each other and soon become inseparable. In this sense, *The Bad Infinite* becomes an allegory of cinematic investiture, and raises a serious question about Thater's work. In reconvening the optical and narrative apparatus, whether through overlay or simple juxtaposition, is Thater simply remaking cinema by other means, a cinema in which there is "some assembly required" and some questions asked? The answer is in part yes, but not simply. Viewed as a model of Thater's practice, *The Bad Infinite* reconstructs – in principle more than in specific form – prior structural (vs. semiotic) deconstructions of cinema, that is, it constructs a "cinema" out of techniques that previously took it apart. It constructs "cinema" in a fashion that doesn't permit the place of the subject to remain ideological, that is, unconsciously obedient to a fixed model of relation. And it constructs "it" as a demon and a machine, not an ideal second consciousness.

The allegory buried in *The Bad Infinite* is not solely on the side of the subject, however. If we associate Thater's image with the arctic passage of Mary Shelley's story, we realize the monster is not just a "nascent subject;" it is a subject headed for oblivion. Although Lord Byron would have denied it, *Frankenstein* may be regarded as an allegorical (and prophetic) history of romanticism, which, to make two long stories short, charts the transformation of the innocent into the tyrant, and sketches the "proto-fascism" latent in the model of the Byronic hero.[10] In Thater's work, the suspicion of romantic innocence would appear to surface in several ways analogous to Shelley's allegory. Treatment of the landscape as a sign of the spiritual, the transcendent, or the ideal is anathema to Thater's practice. The nature-image is always blatantly mediated and destabilized, and it is addressed not as sign, but as movement and duration, as a constant passing-through of the subject. It is a state of confusion then, like Schiller's sublime, that identifies the nature-image. In Thater's mirror, cinema is alternately regressive and tyrannical, but so is anti-cinema. The reductionist strain of structural film and video – in particular, the apparatus analytic – is recapitulated, but its illusions of finality are put out to pasture, as it were. As *The Bad Infinite* shows, neither the monster-image nor the monster-narrative is reducible to a common machine, yet both are co-creative of one nonetheless – one we get uncomfortably close to. Lest we eliminate a whole dimension of possible meaning – like that posed by El Greco's astigmatism – just because we are interested in material questions, we had better get used to *thinking* about some things inclusively that, for structural, political, or esthetic reasons, we prefer to keep apart.

No Story, No History

Pas d'histoire, Pas d'histoire

The work of Joëlle Tuerlinckx
was shown in the exhibition
Pas d'histoire, Pas d'histoire at
Witte de With, from 12 November until 31 December 1994.
Tuerlinckx was invited to
present here the notes she
made while installing her
project in Witte de With.
Tuerlinckx documented her
exhibition and presents it in
this *Cahier* as a new work.

Pas d'histoire, Pas d'histoire by Joëlle Tuerlinckx can be seen in conjunction with two other exhibitions held at Witte de With in 1994, those of Willem Oorebeek and Diana Thater. Each of these exhibitions explored the phenomenological, offering a different manifestation and experience of the space in which the work of art is represented.

In Witte de With Tuerlinckx took over both floors, effectively "filling" it with works made especially for its spaces, achieving what she herself called, "a slow advance into my own brain … 1,200 square meters of brain."

It is as if she had anticipated this exhibition when she wrote for *Witte de With – Cahier # 2:* "When you exhibit alone you only come up against walls, doors or windows. In a group exhibition you come up against other forms, human forms or traces of human forms. And where in the first case that type of limit seems like a necessity, in the second case it is more difficult to formulate, less immediately desirable" (p. 102).

The work of Joëlle Tuerlinckx makes us aware of the transience of objects and the cycle of matter. In it the perception of space is inextricably bound to the perception of time, an aspect equally inherent to her choice of material and to her method of presentation. Some of her objects, scraps and bits of everyday materials, are locked up, wrapped, while others are literally left open and bare, shredded in the space. At times her works are merely projected or described, existing only as vague contours or as an inventory of ideas.

Joëlle Tuerlinckx's work is an overt continuation of the minimalist tradition with a "brazenly lyrical" twist. Her installations and objects confirm the principles of abstraction and present themselves as a pure form of beauty. The viewer thus can not escape becoming part of the schisms present in her work: confrontations between wall and floor, large and small, angular and round, color and lack of color, opacity and transparency, acceleration and deceleration, visibility and invisibility, seriousness and humor, profusion and shortage, continuity and discontinuity, and the innate conflict between meaning and signifier, in other words, between limit and boundary.

The title of the exhibition alone, *Pas d'histoire, Pas d'histoire*, demonstrates the simultaneous precision and ambiguity of her work. It can be understood as either the French expression for "never mind, never mind" or be provocatively translated as "no story, no history" – as a longing for progress, both in terms of the cultural project of history and the movements of its participants. But then again, perhaps it refers to the steps of a story, to the steps of a history? Without realizing it, our steps are choreographed by Joëlle Tuerlinckx's works; we walk along with her stories and discover that they, like her photographs, express the promise of happiness.

Joëlle Tuerlinckx
Pas d'histoire, Pas d'histoire
Witte de With, Rotterdam, 1994
photographs by Joëlle
Tuerlinckx

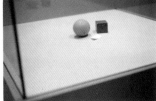

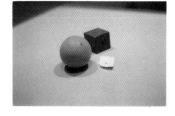
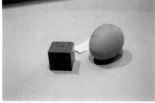
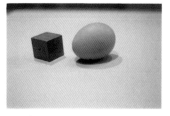
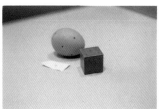

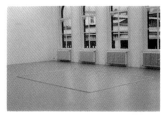
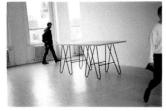

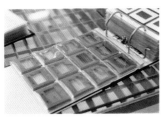

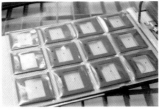
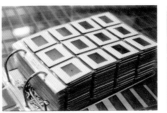

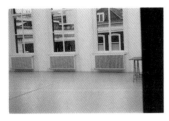
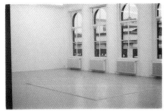

Pas d'histoire,

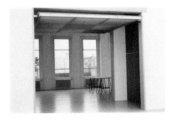

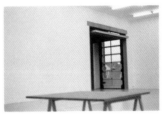
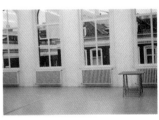

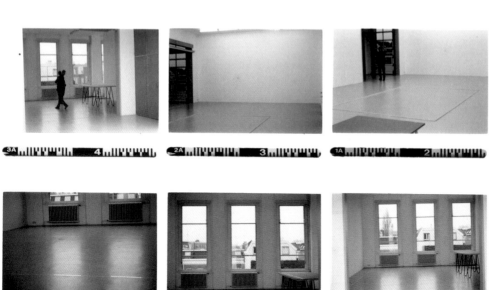

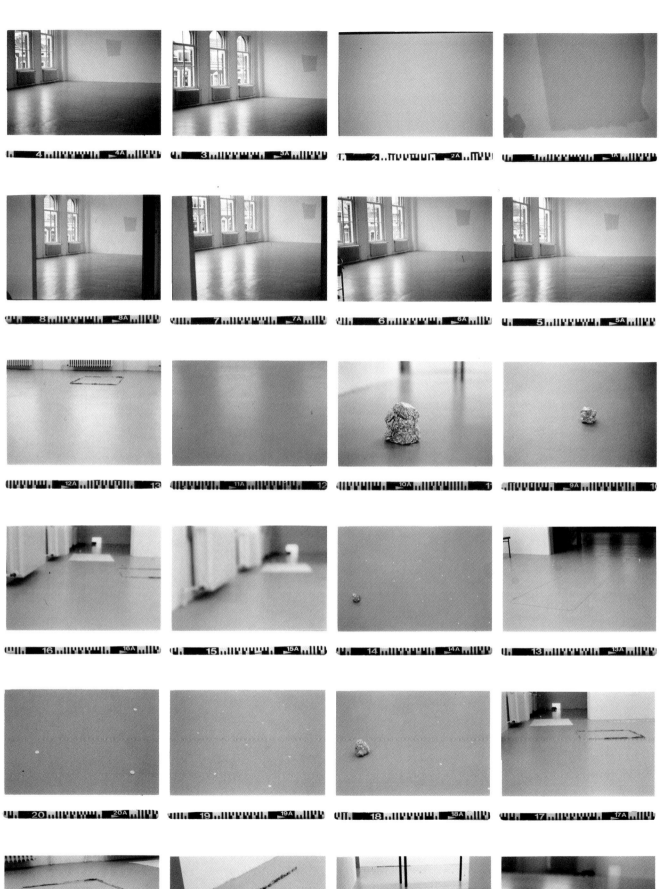

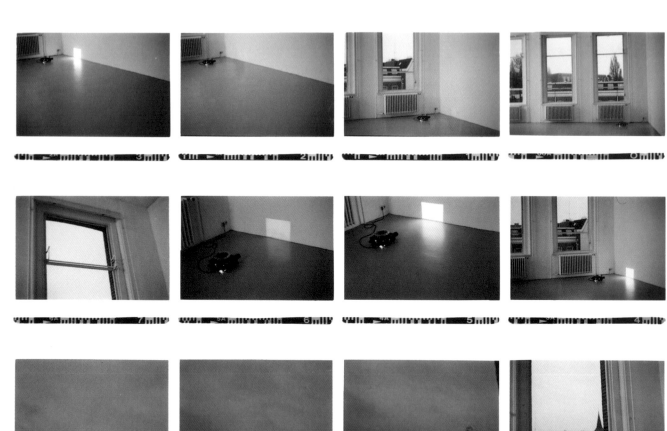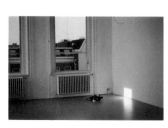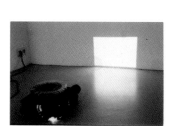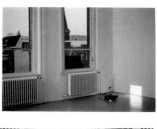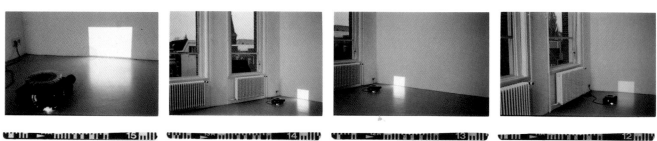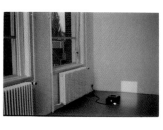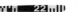

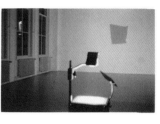
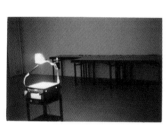
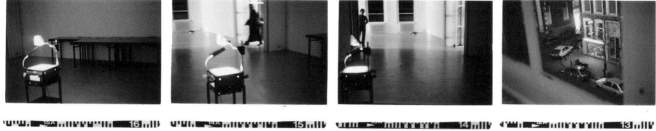

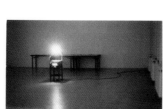

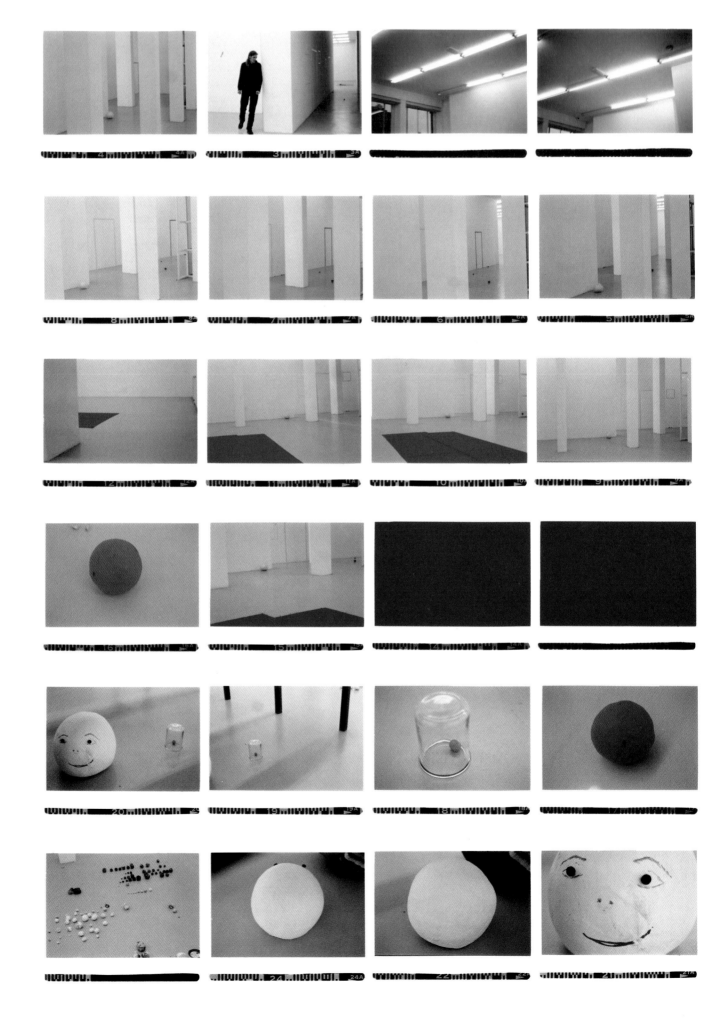

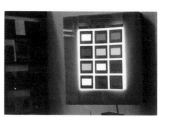

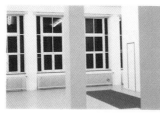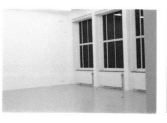
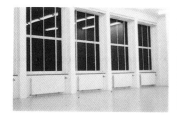

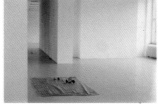
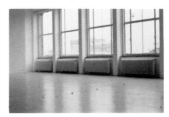
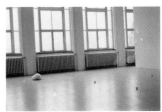
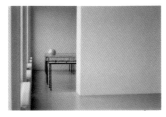
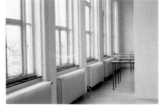
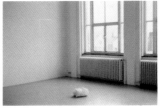

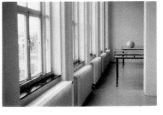

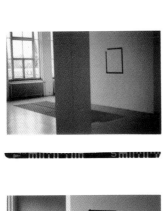
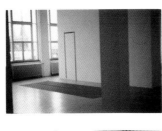
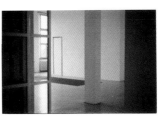
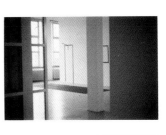

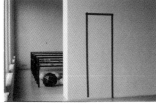
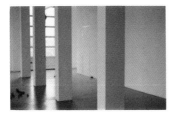
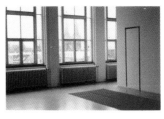
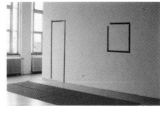
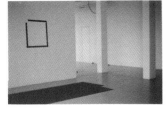
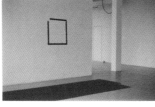
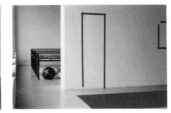
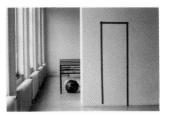
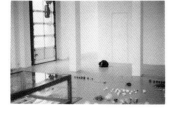
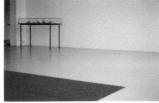
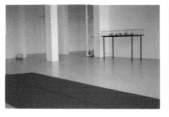
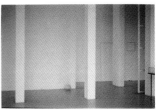
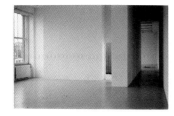
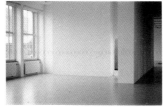
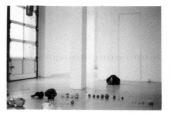
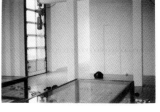
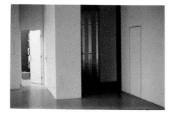
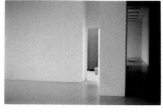
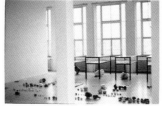
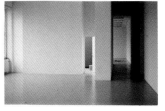

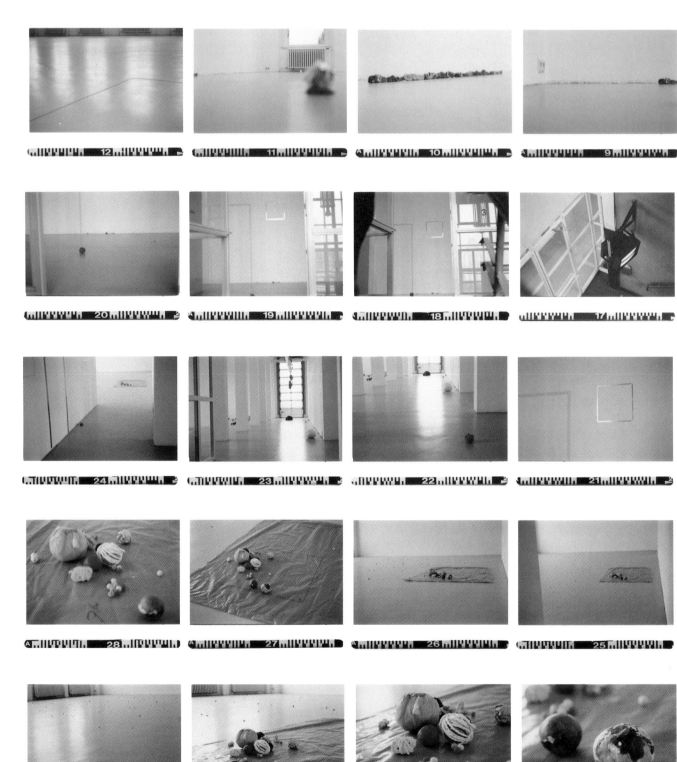
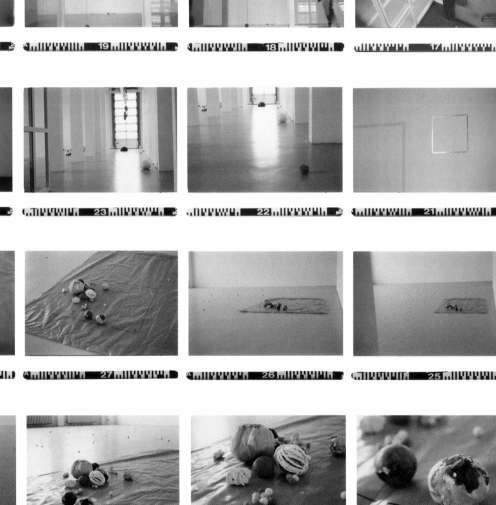
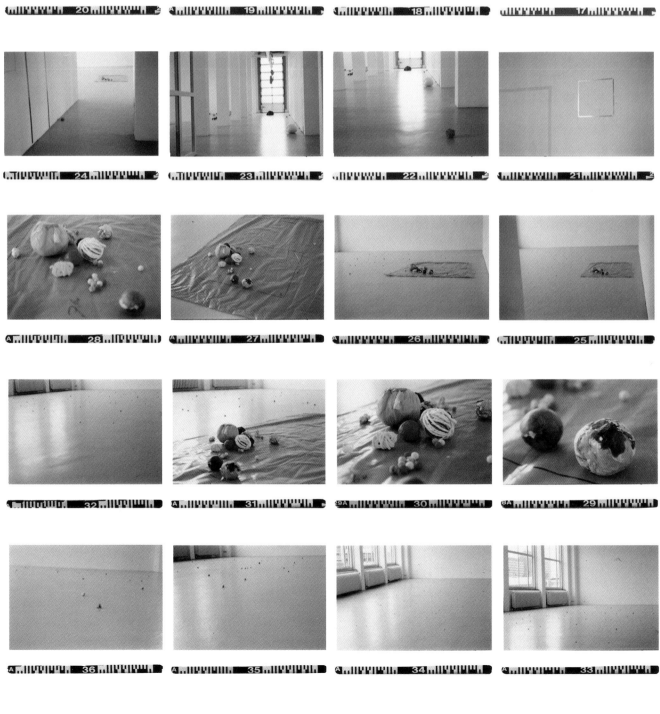
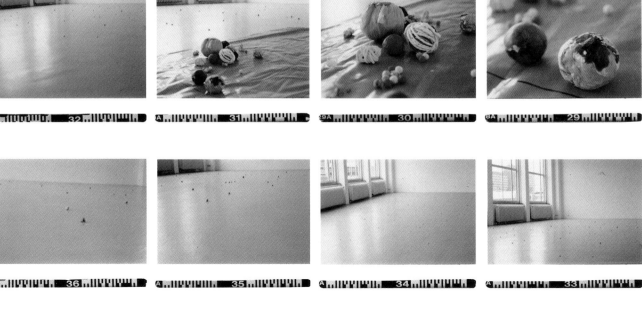

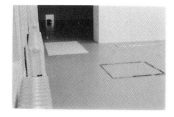

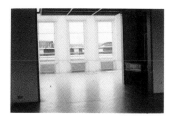 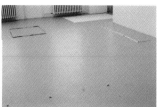 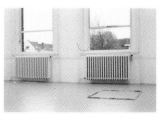

 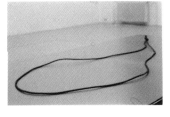 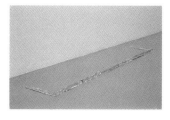

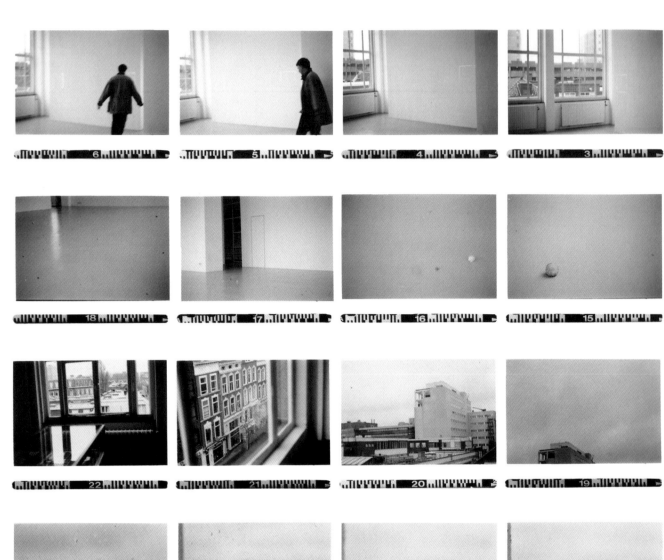

 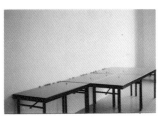 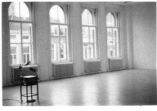 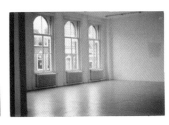

 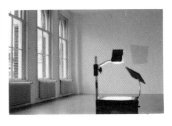

Departures from
NO STORY, NO HISTORY
an exhibition by Joëlle Tuerlinckx

(THE STORIES)
a proposal by Joëlle Tuerlinckx for *Cahier # 3* the whole forming an
ensemble which includes
– color photographs from an evening and a day (arranged, for consid-
erations of layout, in 24-image plates, the chronology of the documents
following as closely as possible the order of the shots)
– notes from one day
– plus, also supplied for the *Cahier # 3*, a group of black-and-white
image-materials, accompanying the text by the critic Mark Kremer

(a) selection
notes from Sunday, 6th November

notes written "here and there," or
mental notes that I will put together
in the following form, that is to say, as
they spring to mind, as faithfully as
possible

introductory notes
what has often been thought:
"I envisage this exhibition more and
more as a slow advance into my own
brain. but this could be a brain, here:
1,200 square meters of brain.
 organized zones, zones of deposits,
(vague) zones of memories, zones of
colors, zones of tattered images, zones
of absence …
 the (apparent) abstraction or the
(approximate) geometry are only
tools, means of access to see how
thought is getting along, how it is
advancing in space."

———

concerning the doors and windows
added on the upper floor

1. the fact of exhibiting is always a
passage from the extraordinary toward
the ordinary, from the inhabited and
habitual to the uninhabitable …

2. the wall, for its part, is not an
obstacle
you can always make a hole in a
wall
(here I'll attempt to render this
aspect in the form of the
imaginary)

3. this rectangle of sticky paper is
called a door (and yet. there is no han-
dle) or a window: (you see nothing)

4. nothing?

———

final notes? or what I have observed
the question remains: what does the
sculpture say that can't be written (or
(says L) that one doesn't dare write)

———

general note
I never stop starting
(or I never stop stopping)

———

very general note
I can see at full speed or in slow
motion much better than before. I
learned the gaze from machines that
reproduce reality. the camera, the
photocopy … just like the idea of
abstraction as a moment in the per-
ception of the visible (a badly adjusted
photocopier transforms a Rembrandt
into an abstract painting, a very badly
adjusted photocopy transforms all the
paintings of the world into the same
abstract painting).

———

notes concerning a general impression
of absence of image (or the idea of a
vague object)

1. the color in the image remains
color. yellow or green *or* …
color without image becomes a
volume

2. color without image is still not pure
color.
here it is "dirtied," scratched, in
plastic

3. the absence of image is a question
of viewpoint. a room from faraway
with the television on produces an
impression of color abstraction. a
drunk or maybe a myopic person
has the same impression of
abstraction (I try to make vague
objects, vague vitrines)

———

notes concerning the apparently
unfinished character of certain
constructions

the moment when I stop is very
important. it is a very precise moment
when I can still go into reverse as it
were, all the way to the start (of the
drawing) the drawings seem un-
finished or not depending

on whether you look at them from the narrative viewpoint
or not

notes concerning the table in the entry way with the (too)
long white string placed on it, or explanatory notes based on
it, concerning the absence of titles in the exhibition

1. the object below bears the name of table and the object
above that of rope
if the total object bore a name, it would bear a title.
the other objects in the exhibition, just as unnameable, have
not found any titles either

note on "words and walls are not obstacles"
the construction of a word is a matter of time, of a group
effort as well …
even though thrown quickly on the table, the ropes and strings
also define fields …
nonetheless, their forms can be changed. and the "I" who ties
the knot can still untie it, enlarge the form or change strings …

note concerning that table at the entry way and all the different
balls on the second floor

there are slow deposits (the tables and certain plasticine
balls) and there are fast or ultra-fast deposits. involuntary
deposits (the party favors) …, decisive deposits (the piled-up
masses of aluminium)
there are cumbersome deposits (the table) and others that only
encumber the view (the plasticine on the upper floor).
the table and the deposits are *obstacles*.
some are found, the others constructed on site.
sculpture in a general way is an obstacle.

here: the sole addition on the 11th (November)
1 table in excess. (the table in the entry way). get rid of the
excess. get rid of the idea of excess. get rid of the excess
ideas. get rid of all the ideas.
or hide them

annex
the crossing of a space, of a room, is generally accompanied by
losses, loss of time, loss of memory, loss of energy … if the alumi-
num balls crystallize a force (of work), the little balls, the deposits
of plasticine and the party favors condense the losses (of energy)

another annex:
the deposits of plasticine (or the colored stickers) are sometimes
nearer, sometimes farther from each other
That's perfectly normal
1. there is memory and the work of memory
2. there are, in space, walls and the knowledge of the wall
accelerating or slowing one's course on approach is a choice,
and changing speed is, in this case for example, a (vital)
necessity

final annex: important working note
… certain other forms, impossible alone, are made by twos
an example: the orange string laid on the ground in the form of a
large rectangle

concerning the "preservation" of the balls
I reserve the most "beautiful" balls, the ones that shine, for
the commerce of take-away portions of space
the most precious of them (still the same ones) will be
preserved

putting the balls into preserves is the best way to preserve them
art is concerned with conservation (museums, catalogues, cura-
tors or "conservation experts" …)
life, too, is also concerned with conservation (alimentary pre-
serves, provisions …)

descriptive notes on the commercial comodity, plus note on
utopia, probably to be followed by an important note
… you pay to see
… nobody floats in the atmosphere of a room. In Witte de With,
all the aluminium balls thrown in the air fell down. all of them.
the vitrines on the third floor form: portions of the space of
a fourth floor (the missing floor)
what one vitrine shows: one or several fractions of a second (in
this case, a ball thrown in the air)

IMPORTANT FOLLOW-UP
the space of commercial preserves, like the space of the vitrines,
is a space without dimensions
the visible can always be enlarged or reduced
between the weight of the visible and the perception of the visible
there is: history, there are stories

concerning the slide projections, and a word on
the film

inexact terminology

these are COLOR VOLUMES
there is volume I volume II, volume III ...
however each ensemble has a private name, necessary terminology for the work of constitution and classification
example: the volume with the grey tones, "le slechte dag"

a word on the video
here too, inexact terminology.
what can be seen: an ensemble of slides projected at accelerated speed, sometimes with the passage of a body
given the speed of projection, it naturally ends up forming a film
the television is a means, it shows the film, and yet the television remains an object (sometimes it has to be cleaned)

————

concerning the colored disks, confetti, colored stickers, or slides.
these are "borrowings" of color, governed by the idea of a movement from one color toward another.
Between yellow and red one can imagine a full expanse, a surface of color which regularly unloads a hue in order to fill up with a different one.
the yellow and the red, for example, are moments excerpted from varying space, privileged moments that escape from the zones of absence of color in the form of *leaks.* *
but: It's in the neighborhood of another that each particle of color is really transformed into a particle of space-time.

* (this is why color is often given in the form of "excerpts")
According to the principle of sampling. If I reduce the quantity of visible color, other expanses will develop but this time, either in the imaginary or perceptually
certain colors, orange for example, certain intensities will provoke virtual movements of expansion more naturally than others
here, color is nothing more than one means among others to see how, on the basis of visible givens, a mental material can attach itself to the material being worked, to space.
I experience the physical material. the mental material escapes me (through the gaze of others)

————

concerning "what happens in an empty room"
an exhibition is always an occasion. the occasion to exercise an activity somewhere. this activity has to do with human "making" in general, and with artistic "making" in particular. when I say "making," I mean the ensemble of gestures of construction or destruction of humanity as a whole (the new gestures, the gestures of work, the gestures of pleasure, the gestures of survival ...) in a way the empty spaces bring back this part of humanity

an exhibition is a way to account for, to give accounts in the form of the visible

à partir de
PAS D'HISTOIRE, PAS D'HISTOIRE
une exposition de Joëlle Tuerlinckx

(LES HISTOIRES)
une proposition de Joëlle Tuerlinckx pour le *Cahier # 3*
le tout formant un ensemble comprenant
– des clichés photographiques en couleurs d'un soir et d'un jour (regroupés, pour une question de mise en page, par planche de 24 images, la chronologie des documents respectant autant que possible l'ordre de la prise de vue)
– des notes d'un jour
– en plus, remis également pour le *Cahier #3*, un ensemble de matériaux-images en noir et blanc, sous le texte du critique Mark Kremer

Générique : notes du dimanche 6
– notes d'introduction
 ce qui a été pensé, souvent
 l'abstraction et la géométrie
– notes à propos des portes et fenêtres rajoutées à l'étage
 le passage, l'obstacle, ou bien, rien
– notes finales ? ou ce que je constate
– note générale
 le commencement et les nombreux arrêts
 l'idée d'abstraction
– notes à propos des dessins de gommettes, au 2° étage
 l'apesanteur, le peu de couleur
 l'impression d'ensemble, l'intention de détail
– note à propos d'une impression générale d'absence d'image
l'objet flou, la couleur qui n'est plus pure
 les erreurs des machines, la table et la corde comme une autre erreur
– notes à propos du caractère apparemment inachevé de certaines constructions
– notes à propos de la table à l'entrée avec la (trop) longue ficelle blanche posée sur elle
 ou notes explicatives à partir d'elle sur l'absence de titres dans l'exposition
– note sur "les mots et les murs ne sont pas des obstacles"
– notes à propos de cette table à l'entrée et de toutes les boules et boulettes du second étage
 les dépôts lents, les dépôts ultra-rapides
 annexe : la transformation des pertes d'énergie
 autre annexe : le changement (de vitesse). pourquoi.
 note sur : sculpter ou escamoter. faire apparaître faire disparaître.
– à propos de la "conservation" des boulettes
 l'art, la vie et la conservation
 le musée, les conservateurs, les conserves d'aliments comme preuves
– à propos des effets de l'écoulement des marchandises du commerce
 note sur cette idée tout à coup de faire commerce
– à propos du savoir et du cerveau
 l'impossible et le possible
 une autre façon de faire commerce
 le commerce d'idées, le commerce de couleurs, le commerce de visions
– notes descriptives sur la marchandise du commerce et à partir d'elle notes sur l'écoulement des marchandises
 le trop d'objets. le trop peu d'objets. 2 problèmes
 les portions d'espaces utopiques
 la différence entre : le poids du visible et la perception du visible ou l'espace des histoires
 note plus ancienne sur le désordre à partir du dedans
– note
 ici
 ce que ce terme comprend, ce qu'il comprend aussi, par différence
– note à propos des projections de diapositives
 volume 1, volume 2, volume 3
 le voyage infini dans la couleur
– à propos des disques de couleurs, des confettis, des gommettes ou des diapositives
 le principe d'échantillon et les fuites de couleurs, les zones d'absence de couleur
 le matériau mental et le matériau physique
– à propos de : qu'est-ce qui se passe dans une pièce vide
 les comptes à rendre (sous la forme du visible)
l'objet doré
 s'il y a du soleil
 là où il y a du soleil
– l'inventaire
 le matériel lourd, le matériel plus léger et le matériel lumineux, y compris les néons allumés, et y compris les néons éteints

(une) sélection
notes du dimanche 6 novembre

notes écrites "par-ci par-là", ou no-
tes mentales que je re-grouperai sous
la forme suivante, c'est-à-dire
comme elles me viendront à l'esprit,
le plus fidèlement possible.

notes d'introduction
ce qui a été pensé souvent:
"j'envisage cette exposition de plus
en plus comme une lente avancée
dans mon propre cerveau. Mais ce
peut être un cerveau, ici: 1200 mètres
carrés de cerveau.
 des zones organisées, des zones de
dépôts, des zones de (vagues) souve-
nirs, des zones de couleurs, des zones
de lambeaux d'images, des zones
d'absence …
 l'abstraction (apparente) ou la géo-
métrie (approximative) ne sont que
des outils, des moyens d'accès pour
voir comment va la pensée, comment
elle avance dans l'espace."

———

à propos des portes et des fenêtres
rajoutées à l'étage

1. le fait d'exposer est toujours un
passage de l'ordinaire vers l'extraor-
dinaire, de l'habité et l'habituel vers
l'inhabitable …

2. le mur, quant à lui n'est pas un
obstacle
on peut toujours faire un trou dans
un mur
(ici je vais tenter de rendre cet aspect
sous la forme de l'imaginaire)

3. on appelle ce rectangle de papier
collant une porte (et pourtant: il n'a
pas de clenche) ou bien une fenêtre:
(on ne voit rien)

4. rien ?

———

notes finales ? ou ce que je constate
l'autre question reste: qu'est-ce que
dit la sculpture qu'on ne peut pas
écrire (ou qu'on n'ose pas (dit L.))

———

note générale
je n'arrête jamais de commencer
(ou je n'arrête jamais de m'arrêter)

———

note *très* générale
je peux mieux qu'avant voir à toute
allure ou au ralenti. ce regard, je l'ai
appris des machines qui travaillent à
reproduire le réel. l'appareil de
photo, la photocopie …
de même que l'idée d'abstraction
comme d'un moment dans la percep-
tion du visible (une photocopieuse
mal réglée, cela transforme un ta-
bleau de Rembrandt en tableau ab-
strait, une photocopie très mal réglée
transforme tous les tableaux du mon-
de en le même tableau abstrait.)

———

notes à propos d'une impression gé-
nérale d'absence d'image (ou l'idée
d'un objet flou)

1. la couleur dans l'image reste de la
couleur. du jaune *ou* du vert *ou* …
la couleur sans image devient un
volume

2. la couleur sans image n'est pas
pour autant la couleur pure.
ici, elle est "salie", griffée, en plasti-
que

3. l'absence d'image, c'est une ques-
tion de point de vue. une chambre de
loin avec la télévision allumée produit
une impression d'abstraction de cou-
leur. un ivrogne ou peut-être un
myope a cette même impression
d'abstraction (je cherche à faire des
objets flous, des vitrines floues)

———

notes à propos du caractère
apparemment inachevé de certaines
constructions

le moment où je m'arrête est très im-
portant. c'est un moment très précis
où je peux encore faire comme mar-

che arrière jusqu'au début (du dessin)
les dessins ont l'air inachevés ou non selon qu'on
les envisage ou non d'un point de vue narratif

———

notes à propos de la table à l'entrée avec la (trop)
longue ficelle blanche posée sur elle, ou notes ex-
plicatives à partir d'elle sur l'absence de titres dans
l'exposition

1. l'objet du dessous porte le nom de table et l'objet
de dessus celui de corde
si l'objet total portait un nom, il porterait un titre.
les autres objets de l'exposition, tout aussi innom-
mables, n'ont pas trouvé de titres, non plus

———

note sur "les mots et les murs ne sont pas des obs-
tacles"
la construction d'un mot est une affaire de temps,
de collectivité
aussi …
quand bien même vite jetées sur la table, les cordes
et ficelles
définissent aussi des champs …
néanmoins, on peut changer leurs formes. et le "je"
qui fait le noeud, peut encore le défaire, agrandir la
forme ou changer de
ficelle …

———

notes à propos de cette table de l'entrée et de tou-
tes les boules et les boulettes du second étage

il y a des dépôts lents (les tables ou certaines boules
de plasticine) et des dépôts rapides ou ultra-rapi-
des. des dépôts involontaires (les cotillons) …, les
dépôts décisifs (les masses d'aluminium en tas) il y
a des dépôts encombrants (la table) et juste encom-
brants pour la vue (la plasticine à l'étage).
la table et les dépôts sont des *obstacles.*
les uns trouvés, les autres construits sur le champ.
la sculpture d'une façon générale est un obstacle.

ici: unique rajout du 11 (novembre)
1 table de trop. (la table à l'entrée). supprimer le
trop. supprimer l'idée du trop. supprimer les idées
en trop. supprimer toutes les
idées.
ou les cacher

———

annexe
la traversée d'un espace, d'une pièce s'accompagne

toujours de pertes, perte de temps, perte de mémoire, perte d'énergie …
si les boulettes en aluminium cristallisent une force (de travail), les boulettes, dépôts de plasticine et cotillons condensent les pertes (d'énergie)

———

autre annexe:
les dépôts de plasticine (ou les gommettes) sont parfois plus rapprochés, parfois plus éloignés les uns des autres
C'est normal
1. il y a la mémoire et le travail de la mémoire
2. il y a, dans l'espace, les murs et le savoir du mur
précipiter ou freiner sa course s'en rapprochant est un choix
et, changer de vitesse est, dans ce cas par exemple, une nécessité (vitale)

dernière annexe: note de travail importante
… certaines autres formes, irréalisables seul se font à deux un
exemple: la ficelle orange posée sur le sol en forme de grand rectangle

———

à propos de la "conservation" des boulettes
les plus "belles" boulettes, celles qui brillent, je les destine au commerce de portions d'espace à emporter
les plus précieuses (toujours les mêmes) seront conservées

mettre des boulettes en conserve c'est le meilleur moyen de les conserver
l'art est concerné par la conservation (musées, catalogues, conservateurs …)
la vie aussi est concernée par la conservation (les conserves d'aliments, les provisions …)

———

notes descriptives sur la marchandise du commerce, plus note sur l'utopie, suivie sans doute d'une note importante
… on paye pour voir
… personne ne flotte dans l'atmosphère d'une pièce. Dans Witte de With, toutes les boulettes d'aluminium lancées en l'air sont retombées par terre. toutes. les vitrines du 3° étage forment: des portions d'espace d'un quatrième étage (l'étage manquant)
ce qu'une vitrine montre: une ou des fractions de seconde (dans ce cas, une boulette lancée en l'air)

SUITE IMPORTANTE
l'espace des conserves du commerce, tout comme l'espace des vitrines est un espace sans dimensions
on peut toujours agrandir ou diminuer le visible
entre le poids du visible et la perception du visible, il y a: l'Histoire, il y a les histoires

———

à propos des projections de diapositives et, un mot sur le film

terminologie inexacte

ce sont des VOLUMES DE COULEURS
il y a le volume I, le volume II, le volume III, …
cependant chaque ensemble porte un nom privé, terminologie nécessaire dans le travail de constitution et d'archivage exemple: le volume aux gris nuancés, "le slechte dag"

un mot sur la vidéo
terminologie inexacte, elle aussi.
ce qu'on peut voir: un ensemble de diapositives projetées à vitesse accélérée, avec parfois le passage d'un corps cela finit, vu la vitesse de projection, par former naturellement un film
la télévision est un moyen, elle montre le film: cependant, la télévision reste un objet (il faut la nettoyer parfois)

———

à propos des disques de couleurs, des confettis, des gommettes ou des diapositives. ce sont des "emprunts" de couleurs, régis par l'idée d'un déplacement d'une couleur vers une autre. Entre le jaune et le rouge on peut envisager une étendue pleine, un plan de couleur qui régulièrement se déchargerait d'une teinte pour se réemplir d'une autre. le jaune et le rouge par exemple ici sont des moments extraits de l'espace variant, des moments privilégiés qui s'échapperaient des zones d'absence de couleur sous forme de fuites.*
mais: C'est dans le voisinage d'une autre que chaque particule de couleur se transforme réellement en particule d'espace-temps.

* (c'est pourquoi la couleur est souvent donnée sous forme d' "extraits") Selon le principe d'échantillonnage. Si je reduis la quantité de couleur visible, d'autres étendues se développent mais cette fois, soit dans l'imaginaire, soit perceptivement certaines couleurs l'orange par exemple, certaines intensités provoqueront plus naturellement que d'autres, des mouvements virtuels d'expansion la couleur n'est ici qu'un moyen parmi d'autres pour voir comment, à partir des données du visible, un matériau mental peut se greffer au matériau travaillé, à l'espace.
le matériau physique, j'en fais l'expérience. le matériau mental, il m'échappe (par le regard des autres)

———

à propos de "qu'est-ce qui se passe dans une pièce vide"
une exposition est toujours une occasion. l'occasion d'exercer quelque part une activité. cette activité a à voir avec le "faire" humain en général, et le "faire" de l'art en particulier. quand je dis le "faire", je veux dire l'ensemble des gestes de construction ou de destruction de l'humanité toute entière (les gestes neufs, les gestes de travail, les gestes de plaisir, les gestes de survie …) les espaces vides font comme ressurgir cette part d'humanité

une exposition c'est une façon de rendre compte, de rendre des comptes sous la forme du visible

Mark Kremer
A Sweet Iconoclasm
The Work of Joëlle Tuerlinckx

1. Gilles Deleuze and Claire Parnet, *Dialogues*, trans. Hugh Tomlinson and Barbara Habberjam (New York: Columbia University Press, 1987), p. 24.
2. *Transfer* (Ghent: Sint-Pietersabdij, et al, 1993-94), p. 174.

Mark Kremer and I agreed together on a text that would take a few detours, among them the images, reselected this time or completed with other choices by Mark Kremer. As to these images, they originally existed in different visual forms: they are re-filmed, re-photographed, re-photocopied … In this sense they are more or less than an image, they are an image-material to be (re)-distributed.
Joëlle Tuerlinckx

… what is a white wall, a screen, how do you plane down the wall and make a line of flight pass?[1]

1.

"Wasting time making useless things seems to be the only sensible answer, the most sensible thing I can do at the moment."[2] This is how Joëlle Tuerlinckx defined her ambition as an artist in 1993. At the time, she had, for a while already, been busy experimenting with pieces of paper, paper balls, confetti and colored plasticine, which she placed on the floor of her studio and, subsequently, observed to see how the materials reacted to light, how they crumbled and disintegrated, expanded, and shrunk. Tuerlinckx describes the results of these experiments as suppositions of form, i.e., substantiated conjectures relative to form or, more precisely, tangible thought.

During the past two years, Tuerlinckx has elaborated on and enunciated her experiments in exhibitions and publications. The exhibition, *WATT* (at Witte de With and the Kunsthal Rotterdam) in early 1994, demonstrated how Tuerlinckx's suppositions of form can function within the context of a group show. The nature of this event elucidated qualities of Tuerlinckx's work that, in a more relaxed context, may have gone unnoticed. The layout of the Witte de With exhibition was characterized by distance, the work of each artist having its own realm. Artists tolerated each other's presence, but there was no actual contact. In the Kunsthal, this tolerant exhibition model was forced open. The space occupied by one artist flowed into the space occupied by another, giving rise to discourse, squabbles and courtships.

Amid sculptures, assemblages, mobiles, drawings, paintings and other objects by co-exhibitors, Tuerlinckx exhibited her *Stukjes stukjes stukjes en dingen, dingen dingen en stukjes* (Pieces Pieces and Things, Things Things and Pieces). Made up of two parts, this work seemed to be conferred with a discreet, almost hollow presence. In one of Witte de With's galleries visitors were met with hand-torn snippets of paper placed on the floor in quasi-right-angled patterns, reminiscent of floor plans or outlines. Likewise, in the large gallery of the lower level of the Kunsthal, visitors encountered a confetti-strewn floor. These colorful, machine-made paper fragments were regulated into similar orderly patterns. Devoid of mass or volume, the configurations in both locations derived their meaning from an implied connection with everything with which they were surrounded: the proportions and spacing of the architecture; visitors, whose movements were dictated by the positioning of the paper snippets; the works exhibited by other artists; and the commonplace objects that were part of the surroundings.

Tuerlinckx's work functioned like a sensitive instrument, as a sort of seismograph, detecting and recording waves of energy. Her paper snippets appeared to be silhouettes of their surroundings. In some of the configurations, one recognized the proportions of the environing architecture; the contours of other forms alluded to specific objects present elsewhere in the same space; and still other configurations, altered by the footfalls of visitors, were records of demolition.

While the objects exhibited by the other artists were elevated off the floor, outwardly courting the space, Tuerlinckx's work seemed withdrawn, to the point that it appeared to be a renouncement of any attempt to take possession of the space. Her work sought minimal presence. Boundaries were mocked to the extent that one experienced the work more as a tenuous, shifting energy than as a series of striking shapes. Her configurations of paper shreds, seemed on the verge of assuming mass and volume. At the same time, they looked like images that had fallen to pieces on the ground. Tuerlinckx makes reference here to a drawing by Leonardo da Vinci that depicts objects suspended in the air. It is like a portrait that captures the moment of a collective fall. Straight lines lead the objects back to their point of origin: the earth. Tuerlinckx's reference is apt. I propose projecting Da Vinci's drawing onto the present-day and determining its meaning. The implication seems clear to me. Following the very recent history of art, in which objects were celebrated, the time has come for a countermove.

2.

Joëlle Tuerlinckx directs the fall of her objects. Respective to this aspect of her work, she appears to be thinking out loud. The fall is not her goal. It is a means of getting closer to the primary energies of objects. She focusses on the moment immediately prior to the forms becoming fixated. Tuerlinckx's exhibitions can be typified as thought experiments wherein destructive and constructive impulses redeem each other simultaneously. That which is destroyed — or gives the impression of being so — is readily ordered anew. Some of Tuerlinckx's work is suggestive of images that have literally fallen to pieces. And yet even these are not ruins, unrestrainedly given over to the hands of time. The resultant debris

3. Ibid., pp. 175, 177.
4. Joëlle Tuerlinckx,
"2-1-1994," *De Witte Raaf*
no. 47 (January, 1994), p. 7.
5. *Cel Crabeels, Johanna
Roderburg, Andreas Sansoni,
Joëlle Tuerlinckx* (Aken: Ludwig
Forum, 1994).
6. Walter Benjamin, *Das
Passagen-Werk* (1927-40), ed.
Rolf Tiedemann (Frankfurt am
Main: Suhrkamp, 1983), p. 12.
7. Robert Smithson, "A Sedi-
mentation of the Mind: Earth
Projects," *The Writings of
Robert Smithson*, ed. Nancy
Holt (New York: The New York
University Press, 1979), p. 87.
8. Kees Fens, "De zekerheid
van misschien, wellicht, mogel-
ijkerwijs," *de Volkskrant*
(30 September 1994).
9. Op cit., note 2.
10. Op cit., note 2, p. 173.

functions instead as conglomerates, as possibilities out of which a new range of structures and forms can materialize.

How does Tuerlinckx set about directing these falls? I would like to investigate three publications, each one a visual contribution realized by Tuerlinckx in 1993 and 1994: *Les Dépôts* (1993) consists of reproductions of two "strands" of confetti running across the top of a double-page spread. The confetti is made out of postcards: sublime portraits of the city of Aken.[3] "2-1-1994" is a contribution to an edition of *De Witte Raaf*. One page of this art newspaper is "doubled," that is to say, printed twice but in a slightly altered manner. This mutant duplicate appears in the center of the paper, right next to the original, creating a mirror effect. Missing from this new page is the image that the original complimented: a reproduction of a painting by Bram van Velde. Instead she adds another image: a few red, green and black dots flutter across the off-white page, coursing through the text which is about Geer and Bram van Velde based on the essays of Samuel Beckett.[4] Finally I should also mention here a third contribution: eight crosses, drawn using various colored felt tip pens, reproduced on eight consecutive pages in a catalogue published in 1994.[5]

There's a destructive element manifest in each one of these publications. Postcards – typically color-saturated, stiffly composed reproductions depicting various tourist-trodden cultural landscapes – snipped into decorative little bits, the likes of which people scatter among themselves at parties. A culture's reposi-tory, picked up and reshuffled. Or, put another way: lacerated old structural images giving rise to a frag-mentary new order. Depicted on one of these pieces of confetti is a sign with the word "kunst" (art). The shock caused by a detail unexpectedly calling attention to itself causes one to think of Walter Benjamin who, in his *Passagen-Werk*, wanted to preserve the vigour of textual fragments by joining them together, like raw building materials for a house, the excavation of which has only just begun.[6]

I would like to interpret Tuerlinckx's work in *De Witte Raaf* as radically as possible. Life is injected into forms with a tendency toward death. It is significant that the black-and-white reproduction of Bram van Velde's painting is missing on the duplicate page; and that the progression of words about art is decorated with tiny ornaments: colorful, teeming, restless spots gently mocking the text. Robert Smithson wrote: "Look at any *word* long enough and you will see it open up into a series of faults, into a terrain of particles each containing its own void."[7] He saw death in everything, including language. Tuerlinckx's conscious-ness is concordant with Smithson's. There is more death to the things around us and the words we use than we think.

In the untitled publication, Tuerlinckx places her own gesture in parenthesis, implying that visual art is a midpoint, a category, like poetry, that persists between things. Hesitation – Fixing a point: What does that mean? – is the subject of this publication. The word "maybe" is articulated eight times in this piece; a word, according to the Dutch literary critic Kees Fens, that represents the lone wolf opposite the multiplic-ity of the arts and all of life.[8] In an urbane way, Tuerlinckx causes us to become accomplices to a condition characteristic of contemporary art: pulverization of the artistic gesture.

3.

Joëlle Tuerlinckx's exhibitions further help to explain how she directs the fall of her objects. Foremost is her preference for working on the floor, a place that demands a special kind of attention. Think about the modesty of Carl Andre's work, such as his patterning of rolled steel tiles. Tuerlinckx uses the floor as one might use a piece of paper to make a drawing. Speaking about the possibilities inherent in her working method, she explains: "When I draw a line on a piece of paper I can't delay the moment in order to make each point the result of a well-defined choice. Using materials like plasticine or pieces of confetti placed next to one another halts the evolution of a form because it crystalizes within a decelerated time frame, like film where the choice occurs twenty-four times a second."[9]

For the most part, Tuerlinckx's works are made up of a combination of forms that have a low degree of organization. She emphases the inherent potential of elementary substances and the prospect of permeat-ing their character: "One can do the filthiest things on the floor, sprinkle water, let dust accumulate; allow the disorder to take shape and observe it, see how time changes things. Real energies originate, and little by little one realizes that these energies express a living condition because, during their moments of expedi-tion, they see and comprehend the world."[10] Here we encounter someone interested in initial impulses, someone who prefers to think of objects as their original ideas or concepts. Now, let me investigate a trio of exhibitions from the past two years.

11. Exhibition *L. Bianconi, J.-P. Deridder, S. Eyberg, J. Tuerlinckx, C. Vandamme* in the Paleis voor Schone Kunsten in Brussels, 1993, in conjunction with a series of exhibitions entitled *Antichambres*.
12. Exhibition *Transfer Brussel-Düsseldorf*, Goethe Institut, Brussels, 6-30 October 1993.

In the Paleis voor Schone Kunsten in Brussels, in 1993, Tuerlinckx exhibited a piece entitled *Trois formes, quatre salles* (Three shapes, four rooms) that consisted of visual echoes to a decorative pattern by Victor Horta elsewhere in the museum.[11] A spotlight was directed at Horta's actual pattern in the hall. Visitors encountered its visual echo on the floor of the round gallery: Tuerlinckx had placed pieces of colored plasticine there. Foot railings, used to protect paintings from too close inspection, were held together by colored nylon thread and arranged a new order to the gallery that leads to the reception desk. Pieces of white plasticine, the size of a few marble tiles, were placed in the fire closet. In her directions to museum attendants and the public, Tuerlinckx stated: "Pieces of plasticine accidentally impaired by passing visitors will become the subject of daily restoration, either by room monitors or by the visitor who unwittingly treads upon the construction."

Aujourd'hui (Today) was the title of Tuerlinckx's exhibition in the theater of the Goethe Institut in Brussels in 1993.[12] Tuerlinckx partially dismantled the room, removing all the chairs normally used by the public to sit and watch performances, or special events. Attention was to be directed at those moments between performances, a time lacking in expectation respective to a particular space (e.g. the stage). Tuerlinckx requested that the director of the Goethe Institut temporarily relieve the cleaning lady of her job. She had strewn wads of paper of various shapes and sizes over the floor, which promptly became imbued with the theatricality of the space. This was complemented by a repetitive ceremony: two stage curtains opened and closed automatically throughout the period of exhibition, one quickly, the other slowly.

Once again, I would like to call attention to Tuerlinckx's piece in the exhibition *WATT*: *Stukjes stukjes en dingen, dingen dingen en stukjes*. This work can be seen as conversant with the objects exhibited by the other artists. Tuerlinckx's white and colored snippets mimicked the activity going on around them. Their place-

13. Kees Fens, "Een apologie van schaduwbeelden," *de Volkskrant* (29 April 1994).
14. Saskia Bos distinguishes between these two approaches in her article "Topics on Atopy," *Appel Bulletin* (Amsterdam: De Appel, 1989), pp. 16-19.

ment on the floor of Witte de With was based on a static principle; in the Kunsthal chaos set in. Likewise, the snippets gave rise to questions regarding the territoriality of objects. They invoked a subtle critique on the inviolable aura surrounding art objects. At the same time, the assertion of an independent gesture prevailed; the seemingly fragmentary nature of this work didn't diminish its singularity.

In her work Tuerlinckx opts for an enlightened critique, one that structures and intensifies the ability to perceive. In *WATT*, in a very subtle manner indeed, she orchestrated a critique of art's object-character. Visitors were impelled to check their pace for something incredibly miniscule, but which nonetheless filled them with awe. Naturally, you experience a drawing on the ground differently than a drawing on the wall. But the temporizing way in which viewers were led to participate in this work had an almost religious character to it. Momentarily, we were given the chance to really look at things. The work revealed its soul. In the words of Kees Fens: "A work's principal *gestalt* is its interior; its observable form, the germination of an idea, is the beginning of loss."[13]

4.

In many of her writings, Tuerlinckx responds critically and often with surprise to the anonymity and uniformity of institutional art spaces. The manner in which she approaches the patterns of display fostered by these spaces is an extension of the site-specific working method of the 1970s and site-sensitive methods manifest in the 1980s.[14] However, in her work, there's neither talk of investigating the commercial, historical or architectonic conditions of a given space (e.g. Michael Asher), nor of simply adapting the space to suit one's work (e.g. Ettore Spalletti). Tuerlinckx subverts the exhibition space. To begin with, she steers clear of the homogenized display regimens that reigns in so many institutional art spaces. Her choice of the floor as carrier of her work is an example of this. More often than not the floor is grey: a non-zone, a *terrain vague*.

Instead of confronting conditions of the exhibition space directly, Tuerlinckx focuses on conditional gaps, points of weakness: neglected or hidden details (case in point: her exhibition in the Paleis voor Schone Kunsten in Brussels). She undermines existing conditions with finesse. In her exhibition in the Goethe Institut, time and spatial perspectives were canted. Here attention is paid to the intermission, which

de Volkskrant, 13 August 1994

15. "project, project, project; visible projects and invisible projects; more objects; less objects," Joëlle Tuerlinckx's note in op. cit., note 5.
16. Joëlle Tuerlinckx in conversation with the author, Rotterdam 25 August 1994.
17. Exhibition *Transfer* at the Kunsthalle Recklinghausen, 1994.

suddenly assumes the role of the lead player. One could say that, exercising such methods of inversion, Tuerlinckx disarms the exhibition space. Conventions are overturned. The distance that separates us from an object on the wall, or on a pedestal, is no longer extant. The hierarchy between event and non-event falls away. Visual primacy is called into question by the choreographies that steer a visitor's movements. In short, new connections are made between the exhibition space, the objects on display, and the observer.

Tuerlinckx's exhibitions demonstrate that art, once again, can be thought of as an intermediary between the viewer and the world. Since the beginning of the 1990s, other young artists have begun applying this concept of art to their own practice of art-making. Conceiving art as an intermediary means placing one's artistic gesture between brackets. Tuerlinckx's work capitalizes on the doubts currently in play respective to the function of art. Her conception of art arises out of the notion of uncertainty. What to do? What not to do?

> *projet projet projet*
> *projets visibles et projets invisible*
> *objets en plus*
> *objets en moins*[15]

In her work, Tuerlinckx searches for a midpoint between universality and particularity. Assuming a porous position, she skirts around the dilemma associated with modernism and postmodernism. For example: the work of colored plasticine exhibited in the Paleis voor Schone Kunsten in Brussels anticipated the destructive and constructive actions of visitors and museum attendants. The nimbleness of the artistic gesture is authenticated here, agilely jumping from "I" to "you." The subject of this work undoubtedly was the refinement of the artistic gesture. An effective micro-politic enabled this work to forge an opening into the area surrounding it.

Micro-politics make it possible to broach, with due hesitation, universal themes. A number of artists have exploited this notion. Joëlle Tuerlinckx, for one, and her ambition to restore the erotic moment in the connection between things. And the artist Absalon, who died in 1993, who was instructed by the aspirations embodied by early modernism as a result of the distance he took from them. He conceived his works as bound to his person. *Cells, Proposal for Living Spaces, Prototypes, Proposal for Everyday Objects*, this is how he titled his work. These singular white constructions of wood, carton and plaster seem, in their reserve, to mediate between the observer and the respective surroundings. Another artist who comes to mind is Jan van der Pavert, who has been working on the same project for many years, the central idea of which is a house. Models of this house demonstrate the degree to which sculpture is integrated into the artist's personal abode. This house, too, is an intermediary. Van der Pavert considers his project a means of restoring critique to the legacy of modernism.

5.

In Joëlle Tuerlinckx's practice, pulverization is deployed as an offensive tool. In the institutional art context, she executes operations based on the sugar-cube principal: a crystalline structure that disintegrates in liquid, dissolves, spreads, and effectuates optimum penetration. Her operations take place within the framework of a micro-politics, and are intent on introducing energies into the artistic domain (*champ de l'art*) that originate in the domestic domain (*champ de maison*).[16]

Our knowledge of the domestic domain has been brought forth in different ways. Seventeenth-century Dutch painting offers superb examples of interior environments which capture the intimacy of the moment. Thinking about the public nature of art in present-day institutions, one could ask: What have we gained? What has been lost? Can we really see – that is: can we experience works physically under conditions where the body is fit into exhibiting-machines that significantly regulate how we see?

Tuerlinckx takes stock when displaying household paraphernalia in places where the intimacy accorded such objects is, in the first instance, misplaced. But it's an ambiguous gesture. Spontaneity and discipline go hand in hand. Her work has to do with choreography and, subsequently, with projected intimacy. This, in turn, gives way to emergence of subtexts. Certain works tend toward the grotesque. For example, the word "kunst" (art) on one of the pieces of confetti reproduced in the publication *Les Dépôts* – a material lapse. There is the inertia of *Quartre formes en vacances* – dormant confetti patterned on tabletops.[17] And, here on my desk, lies a slide of a felt-pen drawing consisting of small, green dots that outline the contours of a box. Projecting the slide, what one sees is a house made of confetti, a fragile little building for art.

Tuerlinckx elaborates her conception of domestic art with light-sensitive materials and forms that embody varying degrees of presence. Qualities of volume and mass are suggested. In the past years Tuerlinckx

18. *Antichambres* (Brussels: Paleis voor Schone Kunsten, 1993).

19. Mark Kremer and Camiel van Winkel, "Interview with Stephen Prina. 'I've been described as an impure conceptual artist. And I celebrate and embrace that!'," *Archis*, no. 11 (November 1993), p. 76.

has developed a vocabulary in which structure – in itself a relatively closed unity – can be associated with a house. The ambition to create, in art, an affinity to phenomena associated with one's living room, has a studious base. Tuerlinckx's observations respective to the accumulation of dust are reminiscent of the photograph by Man Ray, taken in 1920 of a dust print on the floor of Marcel Duchamp's studio left by his *Large Glass*. But Tuerlinckx would never fix such a phlegmatic moment. Two of her works from 1989 – musings on the art of painting and sculpture – substantiate her interest in motivity.

One of the works (*Sans titre* (Untitled), 1989) is comprised of two long slats leaning against the wall, a pink rubber glove slipped onto the top of each one. The left-hand glove is pressing a yellow piece of paper against the wall, like a window. The right-hand glove is holding a red piece of paper, the shape of a small rectangle, against the yellow background. The second work (*Sans titre* (Untitled), 1989) consists of an inflated paper sack lying on the floor, its opening weighed down by a thin sheet of glass. Both works have anthropomorphic traits. (Tuerlinckx implicitly affirms this interpretation when she describes energies as conditions of being.) The paper sack filled with air is reminiscent of Matt Mullican's *Sleeping Child* (1973): a white pillow placed on the floor with a raw piece of wood lying on it. In both works Tuerlinckx creates a preverbal space in which the identity of things is determined viscerally.

6.

Joëlle Tuerlinckx formulated her artistic concept in the 1980s. She came eye to eye with the display regimens indicative of most institutional art spaces; the rules of which were internalized by many artists who at the time were just beginning to venture out on their own. These artists didn't criticize or question the existing order but, instead, incorporated it into their working method. Tuerlinckx, as I've said before, circumvented these rules. In exhibitions in the early 1990s, she focused on the limitations of existing conditions, established for the purposes of display. She literally forced openings into the exhibition space in order to make exterior notions of time and space active elements of her work: Anonymous spaces acquire an identity. Art reveals itself as a drama, a subdued spectacle arising out of conditions unique to the here and now.

In 1990 Tuerlinckx had an exhibition in the Centre Régional d'Art Contemporain Midi-Pyrénées, an art center in the countryside of Toulouse, in the middle of the fields. What once was a farm is now a place for art. Its interior is cool, quiet, and white. The outside wall is red brick. Everyday the bricks glow in the light of the sun. The possibility of creating a breathing space arose in Tuerlinckx's mind.[18] She drilled holes directly into the walls of the building that progressed as a sort of contour around its periphery. In order to have sunlight fall directly into the space, she removed the tarpaulin from the cupola. The drilling residue was left where it fell: red powder from the outside brick walls, white powder from the inside walls, beige sawdust from the partition. The title of the work is apt: ...

A year later Tuerlinckx made an exhibition in the Espace d'Art Contemporain in Lausanne that subtilely addressed the question regarding the isolation of art space. Tuerlinckx linked the interior exhibition space to the country's beautiful natural surroundings. Five double windows were opened so that the sounds, smells and colors of the "real" world could penetrate the space. Opposite the windows Tuerlinckx had installed five wine glasses, balanced against the wall on top of driven nails. Each glass was filled with water to catch the light. During the day the water took on a greenish hue, mimicking the verdancy of foliage outside. The date was noted on the wall with each passing day (*samedi le 27 avril 1991* ...).

In recent work, such as the exhibition in the Paleis voor Schone Kunsten in Brussels, Tuerlinckx subtilely deals with an art space's weak points. The rules are contorted from the inside out. The work in the exhibition *WATT, Stukjes stukjes en dingen, dingen dingen en stukjes*, induced visitors to check their pace, rethink their being there, and proceed with caution. A sort of female subservience was brought into play in order to conquer the space and make it a tactile organ. This way of proceeding – sensitizing the exhibition space –is in the spirit of Blinky Palermo, who considered the art space a body in touch with the world.

These works by Tuerlinckx command a place in the narrative of institutionalization, as Stephen Prina calls it.[19] The focal point of this narrative is: in which situations do artists who focus on questions concerning art succeed in transcending a mere analyses or critique of the function of institutionalized art spaces? Tuerlinckx's elegant operations demonstrate – and that is the constructive aspect of her project – what artists have to gain from these kind of spaces.

Around 1970, Jannis Kounellis, Gino de Dominicis and Blinky Palermo realized projects that, in their own way and time, raised questions concerning the vitality of white art space. Kounellis made an exhibition in the Galleria l'Attico in Rome with live horses (1969); De Dominicis exhibited the signs of the zodiac in

20. I elaborated on this issue in my article "The Life of a Repo Man is Always Intense," in cat. *Exhibition* (Vienna: Museum Moderner Kunst Stiftung Ludwig, 1994), pp. 94-101.
21. Italo Calvino, *Lezione Americane. Sei proposte per il prossimo millennio* (Milan: Garzanti, 1988), p. 13. Translated by Patrick Creagh under the title *Six Memos for the Next Millenium*(Cambridge: Harvard University Press, 1988), p. 12.

the same space: a live steer, a lion, a virgin, two dead fish... (1970); and Blinky Palermo installed in Konrad Fischer's gallery in Dusseldorf his beige wall painting of the contours of the stairwell of the adjoining space (1970).

These projects can be taken as a warning against automatism, a factor that would forcibly determine the function of institutional art spaces in the years that followed.[20] Also the interventions of Michael Asher in museums and galleries from 1970s until today are exorcism of the uniformity of these spaces. Tuerlinckx, however, makes clear that the problem can be addressed in yet another way. She poses the question: How does one go about repossessing the white space?

7.

Joëlle Tuerlinckx's recent exhibitions are defined by a narrative impulse; tales spinning creations of their own within a given context; tales mediating between materials, forms, objects, architecture and the outside world. This development is the result of a derailment. Tuerlinckx's work had reached a critical mass, resulting from an increase and complexity of usable forms. Narrative possibilities offer an outlet for a overstrained vocabulary. Case in point: an art auction that took place under Tuerlinckx's auspices on 4 December 1993 in the Neuer Aachener Kunstverein. This spun a tale in a very concrete way. The event was announced via colored paper pamphlets circulated in various neighborhoods in the city of Aken. The highlight of the day was the auctioning of a gold object weighing 35 grams and signed by the artist. The pretension surrounding the object drew attention away from the fact that it was nothing more than a ball of crumpled newsprint covered with gold-colored paper.

The inventory of materials and objects Tuerlinckx used for her solo-exhibition *Pas d'histoire, Pas d'histoire* in Witte de With included: threads, little paper balls, plasticine, confetti, projections of confetti, plastic jump-rope, small plasticine balls in glass cases, little balls in cardboard boxes, a box wrapped in gold-colored paper, colored transparencies, plasticine forms placed on the floor outlining the building's floor plan, et cetera. The elements were actively and passively present in the space. A reservoir of objects, like a stock, was also part of the exhibition. The tale engendered by all these things functioned as a parallel to reality: The placement of the little balls – in or out of a box, on the floor or above it, in a vitrine – refered for example to more or less veiled social hierarchies; as though she were practicing with the hand of fate.

What distinguishes Tuerlinckx's work is its emphasis on the non-spectacle. At a time when many artists are intent on trying to fulfill unrealistic expectations set forth by the various cultural agencies, she opts for refining the personal gesture that the artist can make. She plies the weapon Italo Calvino described with such hope in 1984 (anticipating the first lecture he would present as part of the Charles Eliot Norton Poetry Lectures at Harvard University in Cambridge).

"If I were to choose an auspicious image for the new millenium, it would be this: the sudden agile leap of the poet-philosopher who raises himself above the weight of the world, showing that his gravity contains the secret of lightness, and that what many consider to be the vitality of the times – the noisy, aggressive, revving and roaring – belongs to the realm of death, like a cemetery for rusty, old cars."[21]

– What's the importance of useless activity?

On an Antidote

Anke Bangma
Rotterdam and the *Children's Pavilion* by Dan Graham and Jeff Wall

The *Children's Pavilion* is a collaboration between the artists Dan Graham and Jeff Wall. It is a project that unites Graham's architectural investigations with Wall's pictorial analyses. Witte de With and the Rotterdam Arts Council have investigated the possiblity of realizing the pavillion in a post-war Rotterdam suburb called the Prins Alexanderpolder since 1991. The art historian Anke Bangma presents an account of the difficulties confronted by the pavilion.

The definitely inferior place of the artist can be found in the function of his/her work in our society today: we are marginal suppliers to a huge leisure industry. The business reports of this industry show us the degree of our importance. Moneywise, an artist is replaceable. Whenever I refused to participate in an art project, it didn't matter: the event took place without me anyway. Nobody even cared whether I was in it or not.

Hermann Pitz[1]

Modern art's origin and nature can be traced back not only to the epic history of its finest representatives or to the sensitive testimony of its works, but also, or even especially, to a *theory of the conflicts* that it provoked and continues to provoke. It is wrong to deem these conflicts merely marginal or to want to carefully rectify them pedagogically, because then modern art's enormous potential for conflict is suppressed and, due to mistaken consideration, entrance to its central inquiry remains shut.

Walter Grasskamp[2]

In 1987, as the result of a unique collaboration between Dan Graham and Jeff Wall, the design of a pavilion for children comes into being in which the artists' ideas on architecture and photography meet. The pavilion is not only a play area, it is also an optical machine and a monument. The design refers to such diverse architectonic typologies as the Pantheon, the garden pavilion, the observatory, and Utopian architecture; Edward Steichen's *The Family of Man* is referred to in the tondi with portraits of children that represent the multiracial face of world culture. The design brings practical, artistical, social and political meanings together.[3]

After earlier attempts to realize the *Children's Pavilion* in New York, Blois and Lyon fell through, primarily for financial reasons, the Rotterdam Arts Council (Rotterdamse Kunstichting), at the initiative of Anne-Mie Devolder from the architecture department and Witte de With propose to build the pavilion in Rotterdam. Thomas Meijer zu Schlochtern, staff member of the Art Council's visual arts and exhibitions department, is asked to coordinate the project. The possible realization is connected to *Architecture International Rotterdam – Alexander (AIR-Alexander)*, an event held in 1993 in which the post-war residential areas of Rotterdam's Prins Alexander district are the focus of exhibitions, publications and commissions. The pavilion is to remain in this district as a lasting memento of the event.

An appropriate site for the *Children's Pavilion* is found in one of the post-war areas: the Ommoordse Veld (the Ommoord Field). On the edge of the Ommoord neighborhood, it consists of a playing field with a rowing course and a children's farm. In the middle of the field is an artificial hill that seems made for the *Children's Pavilion*. Both artists find it a suitable location for their pavilion to function in. The neighbors react enthusiastically to the project. The first official presentation of the project takes place at the site in May 1992 with the Rotterdam Arts Council, Dan Graham and Jeff Wall.

The visual arts and exhibitions department of the Rotterdam Arts Council lets it be known that it completely wants to support the realization of the *Children's Pavilion* in this location. The department even immediately promises a sum of 10,000 guilders for the preliminary study on the feasibility of building the project. The Office for Visual Art Commissions at the Ministry of Culture (the Praktijkbureau Beeldende Kunstopdrachten van het Ministerie van WVC) looks for further financial support and presents the proposed pavilion to its advisory board, which in June 1992 favorably assesses it, saying that it "completely agrees to the requested sum for the initial expenses of this interesting project."

In addition to the initial positive feedback and pledges of financial assistance, the first doubts about the feasibility and appropriateness of the *Children's Pavilion* are voiced in this period. In July the Rotterdam Institute for Art Education (Stichting Kunstzinnige Vorming Rotterdam), publishes a remarkably negative report on the practicality of the pavilion. In addition to the production, maintenance and administration costs, two problems with respect to content, which are thought to affect the function of the *Children's Pavilion*, are pointed out. "Wall's photos for the pavilion interior are photos of children that represent population groups which live in Canada and North America. We highly doubt whether this composition can be transferred just like that to Rotterdam." The report further states: "The project is based only on visual observation; behind this observation lies the meaning. In order to understand the project at all, children need to be able to think somewhat abstractly. This kind of thinking (formal operational phase) only begins to develop at about the age of eleven or twelve. As far as this is concerned, younger children fall by the wayside. Furthermore, in the project description different connections are made to examples from art history. Apart

1. Hermann Pitz, "The Role of the Patron," *Kunst & Museum journaal*, nr. 5 (1993), p. 9.
2. Walter Grasskamp, ed., *Unerwünschte Monumente. Moderne Kunst im Stadtraum* (Munich: Verlag Silke Schreiber, 1989), p. 8.
3. Much has been written, especially by the artists themselves, on the architecture and meanings of the *Children's Pavilion*. See, among others, Dan Graham and Jeff Wall, "The Children's Pavilion," *Parkett* nr. 22 (1989), p. 66-68 and Dominic van den Boogerd, "De architectuur van het kinderspel," *Archis*, nr. 6 (June 1991), p. 46-51.

from the fact that as far as we are concerned these sorts of associations are rather contrived, children in any case do not see these connections." Conclusion: "The Institute for Art Education does not see this project functioning for children." Other parties concerned, such as the Rotterdam Center for the Arts (Centrum Beeldende Kunst), which is in charge of commissioning art for public spaces in Rotterdam, also voice their doubts.

Gea Kalksma from the Art Council's visual arts and exhibitions department writes an incensed reaction to this report, in which she not only contrasts the objectives of the artists against the objections of the Institute for Art Education but also points out that the negative judgment is based on only two isolated aspects of the many possible experiences the pavilion can generate. Reducing the *Children's Pavilion* to just one of its possible functions or meanings will prove however to be a constantly recurring problem.

Kalksma is temporarily appointed as project coordinator and is commissioned to investigate the possibility of realizing the *Children's Pavilion*. In September 1992 she presents a report in which, sticking closely to the concept of both artists, she enthusiastically suggests how the pavilion could possibly function. She concludes that, as far as the relevant Rotterdam art organizations are concerned, the artistic quality of the project is beyond question. Furthermore, the location of the Ommoordse Veld appears to have everyone's approval; even the designer of the playing field, Michael van Gessel, suggests that "the pavilion could be very well placed on the pyramid-hill." However, in part as a result of the Institute for Art Education's negative report, the use value of the *Children's Pavilion* for children appears to be in question. In her report Kalksma stresses the design's open structure and experimental value, citing a letter from Jeff Wall to the Rotterdam Arts Council:

> Play is unpredictable in any circumstances. Playground designers are more and more convinced that they must start from a sort of "principle of indeterminacy" and create structures which can be continually reinvented and re-imagined by the children using them. However, whatever they design must be bounded with seating or other facilities for adults, a secure and visible perimeter allowing parents and children to keep each other in view. This fusion of openness and surveillance, indeterminacy and security, is an essential structural feature of public play-spaces, and of the Pavilion as well.

Consequently Kalksma concludes: "The *Children's Pavilion* is an experiment. ... To what point the inhabitants, borough and officials want to accept the experiment will be looked into."

For the daily supervision of the pavilion Kalksma suggests a form that is directly in keeping with both artists' description of how the project could function: the pavilion acts as an informal neighborhood meeting place. It is a simple building that is accessible during the day, is closed in the evening and requires no special surveillance. It only needs to be controlled for maintenance. The extent of the construction and maintenance costs must now be determined by a site-specific construction plan.

Nine months later, in June 1993, the Rotterdam building contractor Jan Stada presents the first estimate of the development costs. He calculates that the construction of the pavilion on the existing hill will cost 600,000 guilders. The land price is not included in this estimate; it is expected that the borough will agree to a favorable arrangement for the purchase of the land.

The realization of the *Children's Pavilion* now seems desired and attainable.

Where Kalksma wants to see the *Children's Pavilion* built out of her conviction in the meaning and importance of the project, the director of the Rotterdam Arts Council has other priorities. He sets the Arts Council the goal of determining all the arguments for and against the project. The feasibility study is considered an important extension of the artwork; the official involvement is understood as the project's first step in public space. With this as a point of departure, the feasibility study is continued.

In November 1993 an exhibition on the *Children's Pavilion* is organized by the art critic Dominic van den Boogerd in the Museum Boymans-van Beuningen in Rotterdam. The exhibition is part of the *AIR-Alexander* event. In a small room drawings, a model, and the tondi with portraits of children are shown. The exhibition is also meant to attract the interest of potential sponsors; at the same time it is seen as an occasion for an information day for the inhabitants of the Prins Alexander district. The exhibition costs 30,000 guilders, precisely the amount transcribed by the Ministry of Culture for the initial construction phase of the *Children's Pavilion*. At the end of the exhibition there is still no definite solution for building the pavilion. In the meantime, the *AIR-Alexander* event has come to an end.

In January 1994 the Prins Alexander borough presents a second assessment of the development costs, in which the unforeseen expenses of the first estimate are included; this study reveals a substantially higher cost of 1,645,000 guilders, three times the amount of the first assessment. The annual operating costs are put at upwards of 200,000 guilders.

Shortly afterwards, in February 1994, the Rotterdam Arts Council's definitive report on the feasibility of the *Children's Pavilion* in the Ommoordse Veld is released. The report states that the pavilion's function has not been clarified. A number of possible functions were up for discussion: an instruction space for the neighboring children's farm, a play area for the Katinka scouts, or part of the nearby Ommoord playground. For practical reasons none of these functions are actually considered. The report concludes that only an autonomous role remains for the pavilion but nevertheless formulates it in functional terms, such as a spot for theater performances or neighborhood activities – functions that have already found their place elsewhere in the neighborhood. The final conclusion of the report formulates two unsolved problems. In the first place there is no commissioner; neither the Rotterdam Arts Council nor the Prins Alexander borough are able to assume the role's great financial responsibility. The management of the pavilion proves to be a greater stumbling block; the maintenance costs estimated in the report cause the borough officials to back out in fright.

Construction of the *Children's Pavilion* in the Ommoord neighborhood of the Prins Alexander district is therefore put off. Officially the most important reason is said to be that the management costs can not possibly be paid by the borough over an extended period. However, the impossibility of determining a definitive function for the *Children's Pavilion* seems certainly to play an equally important role. The problematic nature of realizing it can not be considered separately from its unique status: it can not be reduced to just a playground, structure, artwork or Utopian monument. The combination of practical, artistical and philosophical principles raises questions and problems that an ordinary artwork, an ordinary construction, or an ordinary playground would not have raised. Precisely because of its exceptional intermediate position, which determines its unique value, the *Children's Pavilion* can not be put within the existing bureaucratic order where it can not function. Realization of the *Children's Pavilion* requires an open and flexible attitude.

The Rotterdam Arts Council decides to make another last attempt at looking into the possibility of building the *Children's Pavilion* in other locations in the city. The new *Children's Pavilion* work group is given the following assignment: "To look into other locations in Rotterdam that are interesting from either the viewpoint of multicultural society or from the viewpoint of children, and to give the pavilion so much extra value that sponsors will want to put their money into it." In particular, a location in the Museumpark is considered that is not only in the city's center but also borders Rotterdam's most important museums as well as the Sofia Children's hospital.

Hein van Haaren, former director of the Rotterdam Academy of Fine Arts (Rotterdamse Academie van Beeldende Kunsten) is commissioned in June to look into possible funding for the project via national and international funds. Rather than the expected report with an objective survey of new financial options and potential new locations, van Haaren at the end of August submits what has by now become a typical recommendation, which again stokes the debate over the value of the design of the *Children's Pavilion*.

> The idea and the design of a pavilion for children has deservedly caught the attention of everyone involved in the development of the arts in public space and the design of the municipal environment. It seems an obvious fact that Dan Graham and Jeff Wall's proposal inspired many people and prompted them into wanting to realize it in Rotterdam. After all, this is a question of an artwork that frankly wants to relate to the daily behavior of people, in particular of children.
>
> Social intent and quality of design are clearly present in the plan. The artists' engagement with society is obvious and consequently stimulating for potential patrons. There seems however to be an essential flaw, which I sense in the proposals. The artists felt the need to create an environment for children according to their image of them. There are quite a few determinants based on their own childhood memories and especially also expectations that are imposed on children; the planned environment possibly invites occasional creative action but probably dictates behavior even more.
>
> The design evokes artworks by qualified visual artists from the late fifties and sixties who made sculptures that were meant not only to be looked at but also to be places in which one could step and walk through (Etienne Csekely, *e tutti quanti*). A high point was Constant's *New Babylon*, where the freedom of human behavior was so optimal that one could only breathlessly participate. Conditioning was unavoidably inherent to the artist's concept. It was and is a splendid image, but not a practicable reality.
>
> The *Children's Pavilion*, to a lesser degree, shows characteristics of such a visionary concept. There is much to learn and much inspiration to gain from it, but by all means it should not be realized. It mixes the autonomy of the image with a longing for social engagement that is not yet mature in either thought or feeling. It is in fact a lesson for art's policy makers: look and listen, but don't immediately

bring ideas back to daily reality, use them rather as a source of inspiration and as a bridge between art and society. Rather than planting artists' ideas directly into society, there are many of such bridges that need to be built.

In short: as it stands now there is no space for the *Children's Pavilion*, not in Rotterdam or elsewhere in this world. Let it act as a catalyst. As such it can be used for practical interpretations at a level on which idea and practice meet.

The unprecedented example that the Rotterdam Arts Council wanted to set, with its exhaustive investigation into the feasibility of a public artwork such as the *Children's Pavilion*, took a striking turn. The example was at the very least of uncertain allure: after all, the *Children's Pavilion* is still not built. After four years it seems that in the last phase of the investigation the project was even pronounced an undesirable monument. Finally, the efforts at erecting the *Children's Pavilion* in an ordinary Dutch residential neighborhood did not break down into the classic conflict of the art world on the one side and the uncomprehending everyday world on the other. The subversion keeps coming from within the official bureaucracy of the Rotterdam art world itself. Hein van Haaren's conclusion is just the most recent prod of a feasibility study that, in its accumulation of incompatible reports and arguments, constantly turns against itself. The aspiration of giving equal consideration to all views on the execution of Dan Graham and Jeff Wall's concept has meant that the unique and engaged concept of the two artists is in danger of completely disappearing from view behind an incessant stream of democratic and bureaucratic procedures and recommendations.

The realization of the *Children's Pavilion* in Rotterdam has taken so long that another Dutch art institution has been mentioned as a possible Maecenas for the pavilion: the Rijksmuseum Kröller Müller in Otterlo has revealed that it is interested in placing the construction in its sculpture garden, which has attracted the attention of the Ministry of Culture.

In the meantime, the Rotterdam Arts Council has let it be known that it does not want to let the *Children's Pavilion* pass Rotterdam by, and that it will still actively and seriously look into the possibility of realizing the project in Rotterdam's Museumpark.

October 26, 1994

Rotterdam Prins Alexander district, Ommoordse Veld (Ommoord Field), proposed location for the *Children's Pavilion* by Dan Graham and Jeff Wall October, 1993

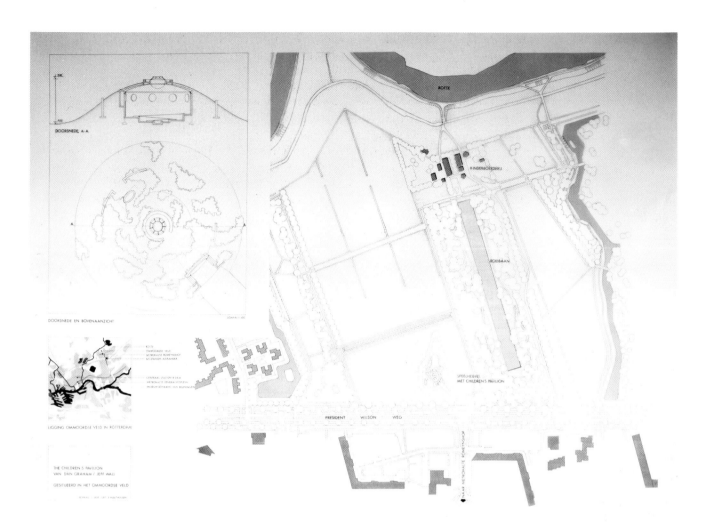

Dan Graham/Jeff Wall
Children's Pavilion, phase 2,
(project Ommoordse Veld), 1993
courtesy Galerie Roger Pailhas,
Marseilles-Paris

Maria Eichhorn

Upon the suggestion of Witte de With, the German artist Maria Eichhorn was invited by the Public Works Department in Rotterdam to propose a new color concept for their buildings. The other artists, Fransje Killaars and Roy Villevoy, both from the Netherlands, were also asked to participate. Over the course of 1995, each proposal will be realized; afterwards, one will be chosen as the final solution and be permanently installed.

Gemeentewerken Rotterdam

In the Galvanistraat in Rotterdam, there are four tower blocks (I, II, III and IV) almost identically built. Three of these buildings house the Public Works Department, which fills a total of 19 floors with such departments as Architecture; Environment; Harbor, Bridge and Road Construction; and Water Supply (in building II, four floors; in building III, fourteen floors; in building IV, one floor). The complete interior of the work spaces, including walls, floors and doors, has to be renovated. I was invited to develop a new color concept for the elevator halls, which in the future will function as exhibition spaces.

COLORS
– Primary colors red, blue, yellow
– Complementary colors green, orange, violet
– Color white

ORDER
The order of each individual color stems from the color that precedes it and relates to the color that follows it:
– as a given color
– as a color from a mixed color
– as a primary color
– as a complementary color
– as a total of all the colors from the spectrum: white

POINT OF DEPARTURE
The walls of the elevator hall on the ground floor of building III are made out of brown stone. The color brown is composed of red and black; brown is the point of departure of the color range.

EXAMPLE
Following the color brown on the ground floor, is the color red on the first floor. Red's complementary color is green. Therefore, the second floor should be painted green. Green is the mixture of yellow and blue. The third floor should consequently be painted blue. The complementary color of blue is orange. The fourth floor should therefore be painted orange, etc. The color white forms the end of the color range. This color should be used for the 13th and 14th floor (the 14th floor is only partially rented by the Public Works Department) of Building III and as an alternative to red on the first floor of Building IV. The vertical trip in the elevator, up or down, completes the total color scale, as each successive color leads to white.

INTERRELATION BETWEEN THE BUILDINGS
To create an interrelation between the buildings, the elevator halls on the parallel floors of the different buildings will get the same color. For example, the elevator halls on the second floor of buildings II and III should be painted green and the two halls on the third floor should be painted blue.

COLOR COMPOSITION
Watercolor pigment dissolved in water. The proportion of pigment to water depends on the consistency of the base coat.

BASE COLOR
The white wall-color should be applied evenly with a brush (not with a paint roller).

PAINT APPLICATION
The paint should be fluid and applied very thinly so that only a shimmer of the color appears, like when colored light shines on a white wall. The white background should shine through the transparent color.

ELEVATOR DOORS
The elevator doors and walls on the same floor will be painted the same color or the full tone of the basic color.

LIGHTING
The fluorescent tubes have to be replaced by True-Lite tubes. These full spectrum tubes almost identically replicate the full color and light spectrum of natural daylight.

BUILDING II
II/2 green
II/3 blue
II/4 orange
II/5 yellow

BUILDING III
III/1 red
III/2 green
III/3 blue
III/4 orange
III/5 yellow
III/6 violet
III/7 blue
III/8 orange
III/9 yellow
III/10 violet
III/11 red
III/12 green
III/13 white
III/14 white

BUILDING IV
IV/1 white (red)

Maria Eichhorn

Gemeentewerken Rotterdam

In der Galvanistraat in Rotterdam stehen vier Turmhäuser (I, II, III und IV) in fast identischer Bauweise. In drei dieser Häuser ist das Stadtbauamt auf insgesamt 19 Etagen mit den Abteilungen Architektur, Umwelt, Hafen, Brükken- und Straßenbau, Wasserversorgung etc. untergebracht (im Haus II vier, im Haus III 14 Etagen, im Haus IV eine Etage). Die Gesamteinrichtung der Arbeitsräume inklusive Wand, Boden und Türen soll erneuert bzw. renoviert werden. Ich wurde eingeladen, eine Farbenreihe für die Aufzugshallen zu entwickeln, die weiterhin als Ausstellungsort genutzt werden sollen.

FARBEN
– Grundfarben Rot, Blau, Gelb
– Komplementärfarben Grün, Orange, Violett
– Farbe Weiß

ABFOLGE
Die Abfolge der einzelnen Farben ergibt sich aus der jeweils vorhergehenden Farbe und bezieht sich auf die nachfolgende Farbe:
– als gegebene Farbe
– als Farbe aus einer Mischfarbe
– als Grundfarbe
– als Komplementärfarbe
– als Summe aller Spektralfarben: Weiß

AUSGANGSPUNKT
Die Wände der Aufzugshalle parterre im Haus III sind aus braunem Naturstein. Die Farbe Braun setzt sich zusammen aus Rot und Schwarz; Braun ist der Ausgangspunkt der Farbskala.

BEISPIEL
Aus der Farbe Braun im Parterre folgt für die erste Etage die Farbe Rot. Die Komplementärfarbe zu Rot ist Grün. Die zweite Etage soll demzufolge grün angestrichen werden. Grün ist die Mischfarbe aus Gelb und Blau.

Die dritte Etage soll demzufolge blau angestrichen werden. Die Komplementärfarbe zu Blau ist Orange. Die vierte Etage soll demzufolge orange angestrichen werden. Etc.
Die Farbe Weiß bildet den Abschluß der Farbskala. Sie soll für die 13. und 14. Etage (die 14. Etage ist nur zum Teil vom Stadtbauamt gemietet) des Hauses III und alternativ zu Rot in der ersten Etage des Hauses IV verwendet werden. Die vertikale Fahrt mit dem Aufzug aufwärts oder abwärts erschließt die gesamte Farbskala, wobei jede Farbe die gegebene zu Weiß ergänzt.

BEZIEHUNG DER HÄUSER ZUEINANDER
Um eine Beziehung der drei Häuser zueinander herzustellen, erhalten die Aufzugshallen der jeweils parallel liegenden Etagen die gleiche Farbe. So sollen beispielsweise die Aufzugshallen der zweiten Etagen der Häuser II und III grün und die zwei Hallen der dritten Etagen blau gestrichen werden.

FARBKONSISTENZ
Das Pigment von Aquarellfarbe in Wasser auflösen. Das Mengenverhältnis von Pigment/Wasser richtet sich nach der Beschaffenheit des Farbuntergrundes.

FARBUNTERGRUND
Die weiße Wandfarbe soll mit einem Quast oder Pinsel (nicht mit der Rolle) gleichmäßig aufgetragen werden.

FARBAUFTRAG
Die flüssige Farbe soll lasierend aufgetragen werden, so daß nur ein Hauch von Farbe entsteht; ähnlich farbigem Licht, das auf eine weiße Wand fällt. Der weiße Untergrund sollte durch die transparente Farbe scheinen.

FAHRSTUHLTÜREN
Die Fahrstuhltüren erhalten die

gleiche Farbe wie die jeweilige Wand oder den Vollton der Ausgangsfarbe.

BELEUCHTUNG
Die Leuchtstoffröhren sollen durch True-Lite-Röhren ausgetauscht werden. Diese Vollspektrumsröhren geben annähernd identisch das gesamte Farb- und Lichtspektrum des natürlichen Tageslichts wieder.

HAUS II
II/2 grün
II/3 blau
II/4 orange
II/5 gelb

HAUS III
III/1 rot
III/2 grün
III/3 blau
III/4 orange
III/5 gelb
III/6 violett
III/7 blau
III/8 orange
III/9 gelb
III/10 violett
III/11 rot
III/12 grün
III/13 weiß
III/14 weiß

HAUS IV
IV/1 weiß (rot)

Daniel Buren Genesis of an Exhibition, "Displaced Placement – Provisionally Situated Work" (1994)

This work was the product of a process whose logic was, strictly speaking, backwards. The inverse logic was the result of last-minute restrictions, imposed by the organization (disorganization?) of the Museum Boymans-van Beuningen.

At first it had been agreed that the large gallery upstairs would be reserved for me to show a series of works that I wanted to construct in response to the piece which was planned to be permanently installed in the actual entrance of the Boymans, physically separating the book shop and cafeteria from the work *Waxing Arcs* by Richard Serra (1980). I considered this exhibition as completely distinct from the permanent piece; though the two were to be simultaneously presented to the public.

Four weeks before the opening I learned that it would be impossible – for the moment – to construct the permanent piece planned for the ground floor. As a result, the work proposed for the upstairs gallery (contradictory dialogue with the ground floor) became impracticable.

I therefore decided to construct the piece originally conceived for the museum entrance, its layout and its functions, on the first floor without altering a centimeter of it and thus to experiment, within the same cultural envelope (the Museum Boymans-van Beuningen), with the particular effects of different spaces.

The unaltered construction on the first floor of this piece that was initially conceived for the ground floor, and therefore removed from the physical space and the reasons which led to its development, obliged me (because the length of the initial space is larger than that of the space used) to position the work diagonally in the utilized room. Placed in this manner, it exceeded the actual length of the room to such an extent that the exceeding part extended into the entry vestibule of the room just behind the stairs that lead into it. It was therefore a piece that stretched from one corner of the given space to the other, extending beyond its surface. Other restrictions, like those inherent to the Museum's budget (use of materials, existing partitions) determined some obligatory dimensions of the piece, and thus its physical appearance.

In this way, the breadth of the doors, the distance between two doors, the height of the doors and the thickness of the entire construction were dictated by these constraints that were beyond my control but which I voluntarily and gladly accepted.

One side of the construction was entirely painted lipstick red, the other was entirely covered with mirrors. The thickness of the walls, visible through the holes or doors, as well as the volumes that protruded from them (extracts of the wall) were highlighted with white and black stripes.

In conclusion, one could say, without overestimating the meaning that the same object will assume when in its definitive place, that, displaced and identically constructed on the first floor, its appearance as a three-dimensional object or sculpture takes precedence over all other possible interpretations. Although conceived to fulfill several specific functions – among others – loosing them for the duration of this exhibition, it was its appearance and qualities as an aesthetic and playful object that predominated during this stage.

The French artist Daniel Buren was invited by the Museum Boymans-van Beuningen in Rotterdam to realize a site-specific work for its new entrance hall. Buren presented the work *Placement-déplacé – travail provisoirement situé* in one of the museum's exhibition spaces from 9 April until 12 June 1994, coinciding with his exhibition *L'œuvre a-t-elle lieu?* at Witte de With. When going to press the final installation of this piece was not yet realized.

Daniel Buren

Genèse d'une exposition, "Placement déplacé - travail provisoirement situé" (1994)

Ce travail est produit grâce à un processus dont la logique est à proprement parler cul par dessus tête. Le principe à la logique inversée est le fruit de contraintes de dernières minutes, imposées par l'organisation (désorganisation?) du Musée Boymans-van Beuningen.

En effet, il était d'abord convenu que la grande salle à l'étage me soit réservée afin d'y exposer une série de travaux que je voulais bâtir en réponse à l'œuvre permanente qui était prévue pour occuper l'entrée même du Boymans, séparant physiquement la librairie et la cafétéria de l'œuvre *Waxing Arcs* de Richard Serra (1980). J'envisageais cette exposition comme totalement différente de l'œuvre permanente, les deux étant présentées au même moment au public.

Quatre semaines avant l'ouverture, j'apprends qu'il sera impossible, pour le moment, de construire la pièce permanente prévue au rez-de-chaussée. Par conséquent, le travail prévu au premier étage (dialogue contradictoire avec le rez-de-chaussée) devenait impossible.

Je décidais alors de construire la pièce initialement prévue pour l'entrée du Musée, sa forme et ses fonctions, au premier étage sans en altérer un centimètre et expérimenter ainsi, dans la même enveloppe culturelle (le Musée Boymans-van Beuningen), les effets propres à des espaces différents.

La construction sans altération au premier étage de cette pièce initialement conçue pour le rez-de-chaussée et donc en dehors de l'espace physique et des raisons qui conduisirent à son élaboration, m'obligeat (puisque la longueur de l'espace intial est plus grande que celle de l'espace utilisé) à positionner l'œuvre sur la diagonale de la salle utilisée. Ainsi dirigée, elle en excède toujours la longueur existante tant et si bien que la partie excédentaire est reportée dans le vestibule d'accès à la salle proprement dite, juste après les escaliers qui y mènent. Nous avons donc une pièce s'étendant d'un angle à l'autre de l'espace donné et débordant au dehors de cette surface. D'autres contraintes, comme celle inhérente au budget du Musée (emploi de matériaux, et de partitions existants) conduisent à certaines dimensions obligatoires de la pièce, donc à son aspect physique.

Ainsi, la largeur des portes, la distance entre deux portes, la hauteur des portes, l'épaisseur de toute la construction, sont dictées par ces contraintes indépendantes de ma volonté mais volontairement et volontiers acceptées.

L'une des faces de la construction est entièrement recouverte de peinture rouge opéra, l'autre entièrement recouverte de miroirs. Quant à l'épaisseur des murs, visible à travers les trous ou portes, ainsi que les volumes qui en sortent (extraits du mur), ils sont soulignés sur leur épaisseur par des bandes blanches et noires.

En conclusion, on peut dire sans présumer du sens que prendra le même objet lorsqu'il sera à sa place définitive que, déplacé et construit à l'identique au premier étage, son aspect en tant qu'objet tridimensionnel ou sculpture prime sur tous les autres. Bien que conçu pour remplir – entre autres – quelques fonctions spécifiques, les perdant pour le temps de cette exposition, c'est son apparence, ses qualités en tant qu'objet esthétique et ludique qui prédominent dans cette étape.

Page 174 - 175
Daniel Buren
Photo-souvenir: Placement déplacé - travail provisoirement situé
(Photo-souvenir: Displaced Placement - provisionally situated work)
9 April – 12 June 1994
Museum Boymans-van Beuningen, Rotterdam
photographs by Daniel Buren

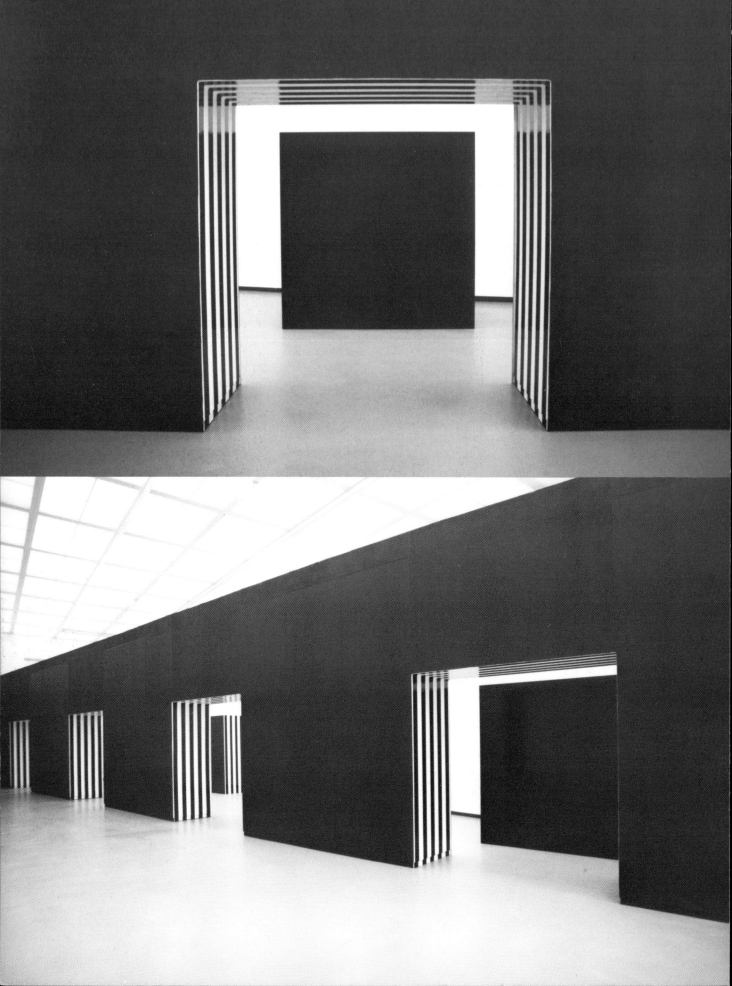

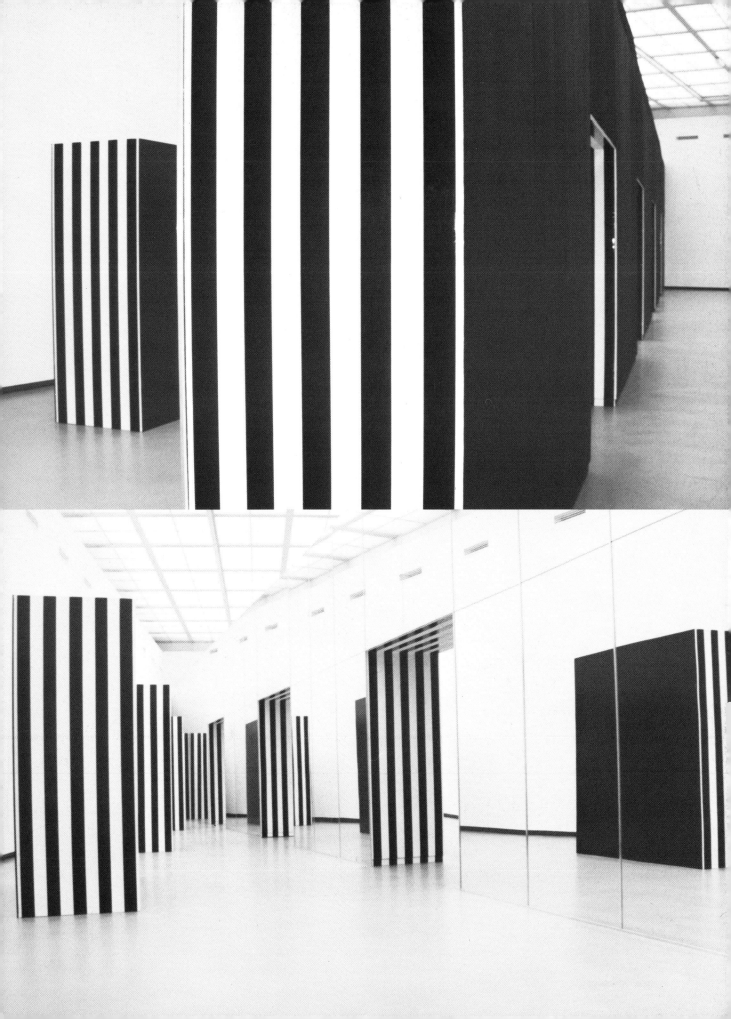

Biographies

Sylvie Amar (1962)

is an art historian living and working in Marseilles. She received her master's degree in art history at the Université d'Aix-Marseille in 1992. She recently curated the exhibition *Port à Port: Rotterdam/Marseille* (Marseilles, 1994). She has worked as a curatorial assistant for the exhibition *Homage to John Cage* and for *Il Padiglione Rosso* by Ilya Kabakov, both presented at *La XLIII Biennale di Venezia* (Venice, 1993), for *More than Zéro* (Le Magasin, centre d'art contemporain, Grenoble, 1993, cat.), and for *L'œuvre a-t-elle lieu?*, curated by Daniel Buren (Witte de With, Rotterdam, 1994). She writes for such art magazines as *Archives de la Critique d'Art*, *Art Press*, *Galeries Magazines* and *Opus International*. She has published essays on Yannick Gonzalez, Ilya Kabakov, Guy Limone, Antoni Muntadas and Hervé Paraponaris.

Giovanni Anselmo (1934)

is an artist living and working in Turin. His work has been shown in solo exhibitions at the Galleria Gian Enzo Sperone (Turin, 1968, cat., 1969, 1970, 1971, 1972, 1975), the Galerie Ileana Sonnabend (Paris, 1969, cat.), the Galleria Franco Toselli (Milan, 1970), the John Weber Gallery (New York, 1972, cat.), the Kunstmuseum (Luzern, 1973, cat.), Sperone/Fischer (Rome, 1974), the Studio d'Arte Lia Rumma (Naples, 1974), the Kabinett für Aktuelle Kunst (Bremen, 1975), the Kunsthalle (Basel, 1979, cat.), the Stedelijk Van Abbemuseum (Eindhoven, 1980), the Marian Goodman Gallery (New York, 1984, 1989, 1992), the Galerie Micheline Szwajcer (Antwerp, 1984, 1988, 1994), the Musée d'art Moderne de la Ville de Paris (Paris, 1985, cat.), *La XLI Biennale di Venezia*, *Padiglione Italia* (Venice, 1990, cat.), and the Centre d'Art Contemporain (Geneva, 1993). and in group exhibitions at the Galleria de'Foscherari (Bologna, 1968, cat.), the Centro Arte Viva (Trieste, 1968, cat.), the Städtische Kunsthalle (Dusseldorf, 1968, cat.), the Arsenale (Amalfi, 1968), the Castelli Warehouse (New York, 1968), the Stedelijk Museum (Amsterdam, 1969, cat.), the Kunsthalle (Bern et al., 1969, cat.), the Kunstmuseum (Luzern, 1970, cat.), the Fernseh-Galerie Gerry Schum (Cologne, 1970), *documenta 5* (Kassel, 1972, cat.), *La XXXVI Biennale di Venezia* (Venice, 1972, cat.), the Nova Scotia College of Art and Design (Halifax, 1972), Art & Project (Amsterdam, 1972), the Art Institute of Chicago (Chicago, 1974), *documenta 7* (Kassel, 1982, cat.), the Castello di Rivoli (Turin, 1984, cat.), P.S.1, The Institute for Art and Urban Resources (Long Island City, 1985, cat.), the Stedelijk Van Abbemuseum (Eindhoven, 1986, cat.), the Musée nationale d'art moderne, Centre Georges Pompidou (Paris, 1986, cat.), *Skulptur-Projekte* (Munster, 1987, cat.), *Expo '93* (Taejon, 1993, cat.), and the *XXII Bienal de Sao Paulo* (San Paulo, 1994, cat.).

Tony Arefin (1962)

is a designer and art director currently living and working in New York. Born in Bangladesh, he moved to London in 1975 where he worked until 1992, designing catalogues for amongst others the Institute for Contemporary Art, the Serpentine Gallery and the Hayward Gallery, as well as for the Fondation Cartier in Paris. He was also an associate editor for *Frieze* magazine. In New York Arefin art directs *I.D. Magazine*, *Bomb Magazine* and *Blind Spot*. Current projects include *The Whitney Biennal Book* and *Dewars*. Arefin is also a visiting critic at Yale University.

Michael Asher (1943)

is an artist living and working in Los Angeles. His work has been shown in solo exhibitions at the La Jolla Museum of Art (La Jolla, 1969), the Lisson Gallery (London, 1973), Heiner Friedrich (Cologne, 1973), the Galleria Toselli (Milan, 1973), the Otis Art Institute Gallery (Los Angeles, 1975), The Clocktower (New York, 1976), the Stedelijk Van Abbemuseum (Eindhoven, 1977), the Museum of Contemporary Art (Chicago, 1979), the Corps De Garde (Groningen, 1979), the Hoshour Gallery (Albuquerque, 1984), the Galerie Roger Pailhas (Marseilles, 1988), The Renaissance Society at the University of Chicago (Chicago, 1990, cat.), Le Nouveau Musée (Villeurbanne, 1991, cat.), Le Consortium (Dijon, 1991), the Musée national d'art moderne, Centre Georges Pompidou (Paris, 1991, cat.), the Kunsthalle Bern (Bern, 1992), the Paleis voor Schone Kunsten (Brussels, 1992, cat.), and in group exhibitions at the Los Angeles County Museum of Art (Los Angeles, 1967), the Whitney Museum of American Art (New York, 1969, cat.), the Kunsthalle (Bern, 1969, cat.), The Museum of Modern Art (New York, 1970, cat.), *documenta 5* (Kassel, 1972, cat.), *La XXXVIII Biennale di Venezia* (Venice, 1976, cat.), *Westkunst* (Cologne, 1981, cat.), *documenta 7* (Kassel, 1982, cat.), *A Pierre et Marie (Part II)* (Paris, 1983, cat.), *Sonsbeek 86* (Sonsbeek, 1986, cat.), *Skulptur-Projekte* (Munster, 1987, cat.), *Intentie en Rationele Vorm* (Mol, 1987, cat.), the Musée d'Art Moderne de la Ville de Paris (Paris, 1989, cat.), *Sonsbeek 93* (Sonsbeek, 1993, cat.), *Expo '93* (Taejon, 1993, cat.).

Anke Bangma (1969)

is an art historian living in Amsterdam and working in Rotterdam. She received her master's degree in

art history at the Universiteit van Amsterdam in 1994. She co-curated the exhibition *Wat eten wij vandaag?* by Jef Geys (Witte de With, Rotterdam, 1993). She is currently coordinator of the Studium Generale program of the Academie van Beeldende Kunsten in Rotterdam.

Hugues Boekraad (1942)

is a philosopher living and working in Amsterdam. He is a staff member of the design department at the Jan van Eyck Academie in Maastricht. He also teaches history and the theory of graphic design at the Academie St. Joost in Breda. He regularly writes on graphic design and typography. He has written essays on the work of Wim Crouwel, Karel Martens, Walter Nikkels and Henryk Tomaszewski, amongst others.

Michel Bourel (1949)

lives in Bordeaux where he directs the educational and cultural services department of the capc Musée d'art contemporain. He has curated the exhibitions *Art Minimal I et II* (1985, 1986), *Art Conceptuel* (1988), *Collection Sonnabend* (1988), *Richard Serra* (1990–91), *Peinture. Emblèmes et Références* (1993). He is the author of essays on minimal art, conceptual art, Andy Warhol, Giulio Paolini, and Ashley Bickerton, which have been published in *Artstudio* and *Artpress* as well as in catalogues of the capcMusée.

Koen Brams (1964)

is an art critic living and working in Ghent. He studied at the Koninklijke Universiteit Leuven. Since 1991 he is editor in chief of *De Witte Raaf*. He has written essays on, amongst others, Jorge Luis Borges, Daniel Buren, Thomas Huber and Rémy Zaugg.

Stanley Brouwn

At the request of the artist no biograhical information is to be published.

Daniel Buren (1938)

is an artist living and working in situ.

Patrick Corillon (1959)

is an artist living and working in Liège. His work has been shown in solo exhibitions at the Galerie Etienne Ficheroulle (Brussels, 1988, 1989, cat.), the Galerie Véga (Liège, 1988), the Kanaal Art Foundation (Kortrijk, 1989), the Galerie Albert Baronian (Brussels, 1990, 1992), the Paleis voor Schone Kunsten (Brussels, 1991), the Galerie des Archives (Paris, 1991, 1993), the Galerie Tanya Rumpff (Haarlem, 1991, 1994), the Galerie Yvon Lambert (Paris, 1993), the Produzentengalerie

(Hamburg, 1992), the Kunstraum München (Munich, 1993, cat.), the Galerie Massimo Minini (Brescia, 1994), and in group exhibitions at the Fondation Cartier (Paris, 1988, cat.), the FRAC Pays de Loire (Clisson-Nantes, 1989, cat.), the Galerie 't Venster (Rotterdam, 1989), the Centraal Museum (Utrecht, 1991, cat.), the Kunstverein für die Rheinlande und Westfalen (Dusseldorf, 1991, cat.), *documenta 9* (Kassel, 1992, cat.), the CCC (Tours, 1992, cat.), De Appel (Amsterdam, 1992, cat., 1994, cat.), the Musée national d'art moderne, Centre Georges Pompidou (Paris, 1993, 1994), *Sonsbeek '93* (Sonsbeek, 1993, cat.), the *Expo '93* (Taejon, 1993, cat.), the Muhka (Antwerp, 1993, cat.), the HCAK (The Hague, 1994), and the *XXII Bienal de São Paulo* (San Paulo, 1994, cat.).

Jacqueline Dauriac (1945)

is an artist living and working in Paris. Her work has been shown in solo exhibitions at the Galerie J. et J. Donguy (Paris, 1983), ARC, Musée d'Art Moderne de la Ville de Paris (Paris, 1984), La Criée, centre d'art contemporain (Rennes, 1987), the Galerie R. Blouin (Montreal, 1987), the Galerie Roger Pailhas (Marseilles, 1987), the Galerie A. Candau (Paris, 1988), Le Nouveau Musée (Villeurbanne, 1989), Musée de St. Croix (Poitiers, 1990), Musée de la Roche sur Yon (La Roche sur Yon, 1990), and in such group exhibitions as *A Pierre et Marie* (Paris, 1983, 1984, cat.), Le Nouveau Musée (Villeurbanne, 1984, 1986, 1988), the Nova Scotia College of Art and Design (Halifax, 1985), the CIAC (Montreal, 1986), the Stedelijk Van Abbemuseum (Eindhoven, 1986), the Fondation Cartier (Paris et al., 1988), the Kölnischer Kunstverein (Cologne, 1989), the Villa Stück (Munich, 1991), the Kunstverein (Stuttgart, 1991), the Tel Aviv Museum of Art (Tel Aviv, 1992), *Expo '93* (Taejon, 1993, cat.).

Stan Douglas (1960)

is an artist living and working in Vancouver. His work has been shown in solo exhibitions at the Art Gallery of Ontario (Toronto, 1987, cat.), the Contemporary Art Gallery (Vancouver, 1988, cat.), the Galerie nationale du Jeu de Paume (Paris, 1991), the World Wide Video Centre (The Hague, 1993), the Musée national d'art moderne, Centre Georges Pompidou (Paris, 1994, cat.), the I.C.A. (London, 1994), the Museo Nacional de Arte Reina Sofia (Madrid, 1994), the Kunsthalle Zürich (Zurich, 1994), the Deutscher Akademischer Austauschdienst (Berlin, 1995), and in group shows at the National Gallery of Canada (Ottawa, 1986, cat.), the Staatsgalerie (Stuttgart, 1989, cat.), the Winnipeg Art Gallery (Winnipeg, 1990), *Aperto '90,*

La XLIII Biennale di Venezia (Venice, 1990, cat.),
The Power Plant (Toronto, 1990, 1992, cat.),
the San Francisco Museum of Modern Art (1991,
cat.), *documenta 9* (Kassel, 1992, cat.),
and the Vancouver Art Gallery (Vancouver, 1993,
cat.).

Maria Eichhorn (1962)
is an artist living and working in Berlin. Her work
has been shown in solo exhibitions at the Wewerka
& Weiss Galerie (Berlin, 1991), the Künstlerhaus
(Stuttgart, 1992), the Nassauischer Kunstverein
(Wiesbaden, 1992), the Galerie Barbara Weiss
(Berlin, 1993), the Martin-Gropius-Bau (Berlin,
1994), and in group exhibitions at the Martin-
Gropius-Bau (Berlin, 1991, cat.), the Musée d'art
Moderne (Paris, 1992, cat.), the Wiener Secession
(Vienna, 1992, cat.), the Nassauischer Kunst-
verein (Wiesbaden, 1992, cat.), the Messepalast/
Deichtorhallen (Vienna/Hamburg, 1993, cat.), the
Muhka (Antwerp, 1993, cat.), the Kunsthalle Ritter
(Klagenfurt, 1994, cat.), and the Museo Nacional
de Arte Reina Sofia (Madrid, 1994, cat.).

Bert Jansen (1946)
is an art critic living and working in Amsterdam.
He received his masters in art history and com-
pleted a post-graduate minor in cultural anthropol-
ogy at the Vrije Universiteit van Amsterdam in
1984. He has curated a series of exhibitions pre-
senting the work of older artists as a reference for
the next generation (Jef Geys, Pieter Holstein,
Douwe Jan Bakker). He writes regularly for such
magazines as *Het Financieele Dagblad*, *Kunst &
Museumjournaal* and *Metropolis M*. He has written
essays on, amongst others, Philip Akkerman,
Guillaume Bijl, Patrick van Caeckenberg, Yves
Klein and Martial Raysse.

Bruce Jenkins (1952)
is a specialist in film and video work by visual art-
ists. He is currently the film and video curator at
the Walker Art Center in Minneapolis and a lecturer
at the University of Minnesota. The retrospectives
he has organized include *Derek Jarman: Of Angels
and Apocalypse* (1986), *Dennis Hopper: From
Method to Madness* (1988), *Jonathan Demme: An
American Director* (1988), *William Klein: Cinema
Outsider* (1989), *John Cassavetes: In Retrospect*
(1989), *Clint Eastwood Directs* (1990) and *Jodie
Foster: A Life on Screen* (1991). Among the exhibi-
tions he has curated for the Walker Art Center are:
Viewpoints: Paul Kos and Mary Lucier (1987), *Le
Corbeau et le Renard, film installation for Marcel
Broodthaers* (1989), *David Hockney: Fax Prints*
(1990) and *Flux Film Wallpaper* (1993). He recently
worked on the exhibition *Chantal Akerman: From

the East* which opened in January 1995 at the San
Francisco Museum of Modern Art.

Krijn de Koning (1963)
is an artist living and working in Amsterdam. His
work has been shown in solo exhibitions at Picaron
Editions (Amsterdam, 1990), the Centraal Mu-
seum (Utrecht, 1991), the Galerie Storm (Amster-
dam, 1992), the Galerie d'Art Contemporain (Her-
blay, 1993, cat.), the Stichting Artis (Den Bosch,
1993), and in group exhibitions at the Galerie Vin-
cenz Sala (Berlin, 1989), the Galerie Tanya Rumpff
(Haarlem, 1991), the HCAK (The Hague, 1992),
Beauty/About Monuments and Vulnerability (Oud-
Amelisweerd, 1992), W139 (Amsterdam, 1993),
Expo '93 (Taejon, 1993, cat.), the Paleis voor
Schone Kunsten (Brussels, 1994, cat.), Artcite
(Windsor, Canada, 1994), and the Institut Néerlan-
dais (Paris, 1994, cat.).

Mark Kremer (1963)
is an art critic living and working in Amsterdam and
Utrecht. He studied history of art at the Rijksuni-
versiteit Groningen and at the Universiteit van Am-
sterdam, where he graduated in 1988. He cur-
rently directs the art program of the Festival aan
de Werf in Utrecht and teaches at the Curatorial
Training Programme of De Appel Foundation in
Amsterdam. He is a regular contributor to such art
magazines as *Archis*, *Artscribe*, *Kunst & Museum-
journaal*, *Metropolis M* and *De Witte Raaf*. He has
written essays on, amongst others, Vito Acconci,
Lili Dujouri, Daan van Golden, Mike Kelley, Sherrie
Levine, Pieter Laurens Mol, Alan Murray, Jan van
der Pavert, Stephen Prina and Berend Strik.

Thierry Kuntzel (1948)
is an artist living and working in Paris and Tarbes.
His work has been shown in solo exhibitions at The
Museum of Modern Art (New York, 1983 and 1991),
the Musée national d'art moderne, Centre Georges
Pompidou (Paris, 1984), the Wiener Secession
(Vienna, 1984, cat.), the Galerie nationale du Jeu
de Paume (Paris, 1993, cat.), the Musée d'Art Con-
temporain (Montreal, 1993-94), and in group exhi-
bitions at the Théâtre Campagne-Première (Paris,
1976), the galerie Ghislain Mollet-Viéville (Paris,
1977), the University Art Museum (Berkeley et al.,
1980), the *Biennale de Paris* (Paris, 1980, cat.),
the Palais des Beaux-Arts (Charleroi, 1983, cat.),
the Stedelijk Museum (Amsterdam, 1984, cat.),
the Paleis voor Schone Kunsten (Brussels, 1984),
the Wiener Secession (Vienna, 1984), the Musée
national d'art moderne, Centre Georges Pompidou
(Paris, 1985, cat.; 1987, cat. and 1990, cat.), the
Long Beach Museum of Art (Long Beach, 1985,
cat.), the Kölnischer Kunstverein (Cologne et al.,

1989, cat.), the Art Gallery of Ontario (Toronto, 1991, cat.), the Musée d'Art Moderne La Terrasse (Saint-Etienne, 1992, cat.), and the Fondacio La Caixa (Madrid, 1994, cat.).

Timothy Martin (1955)

is an artist and writer living and working in Los Angeles. Since 1991, he teaches at the Art Center College of Design in Pasadena. He has written for such publications as *L.A. Weekly*, *Artpaper*, *Art Issues* and *Fama und Fortune*. He has also contributed to exhibition catalogues on Stephen Prina, Mike Kelley and Christopher Williams as well as to that of the recent exhibition *Hors Limites* at the Musée national d'art moderne, Centre Georges Pompidou in Paris.

Willem Oorebeek (1953)

is an artist living and working in Brussels and Rotterdam. His work has been shown in the Museum Boymans-van Beuningen (Rotterdam, 1988, cat.), Witte de With (Rotterdam, 1991, cat. and 1994, cat.), the Centro per l'Arte Contemporanea Luigi Pecci (Prato, 1991), the Kunstverein für die Rheinlande und Westfalen (Dusseldorf, 1991), the Provinciaal Museum voor Aktuele Kunst (Hasselt, 1992, cat.), and at the *VIII Triennale-India* (New Delhi, 1994). Oorebeek teaches at the Jan van Eyck Academie, Maastricht, and de Ateliers in Amsterdam.

Jean-Marc Poinsot (1948)

lives in Rennes where he is director of the Archives de la critique d'art and professor at the Université de Rennes II. Over the past twenty years he has worked for a number of art magazines, including *Kunstforum*, *Parachute*, *Art Press*, *Les Cahiers du Musée National d'Art Moderne*, *Beaux Arts* and *Critique d'Art*. He regularly collaborates with institutions such as le capcMusée d'art contemporain de Bordeaux, the Videomuseum in Paris, le Nouveau Musée in Villeurbanne, organizing conferences, doing research and contributing to their publications.

Diana Thater (1962)

is an artist living and working in Los Angeles. Her work has been shown in solo exhibitions at the Dorothy Goldeen Gallery (Santa Monica, 1991), Bliss House (Pasadena, 1992), 1301 (Santa Monica, 1993), David Zwirner (New York, 1993), Friesenwall 116a (Cologne, 1994), and in group exhibitions at the Fahey/Klein Gallery (Los Angeles, 1990), 1301 (Santa Monica, 1992), the Long Beach Museum of Art (1993, cat.), the American Center (Paris, 1994, cat, and the Deichtorhallen (Hamburg, 1994).

Joëlle Tuerlinckx (1958)

is an artist living and working in Brussels. Her work has been shown in a solo exhibition at the Centre d'Art Contemporain (Lausanne, 1990, cat.), and in group exhibitions at the Musée des Sciences Naturelles (Brussels, 1983), the I.S.E.L.P. (Brussels, 1985), the Paleis voor Schone Kunsten (Brussels, 1988 and 1993, cat.), the Centre Régional d'Art Contemporain Midi-Pyrénées (Toulouse, 1990, cat.), the Galerie des Archives (Paris, 1992), the Goethe Institut (Brussels, 1993, cat.), the Sint-Pietersabdij (Ghent, 1993, cat.), the Neuer Aachener Kunstverein (Aachen, 1993), Witte de With (Rotterdam et al., 1994), the Ludwig Forum (Aachen, 1994, cat.), Palais des Arts, Ecole des Beaux Arts (Toulouse, 1994), and *Inside the Visible*, *Begin the Beguine in Flanders* (Kortrijk, 1994).

Chen Zhen (1955)

is an artist living and working in Paris. His work has been shown in solo exhibitions at the HANGAR 028 (Paris, 1990, cat.), the Ecole des Beaux Arts (Paris, 1991, cat.), the Dany Keller Gallery (Munich, 1991), Le Magasin, Centre National d'Art Contemporain de Grenoble (Grenoble, 1992, cat.), the Centraal Museum (Utrecht, 1993), the Lumen Travo Gallery (Amsterdam, 1993), The New Museum of Contemporary Art (New York, 1994, video, cat.), and in group exhibitions at the Russian Museum (St. Petersburg, 1990, cat.), Pourrière (1990, cat.), *Parcours Privés* (Paris, 1991, cat.), the Asian American Art Center (New York, 1991, cat.), the *Floriade* (The Hague, 1992, cat.), the Galerie des Archives (Paris, 1992), the Frankfurter Kunstverein, Schirn Kunsthalle (Frankfurt, 1993, cat.), the Kunstverein Ludwigsburg (Ludwigsburg, 1993), *Expo '93* (Taejon, 1993, cat.), *La XLIII Biennale di Venezia* (Venice, 1993, cat.), The Museum of Modern Art (Oxford, 1993, cat.), the Wiener Secession (Vienna, 1993, cat.), the Pori Art Museum (Pori, 1994, cat.), and the Rijksmuseum Kröller-Müller (Otterlo, 1994, cat.).

Colophon

Editor: Barbera van Kooij
Assistant Editor: Robin Resch
Editorial Assistant: Sylvie Amar
Typography: Tony Arefin

Contributors:
Sylvie Amar, Giovanni Anselmo, Michael Asher, Anke Bangma, Hugues Boekraad, Daniel Buren, Koen Brams, Stanley Brouwn, Patrick Corillon, Jacqueline Dauriac, Chris Dercon, Maria Eichhorn, Bert Jansen, Bruce Jenkins, Krijn de Koning, Mark Kremer, Thierry Kuntzel, Timothy Martin, Willem Oorebeek, Diana Thater, Joëlle Tuerlinckx, Chen Zhen

Translations:
Meghan Ferrill (Bert Jansen, Mark Kremer); Brian Holmes (Sylvie Amar, Koen Brams, Patrick Corillon, Jacqueline Dauriac, Joëlle Tuerlinckx, Chen Zhen); Ruth Koenig (Hugues Boekraad, Krijn de Koning); Barbera van Kooij/Robin Resch (Maria Eichhorn, Chris Dercon); Robin Resch (Giovanni Anselmo, Anke Bangma, Daniel Buren)

Photography:
Tony Arefin (p. 2-3); Fred Aubert (p. 167); Daniel Buren (p. 174-175); Andrew Freeman (p. 8-17); Claude Gintz (p. 30); Bob Goedewaagen (p. 7, 19, 22-23, 25-29, 31-32, 37, 41, 43, 59-60, 78-79, 100-101, 104-113, 169); Aglaia Konrad (p. 166); Fredrik Nilsen (p. 128); Joëlle Tuerlinckx (p. 133-148); Jens Ziehe (p. 170-171)

Acknowledgements:
Centrum Beeldende Kunst, Rotterdam; Stichting het Fonds voor Beeldende Kunst, Bouwkunst en Vormgeving, Amsterdam; Maria Gilissen, Brussels; Jonathan Hoefler, New York; Line Kramer, Rotterdam; Thomas Meijer-zu Schlochtern, Rotterdam; Maarten Struijs, Rotterdam; Angel Vergara Santiago, Brussels

The exhibition *Stan Douglas & Diana Thater* was made possible with the support of Sony Nederland B.V., Badhoevedorp.

SONY
PROFESSIONAL

Cahier # 3 was made possible with the assistance of the Association Française d'Action Artistique, Ministère des Affaires Étrangères, Paris, and the Rotterdam Arts Council.

Printer: Heinrich Winterscheidt GmbH, Dusseldorf
Edition: 2000
Publisher: Witte de With, center for contemporary art, Rotterdam; Richter Verlag, Dusseldorf

Witte de With – Cahier # 4 will be published in October 1995

Witte de With, center for contemporary art
Witte de Withstraat 50
3012 BR Rotterdam
The Netherlands
tel + 31 (0) 10 4110144
fax + 31 (0) 10 4117924
staff: Gé Beckman, Chris Dercon, Paul van Gennip, Roland Groenenboom, Chris de Jong, Barbera van Kooij, Maaike Ritsema, Miranda Spek, Rutger Wolfson, and interns: Catharine Loth, Iebel Vlieg

Witte de With is an initiative of the Rotterdam Arts Council and is supported by the Dutch Ministry of Culture.

ISBN 90-73362-31-8
Printed and bound in Germany

The cover design was especially made by Diana Thater for Witte de With – Cahier # 3.

Diana Thater
Untitled Index for Cahier, 1995

Diana Thater's work was shown in the exhibition *Stan Douglas & Diana Thater* at Witte de With from 10 September until 30 October 1994.